CONTENTS

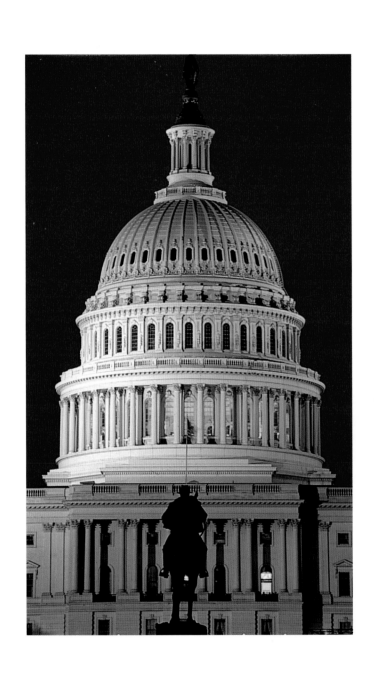

WHITE STAR
PUBLISHERS

WASHINGTON

MARCELLA COLOMBO E GIANFRANCO PERONCINI

1 Seen in the evening shadows, the dome of the Capitol in Washington D.C. is the federal heart of the United States and one of the most famous and best-loved symbols of the American nation.

2-7 Georgetown stands on the banks of the Potomac River. In this print it appears to have been a prosperous port town before the city of Washington was constructed. This is the starting point of the 300-mile long Chesapeake and Ohio Canal, built to join Chesapeake Bay and the Ohio River to the lands to the west. The attractive canal goes as far as Cumberland in the state of Maryland.

3-6 Georgetown is famous for its elegant streets and quiet, pleasant life. Its busiest section is from the junction of Wisconsin Avenue and M Street to the river.

Graphic design
Maria Cucchi

Editorial coordination
Lara Giorcelli

Translation
C.T.M., Milan

© 2003, 2005 White Star S.r.l.
Via C. Sassone, 22/24
13100 Vercelli, Italy
www.whitestar.it

ISBN 88-544-0052-1
REPRINTS:
2 3 4 5 6 09 08 07 06 05

Printed in China
Color separation: Grafotitoli, Milano

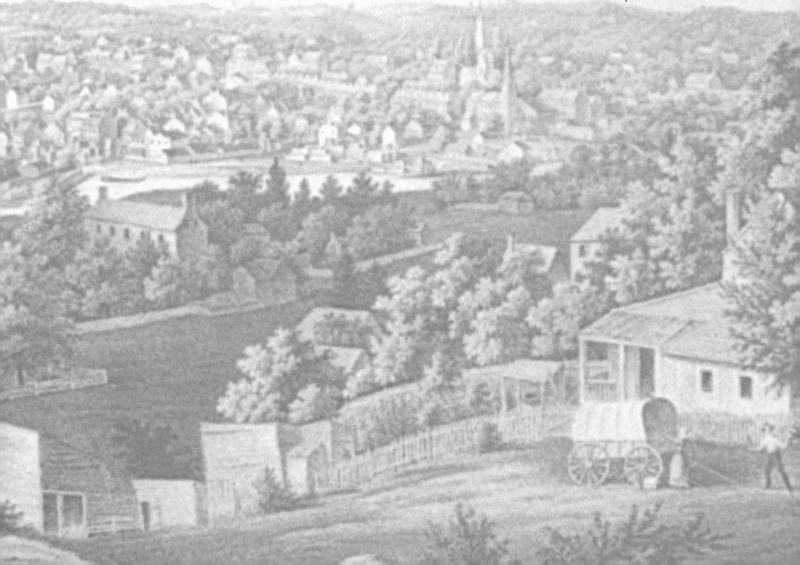

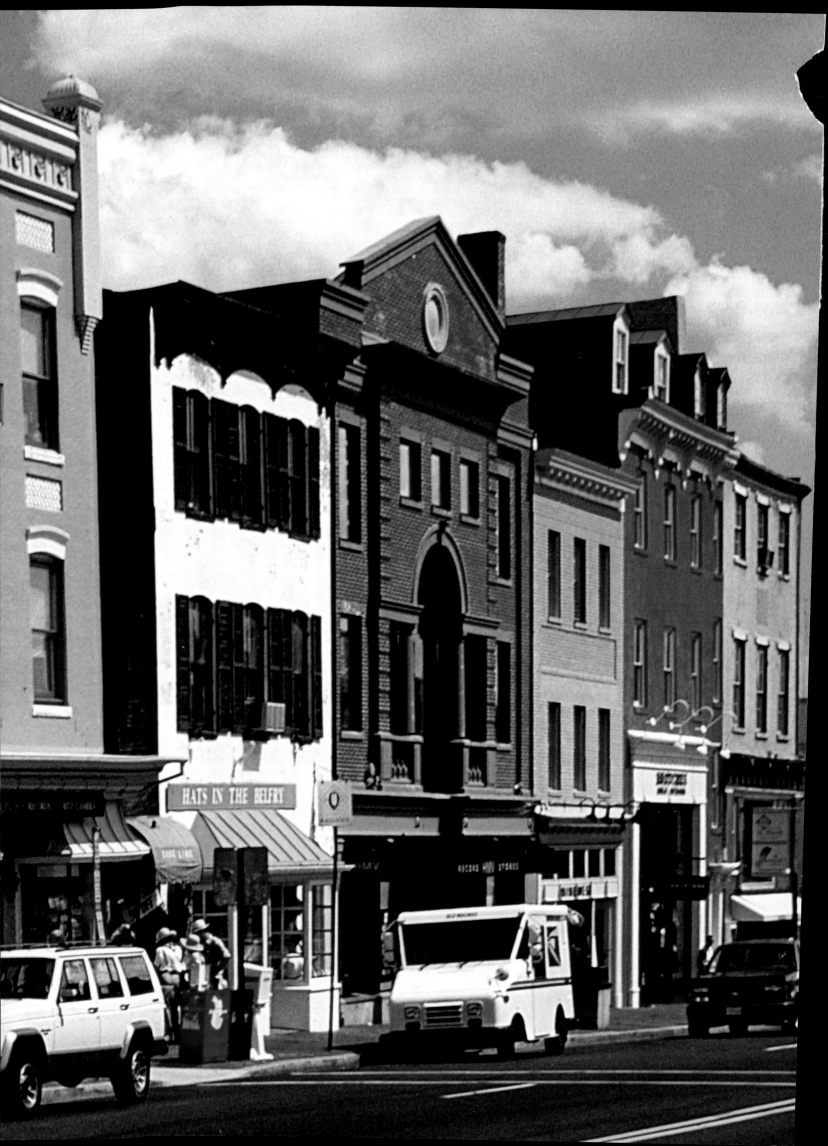

8 *top* left A detail of the Arlington Memorial Bridge that joins Washington to Arlington. Arlington has been the site of United States' national cemetery since the dead Union soldiers were buried there after the Civil War Battle of Bull Run (21 July 186...

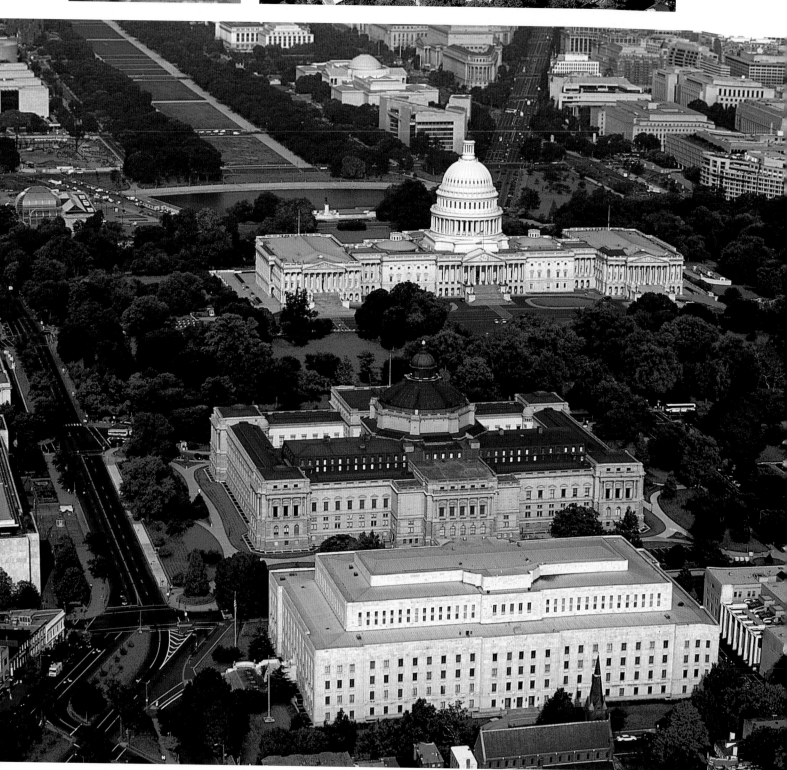

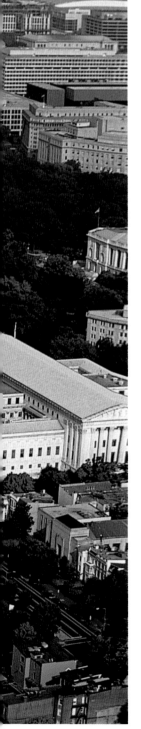

9 The U.S. Treasury was built beside the White House at 15th Street and Pennsylvania Avenue. Recently renovated to its former splendor, it is the oldest federal building in Washington. Construction was decided on 1836 by President Jackson (1829-1837) but it dramatically interrupts the "reciprocity of vision" wanted by George Washington along Pennsylvania Avenue between the Congress, (the U.S. legislative arm) and the White House (the executive arm).

Washington, D.C. A visiting card, a program, a destiny. Washington, District of Columbia. A synopsis of the American adventure. *Columbus* (Christopher) and *Washington* (George), America and the United States. The two beginnings of its history. A route conceived, planned and laid down during the long "American century." A century that had begun in Europe, crossed the mysterious Atlantic, and landed in an unexpected continent on the route to *Cathay.*

A small fleet sails through the darkness as an intangible mood of tension comes over the crews. The ships proceed as fast as they are able; first the *Pinta,* perhaps half a mile in the lead, then the *Santa Maria,* and, beside her, the *Niña.* On the invisi-

ble chronometer of history, the world of the Middle Ages had entered its death throes, on the dial the last seconds were ticking away, grains of sand in an hourglass destined to turn a new page in history. Everyone's senses were straining. Rocks bathed gently by moonlight. 'Land ho! Land ho!' The first cry was cut off in the throat of the young sailor, but the second, third and fourth broke out strongly, raucous and loud. The captain of the Pinta, Martín Alonso Pinzón, confirmed the sighting. Land two leagues off. A small island in the Bahamas, *Guanahaní* in the language of the Taino natives, *San Salvador* as it was quickly renamed by Columbus. So many names for a white coral beach that was to change the fate of mankind. This was the begin-

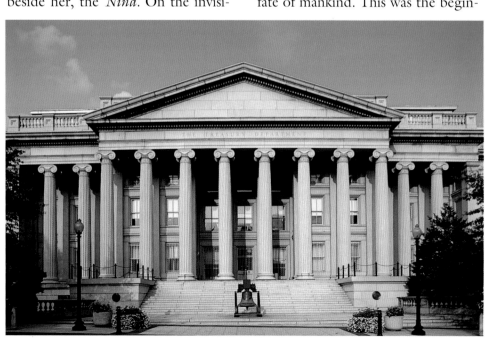

Dawn on 12 October 1492. And dawn on 29 March 1791, when two men unhurriedly amble through the hills of Maryland near the Potomac River. It is the first day of the life of the capital of the United States. George Washington and Pierre Charles L'Enfant were about to bring life to a new nation, born of the rebellion of the 13 British colonies. Washington, District of Columbia. A fascinating history created by the will of a President, a historical compromise and the irritable genius of a French architect. A history marked by a devastating fire, a dramatic civil war, the crisis of the Depression, and two world wars; a history that has developed into embracing the extreme complexity of the contemporary world and the apocalyptic scenes of modern life seen through the dramatic medium of television. A synopsis of the whole American adventure.

It is not difficult to find your way through the urban maze, traffic conditions permitting. The fundamental lines of the city that wanted to recreate an imperial tradition promised and hoped for since the days of the Founding Fathers were traced out using the same methods of the ancient Roman surveyors on a grid of orthogonal lines that start from two main streets: the *cardus* and the *decumanus.* Looking down on the city or, more modestly, at a map, it is easy to make out that The

ning of the history of the United States, born of the courage and stubbornness of an unknown Genoese sailor. This step was to expand to embrace the history of the contemporary world.

He was to reach the District of *Columbia,* the name of which refers to the roots of it all. *Columbus* (Christopher) and *Washington* (George), America and the United States. The discoverer and the President. Two starting points in history. A federal capital in a distinct and separate territory that represents the heart of the nation. A district, not a state, to emphasize the uniqueness and distance of the place from the selfishness, the self-interest and underhand tricks that are inevitable among the 50 tiles that make up the inimitable mosaic of the United States.

10-11 This fountain is dedicated to Samuel Francis Du Pont, a rear admiral in the Union navy. The fountain stands in Dupont Circle, an elegant residential area of Victorian villas that have been transformed into embassies and institutions. Dupont Circle is considered one of the capital's most desirable area.

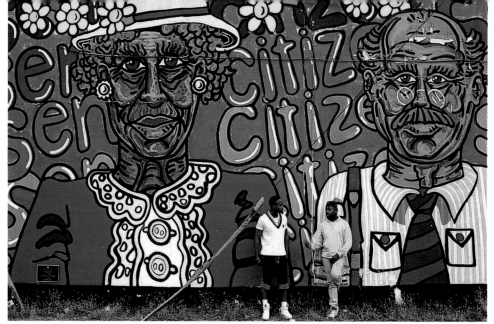

11 A mural brightens the façade of a building in Anacostia, a district on the Anacostia River in the SE Washington, known for its high crime rate. The Smithsonian Anacostia Museum tells the history of Afro-Americans. Anacostia is also the site of the house of Frederick Douglass, a slave who escaped from Maryland and became a famous abolitionist.

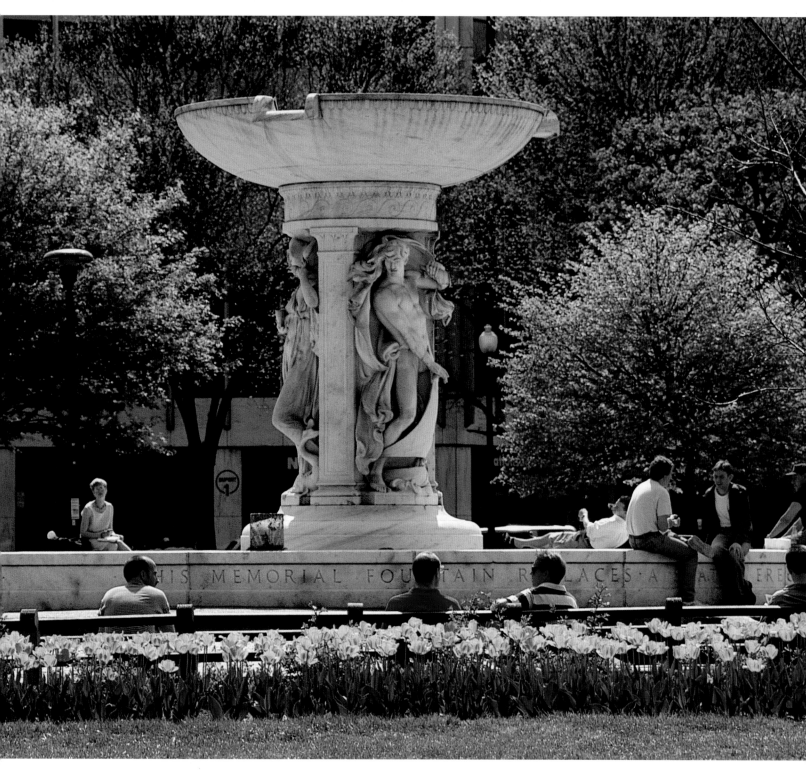

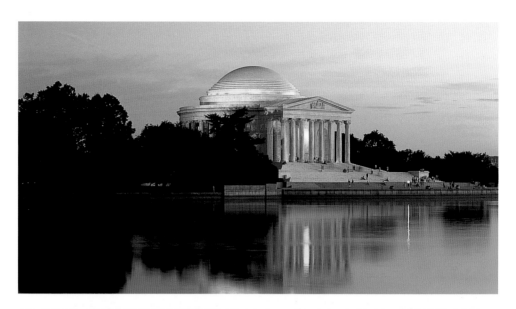

Mall and North Capitol, South Capitol and East Capitol streets converge on a single site, the Capitol itself, thereby dividing the city into four quadrants: north-east, north-west, south-east and south-west. A third of the 600,000 population have government-related jobs whether federal or district; three of the districts have a black majority and only one has a white majority.

Unlike other American cities, there is no Main Street even if Pennsylvania Avenue performs a similar function, perhaps an even greater one, given its connotations of a *via sacra* referred to earlier. In accordance with a plan laid down by Jefferson and introduced in Richmond while he was still governor of Virginia, north-south streets are identified by numbers and east-west streets by letters. The lowest numbers and first letters in the alphabet begin at the Capitol.

This is how Washington is laid out; a city "whose business is power and whose industry is government." It is sophisticated, cosmopolitan and international; there are museums, art galleries, theaters, ballet companies and concerts of all types of music. And seven universities. This galaxy of cultural activities is performed and frequented by the most powerful and the best in the world in a setting that boasts cherry blossom Japan would be envious of and summer humidity the equal of a rainforest.

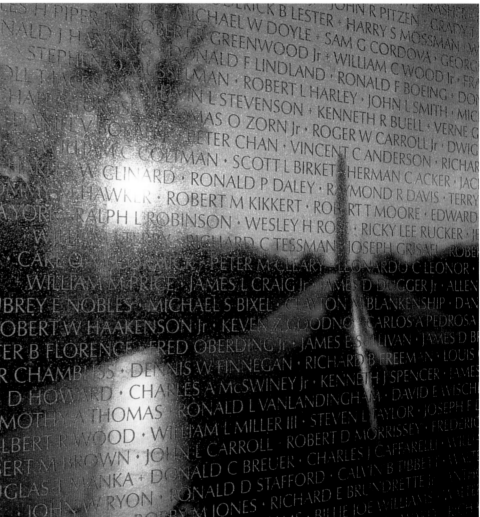

What an extraordinary development since that dry, crispy dawn on which two men on horseback ambled through an unexplored corner of Maryland. Washington, District of Columbia. America and the United States, the two starting points of history.

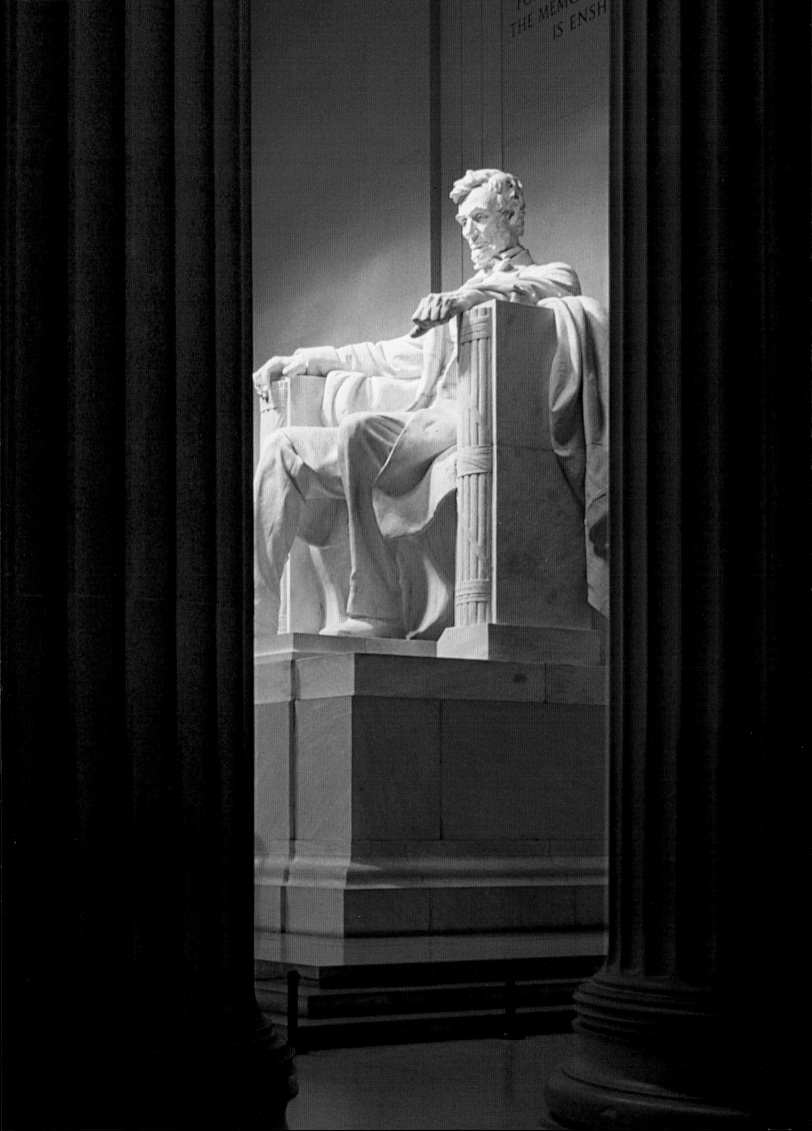

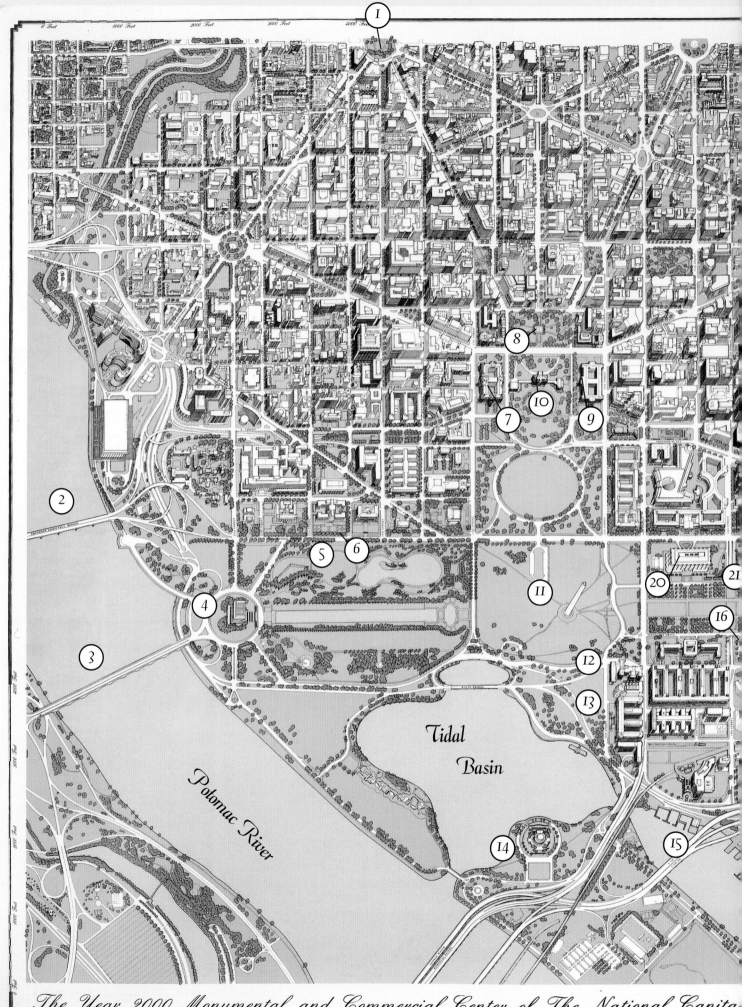

The Year 2000 Monumental and Commercial Center of The National Capital

1 *Dupont Circle*

2 *Theodore Roosevelt Memorial Bridge*

3 *Arlington Memorial Bridge*

4 *Lincoln Memorial*

5 *Vietnam Veterans Memorial*

6 *Constitution Avenue*

7 *Old Executive Office Building*

8 *Lafayette Square*

9 *Treasury Building*

10 *White House*

11 *Washington Monument*

12 *U.S. Holocaust Museum*

13 *Bureau of Engraving and Printing*

14 *Jefferson Memorial*

15 *Francis Case Memorial Bridge*

16 *Freer Gallery of Art*

17 *The Castle (Smithsonian Institution)*

18 *Arts and Industries Building*

19 *Smithsoman Institution*

20 *National Museum of American History*

21 *National Museum of Natural History*

22 *Old Post Office*

23 *FBI*

24 *Ford's Theater*

25 *National Portrait Gallery and National Museum of American Art*

26 *Navy Memorial*

27 *National Archives*

28 *National Gallery of Art, West Building*

29 *National Gallery of Art, East Building*

30 *The Mall*

31 *Pennsylvania Avenue*

32 *Independence Avenue*

33 *The Capitol*

34 *Library of Congress*

35 *Supreme Court*

36 *Senate Office Buildings*

37 *Delaware Avenue*

38 *Union Station*

39 *National Postal Museum*

Three Dimensional Map Of Central Washington

Residential Neighborhoods

Prepared by Joseph Passonneau & Partners Drawn by Vitaly Gevorkian and David B. Akopian

2114-A "O" street, NW, Washington, DC, 20037, tel. (202) 296 8017

0 Feet 1000 Feet 2000 Feet 3000 Feet 4000 Feet

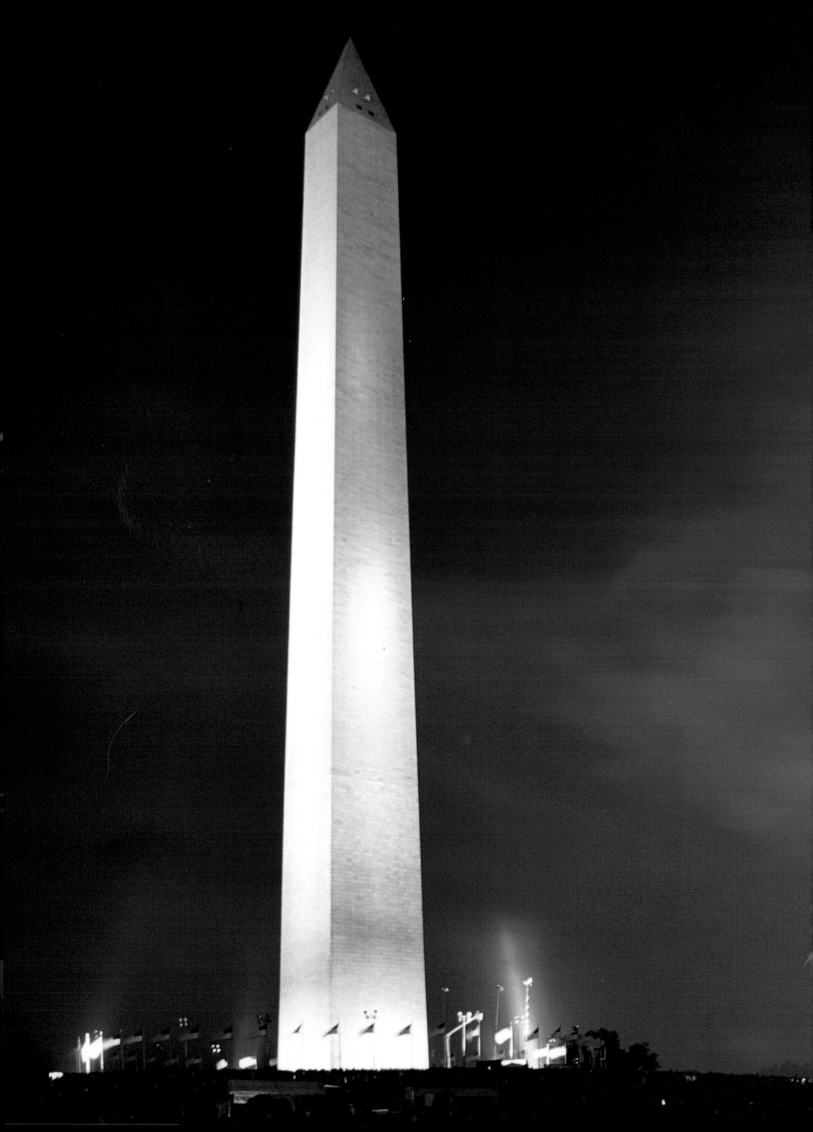

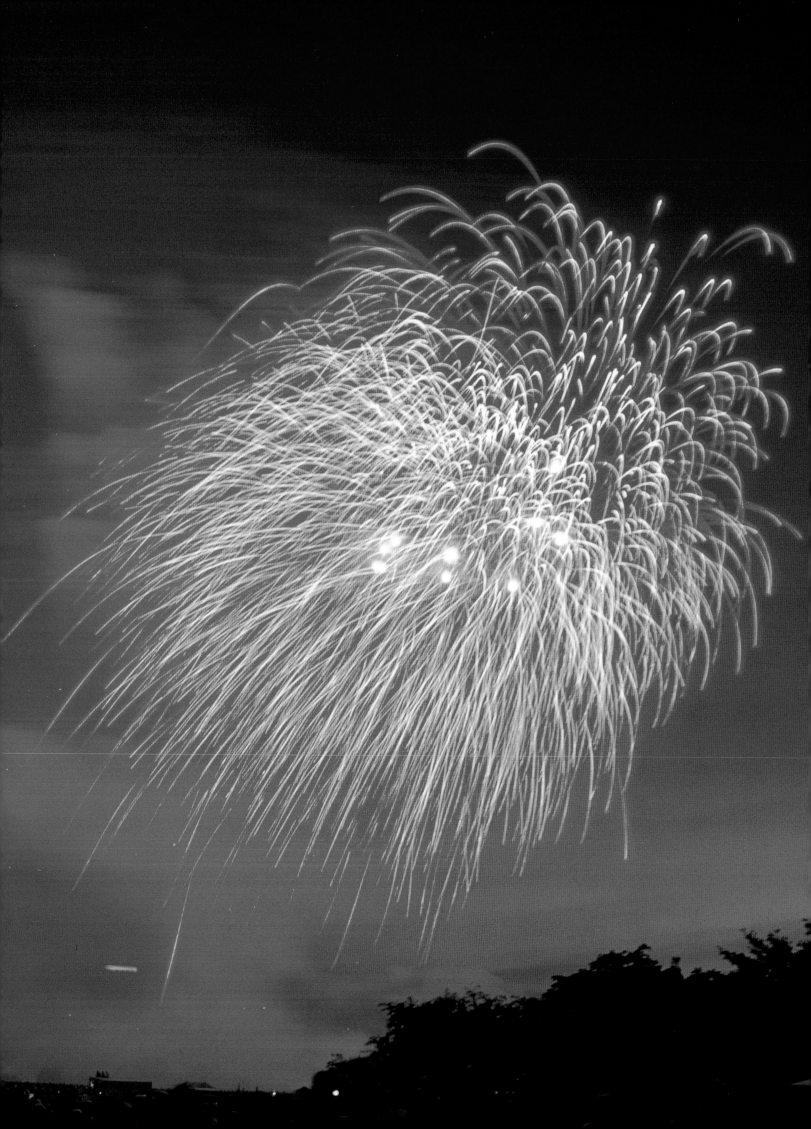

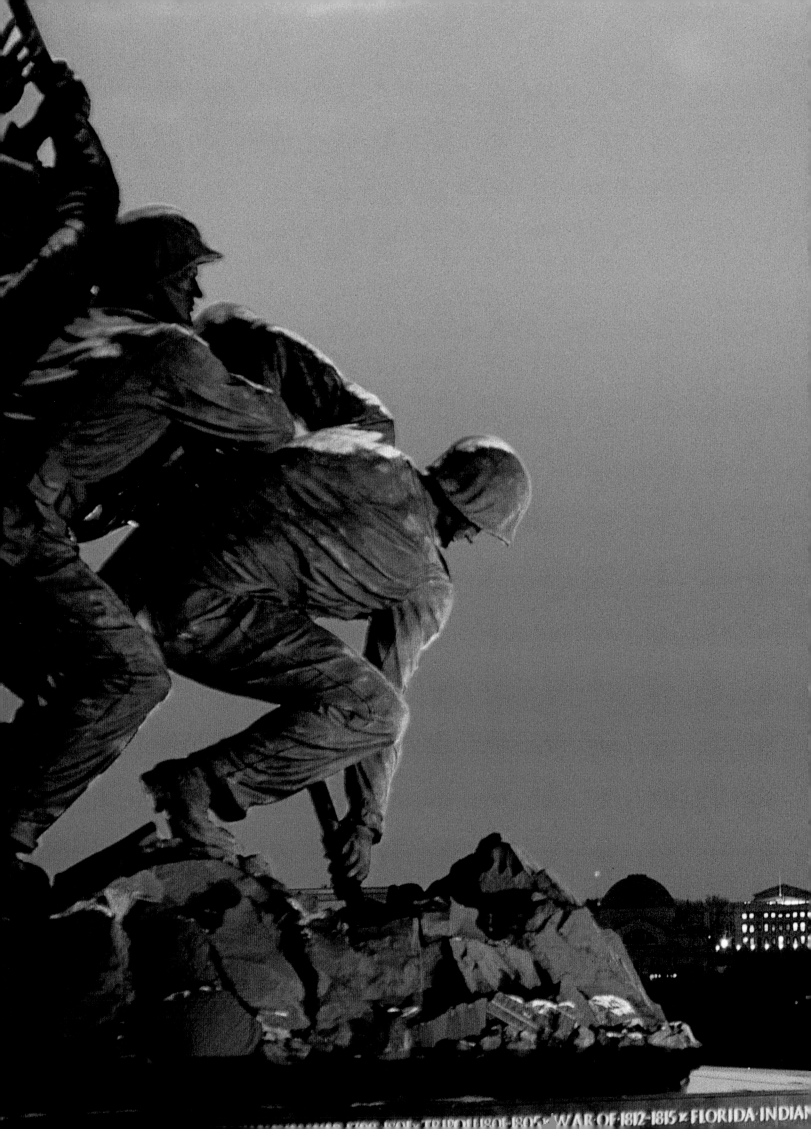

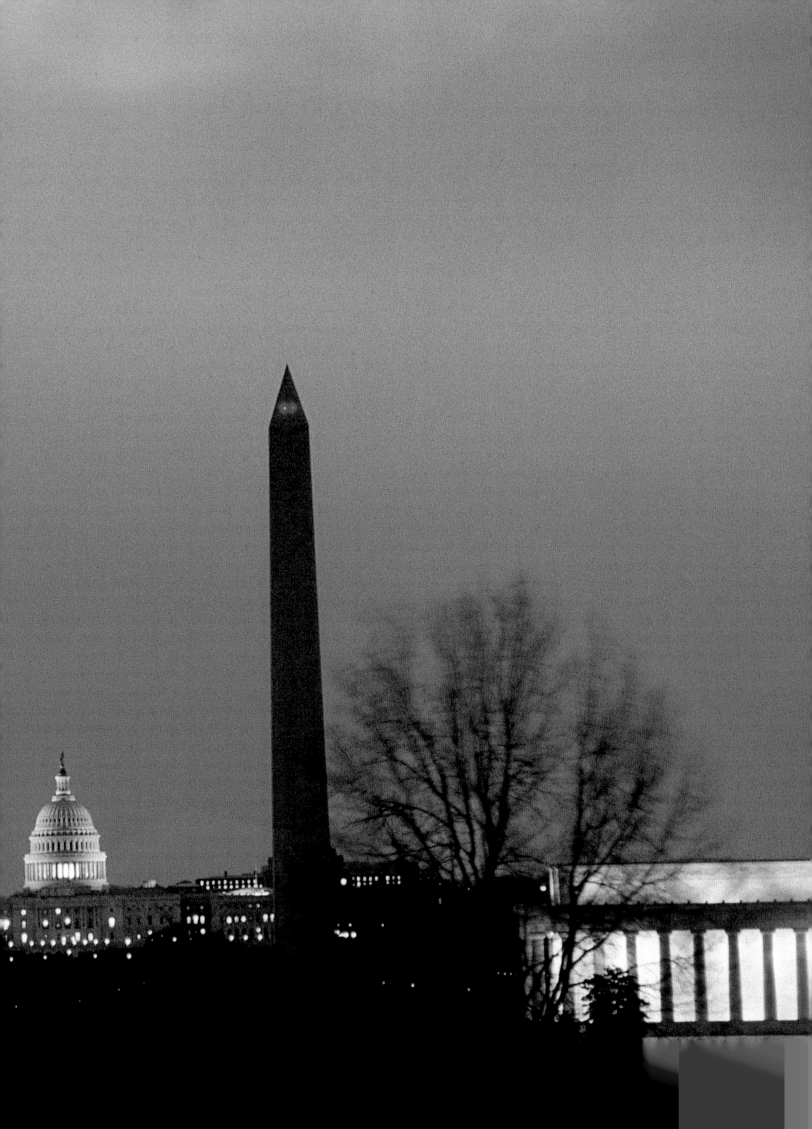

THE HISTORY OF WASHINGTON

*I*n the dry and crispy early morning air of the gently rolling hills of this sliver of Maryland, the silhouettes of two men on horseback slowly come into view. Unhurriedly, they amble along, carefully, though with apparent nonchalance, observing the land wedged between the woods and fields of maize stubble that stretch lazily along the Potomac River. It is dawn on 29 March 1791 which, in some ways, was the first day of existence of the United States of America. This was the day of the founding of Washington D.C. – the city in the District of Columbia.

The tall, strong leading horseman sits well in the saddle; his calm air of authority alone is enough to assert itself over men and events. At 59, George Washington is the first President of the United States of America, a federation of 13 former British colonies that decided to go to war in order to create their own independent destiny, based on hope, glory, success – and happiness – as they had the boldness to proclaim in their Constitution.

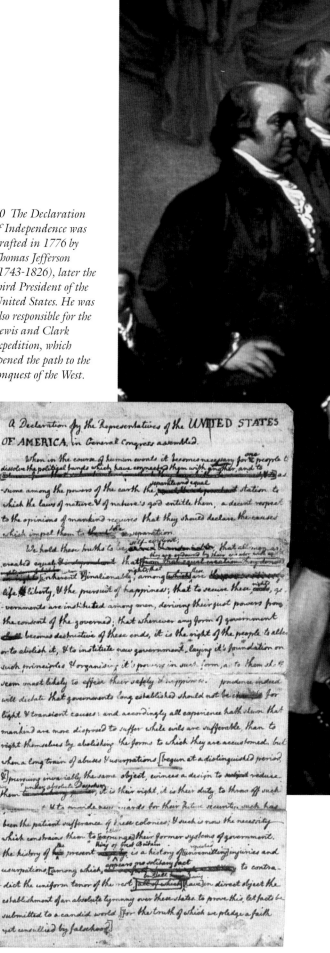

20 The Declaration of Independence was drafted in 1776 by Thomas Jefferson (1743-1826), later the third President of the United States. He was also responsible for the Lewis and Clark expedition, which opened the path to the conquest of the West.

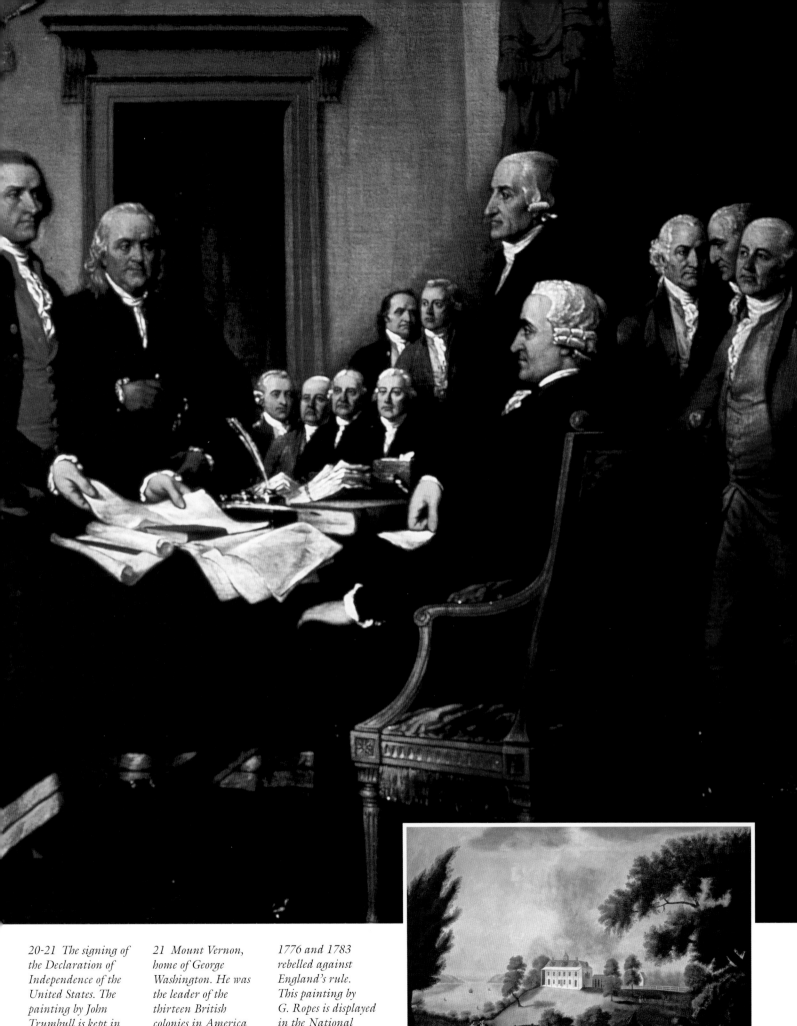

20-21 The signing of the Declaration of Independence of the United States. The painting by John Trumbull is kept in the Capitol in Washington, D.C.

21 Mount Vernon, home of George Washington. He was the leader of the thirteen British colonies in America (the East coast states) that between 1776 and 1783 rebelled against England's rule. This painting by G. Ropes is displayed in the National Gallery, Washington, D.C.

When Washington first explored the hills where he later decided to build the capital, he already knew many things. In Georgetown – the port on the upper Potomac that was always busy organizing the movement of high quality tobacco leaves from Virginia – he had already been told that the large councils of the local Algonquin tribes were held at the foot of the hill now known as Jenkins Hill. This was an excellent precedent for the federal and confederate heart of the recently founded American nation; but there was more. The Commander-in-Chief of the forces at war against the British would certainly have realized the strategic position on top of the hill on which plans were being laid to build the "New Rome" in the New World. Undoubtedly also, it had not escaped the notice of the other man who accompanied the victorious general on that bright, chilly day.

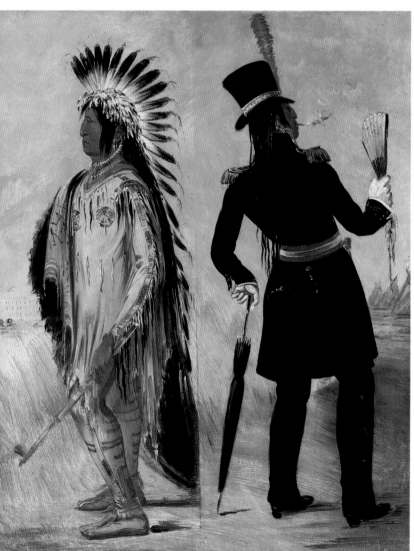

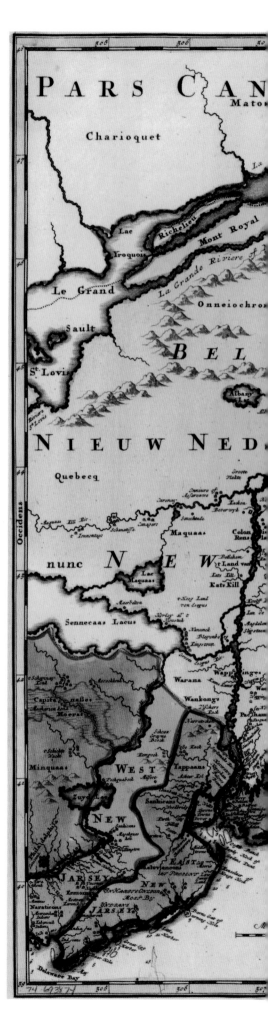

22 This painting by George Catlin (1796-1872) in the Smithsonian American Art Museum in Washington portrays with heavy irony the Indian chief, Pigeon's Egg, before and after a trip to the federal capital.

22-23 The map from the second half of the eighteenth century shows the north-eastern part of the current United States, then divided among various European powers: Nova Anglia (New England) is ringed by colonies belonging to France (to the north), and Belgium and Holland (to the west).

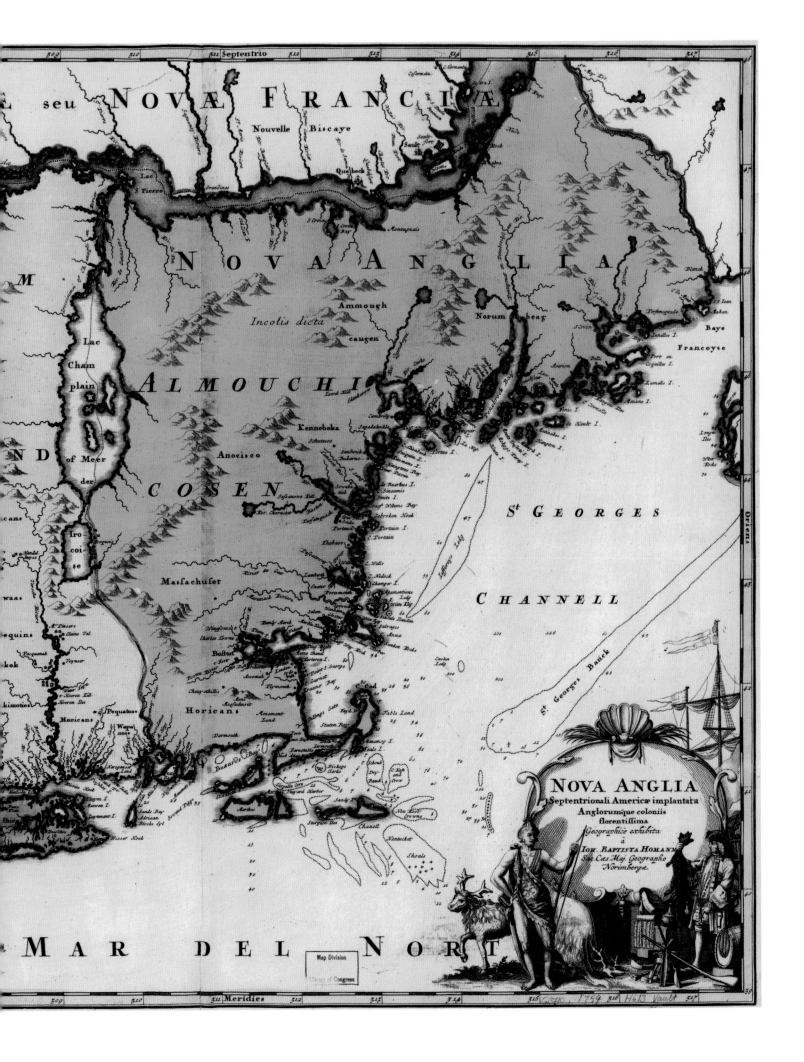

NOVA ANGLIA

Septentrionali Americæ implantata
Anglorumque coloniis
florentissima
Geographice exhibita
à
Ioh. Baptista Homann
Sac. Cæs. Maj. Geographo
Norimbergæ.

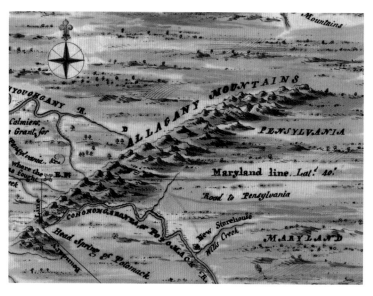

24 top left This 1745 map drawn in ink and watercolors, makes skilful use of chiaroscuro to show relief. It locates the forts and shows the borders of western Pennsylvania, northern Virginia and, at the bottom right, northern Maryland.

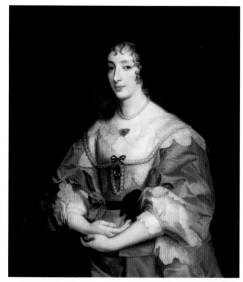

Pierre Charles L'Enfant was born in Paris in 1754, the son of a painter to the court of the king of France, Louis XVI, who was to be guillottined in 1793. In 1777 at the age of 23, L'Enfant had asked, and been granted permission, to join the army of Britain's rebellious American colonies. In 1779 he fought in Washington's army with the rank of captain. Seriously wounded on the battlefield, he was later captured during the siege of Charleston in 1780 and freed after two years of imprisonment. Washington, for whom he had made a preparatory sketch for a portrait, began to appreciate the impetuous young man whom he referred to clumsily in his misspelled letters as "Monsr. Lanfang."

After the war, L'Enfant discovered he had talent as an architect and began to design much-appreciated buildings, for example, he rebuilt the old City Hall in New York which, in 1789, was still expected to be the cap-ital of the new country. These were encouraging beginnings but the arrogance of the tall and elegant genius with the beaked nose and haughty manner was to undermine his dreams of glory and achievement. L'Enfant came to notice when he proudly refused ten acres of land in an area between what is today Third Avenue and 68th Street on Manhattan Island as compensation for his work of rebuilding New York City Hall. The young French engineer considered the retribution too little. The real estate value of that area is now somewhere in the area of $ 300 million but L'Enfant's ambitions were somewhat higher.

Next, the 36-year-old major accompanied President Washington in search of a capital that would match the aspirations of the United States – and his own. Surveying the scene, the two imagined the presidential residence on a hill that overlooked the Potomac and, a mile away, L'En-

24 bottom It shows the arrival of pilgrims on the New England coast in 1620. The Mayflower in the background was the ship that brought the first consignment of colonists across the Atlantic.

24 top right
Henrietta Maria of
France (1609-1669)
was the wife of
Charles I king of
England and
Scotland. In her
honor, Lord Baltimore
named a state of
America Maryland,
where English
Catholics could escape
the restrictions placed
on them in their own
country.

fant recognised Jenkins Hill as being a splendid and natural "pedestal awaiting a monument." The monument that would one day stand on the hill was the Capitol of the United States.

The next day, a proclamation was made by Washington in Georgetown assigning a district of ten square miles for the construction of the new federal capital. The territory stretched as far as Jones Point on the outlet of Hunting Creek near Alexandria – a small port founded in

1749 by a group of Scottish tobacco merchants – thus covering a giant Y from where the Potomac met its eastern branch, the Anacostia River. The land was thickly wooded and included orchards, tobacco fields and marshes. It was still inhabited by American natives though the European colonists had begun to take possession of it by the subtle expedient of giving it a name – Terra Mariae or Maryland – after the young and beautiful wife of Charles I of England.

24-25 A group of
Pilgrims head to
church through a
snowy wood. Taken
from an 1867
painting by George
H. Broughton, the
scene summarizes one
of the salient aspects
of this period of
American history:
wearing European
dress but armed like
pioneers, the new
arrivals were
conscious of living in
a frontier land.

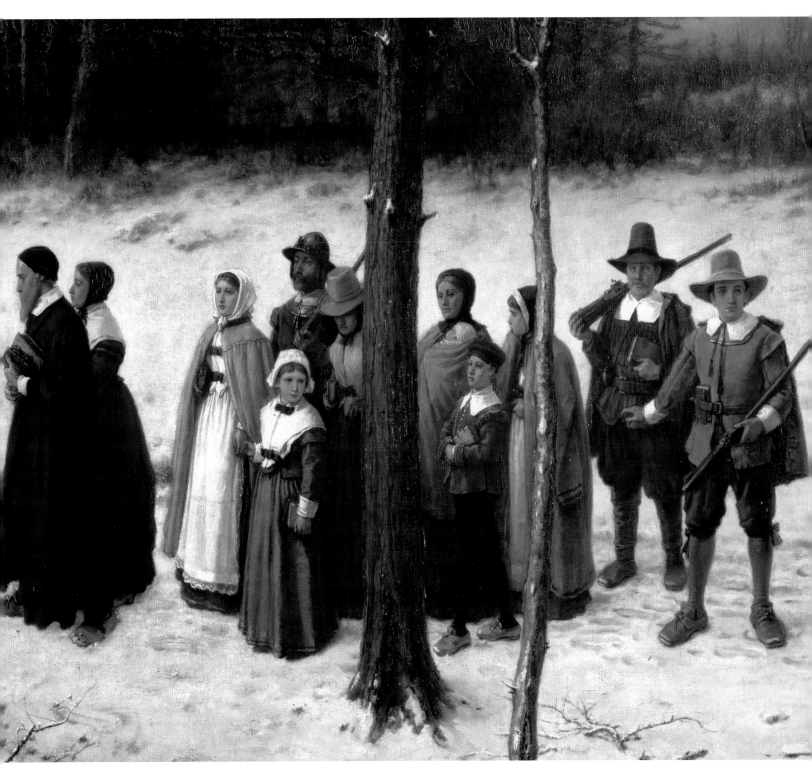

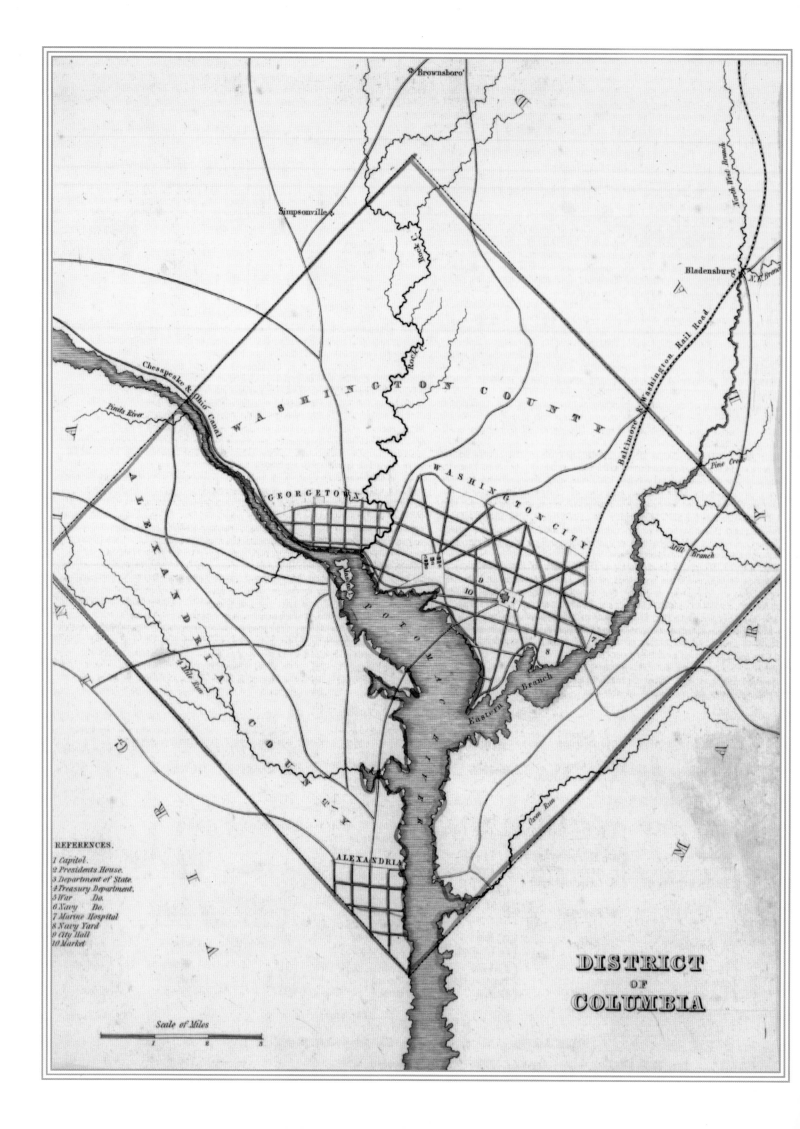

Brownsboro'

Simpsonville

Rock C.

North West Branch

Bladensburg

N.E. Branch

WASHINGTON COUNTY

Chesapeake & Ohio Canal

Pauls River

Baltimore & Washington Rail Road

Pine Creek

A L E X A N D R I A

GEORGETOWN

WASHINGTON CITY

Mill Branch

5 3
6 4
9
10 1

7

8

P O T O M A C

Mason's

4 Mile Run

C O U N T Y

Eastern Branch

Oxon Run

V I R G I N I A

M A R Y L A N D

REFERENCES.

1 Capitol.
2 Presidents House.
3 Department of State.
4 Treasury Department.
5 War Do.
6 Navy Do.
7 Marine Hospital
8 Navy Yard
9 City Hall
10 Market

ALEXANDRIA

DISTRICT
OF
COLUMBIA

Scale of Miles

1 2 3

The fact that the new and foresee-ably splendid capital of the United States was to be located in an un-known site in Maryland was due to the farsightedness of George Wash-ington. He had blocked the authorita-tive candidatures of New York and Philadelphia in his determination to maintain the capital independent of the federation of states as its task would be to serve their interests while mediating their self-centeredness. But before the decision could become cer-tain, it had to be submitted to a deli-cate compromise. The Congress' de-bate on the capital's location was vo-ciferous, flaunting conflicts and argu-ments related to the political and commercial advantages that the choice of site would bring with it. Fifty or so localities had put forward their candidacies but the greatest ten-sion ran between the sides of an open rift that would, in less than a century, give rise to rivers of blood: already supporters of the local interests and abuse of power of both the northern and southern regions of the United States were confronting one another.

On 16 July 1790, Congress passed the *Residence Act* that authorised the President to build the capital on the banks of the Potomac, the river that Washington and L'Enfant had identi-fied as the center for the future con-quest of the North American west. What was to become the District of Columbia took the form of a dia-mond without a south-west corner, as the river marked its boundary there. This was because, in 1846, the land ceded by Virginia for the construction of the capital was returned, thereby reducing the total area of the District by one third.

It was an ideal location due to its

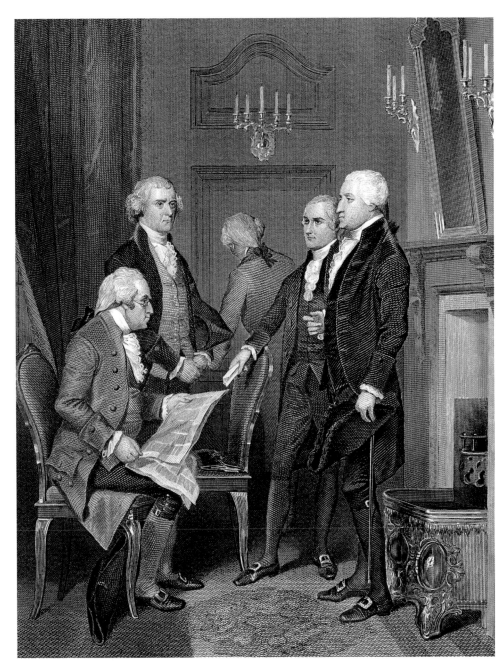

26 *Jefferson's design for the District of Columbia, dated March 1791. In 1846 the territory of the* *capital was reduced by a third to its current size; it is in the shape of a diamond cut on one side by the Potomac River.*

27 *Some of the members of the administration of George Washington: it included Thomas* *Jefferson, Alexander Hamilton (Secretary of the Treasury), Henry Knox and Edmund Randolph.*

direct connection to the Atlantic Ocean via the Anacostia River and its proximity to the frontier and bound-less territories of the West. As a result of the planned Chesapeake and Ohio Canal, Washington was to become not only the political capital of the United States, but of the entire conti-nent.

The vote in Congress had been preceded by a historic compromise ten days or so before, following long and difficult negotiations. The agree-ment had been signed, as in all self-re-specting democracies, far from the

heated and argumentative halls of the legislature. In fact, it had been agreed in a tavern in Manhattan where Alexander Hamilton (the Secretary of the Treasury) and James Madison (the influential delegate from Vir-ginia) had met. Copious draughts of Moselle and a hearty dinner had helped the gentlemen's agreement to come to fruition. The South agreed to pay the war debts of the North and to accept the unpopular notion of centralization of power, in return for which it had the honor of hosting the new capital.

A 1796 painting by Edward Savage in the National Gallery in Washington portrays the first American president with his wife Martha and grandchildren, Nelly and Washington Curtis, on the family farm in Mount Vernon. On the right in the background, we see William Lee, Washington's "valet" (or, to be more exact, their domestic slave). On the table in front of the first presidential family there lies a large map of the capital. In spite of the painting's limited artistic value, it became an enormous success at the end of the eighteenth and beginning of the nineteenth centuries, being printed in tens of thousands of copies. The map reproduces L'Enfant's original plan – the translation onto paper of the dreams, aspirations and ambitions of the French engineer. Today the original is one of the jealously kept treasures of the Library of Congress, the largest, most important and most complete library in the world. Washington D.C. was to take shape in stone and concrete and anchor two centuries of history on the basis of that plan, always staying faithful, *mutatis mutandis*, to the original idea.

As he wrote in the report that went with his project, L'Enfant had chosen three principal co-ordinates around which the rest of the city was to hinge and be subordinate. These were the three hills that provide the sites of the Capitol, the White House and Lincoln Park. The last was to be the location of the zero-marker, i.e., the point from which all distances from the capital were to be measured.

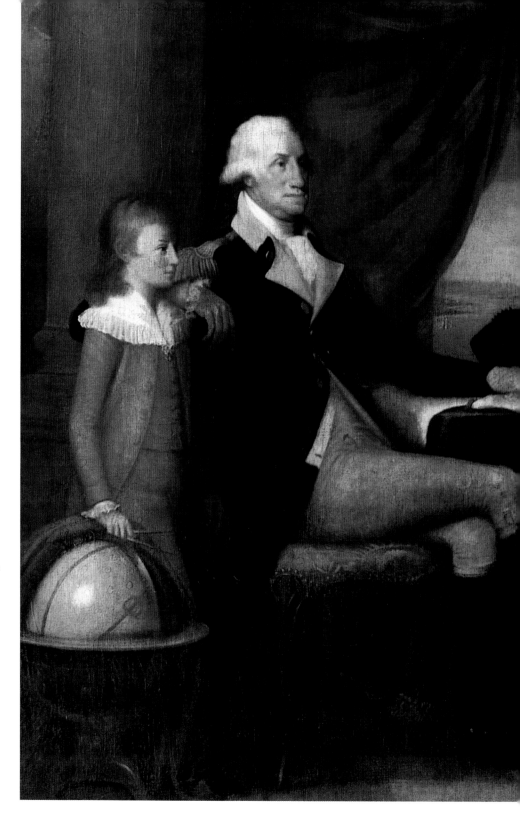

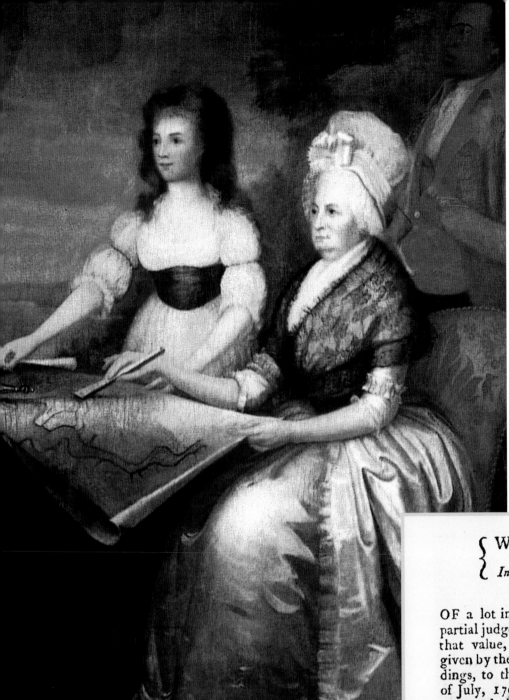

{**WASHINGTON,**}
In the Territory of Columbia.

A PREMIUM,

OF a lot in this city, to be defignated by im-
partial judges, and 500 dollars; or a medal of
that value, at the option of the party, will be
given by the Commiffioners of the Federal Buil-
dings, to the perfon, who, before the 15th day
of July, 1792, fhall produce to them, the moft
approved plan, if adopted by them, for a Capi-
tol to be erected in this City, and 250 dollars,
or a medal, for the plan deemed next in merit
to the one they fhall adopt. The building to
be of brick, and to contain the following apart-
ments, to wit:

A conference room; } Sufficient to ac-
A room for the Re- } commodate 300
prefentatives; } perfons each.
A lobby, or antichamber to the latter;
A Senate room of 1200 fquare feet area;
An antichamber, or lobby to the laft;

Thefe rooms to be of full elevation

12 rooms of 600 fquare feet area, each, for
committee rooms and clerk's offices, to be of
half the elevation of the former. Drawings
will be expected of the ground plats, elevations
of each front, and fections through the building
in fuch directions as may be neceffary to explain
the internal ftructure; and an eftimate of the
cubic feet of brick-work compofing the whole
mafs of the walls.

The Commiffioners.

March 14, 1792.

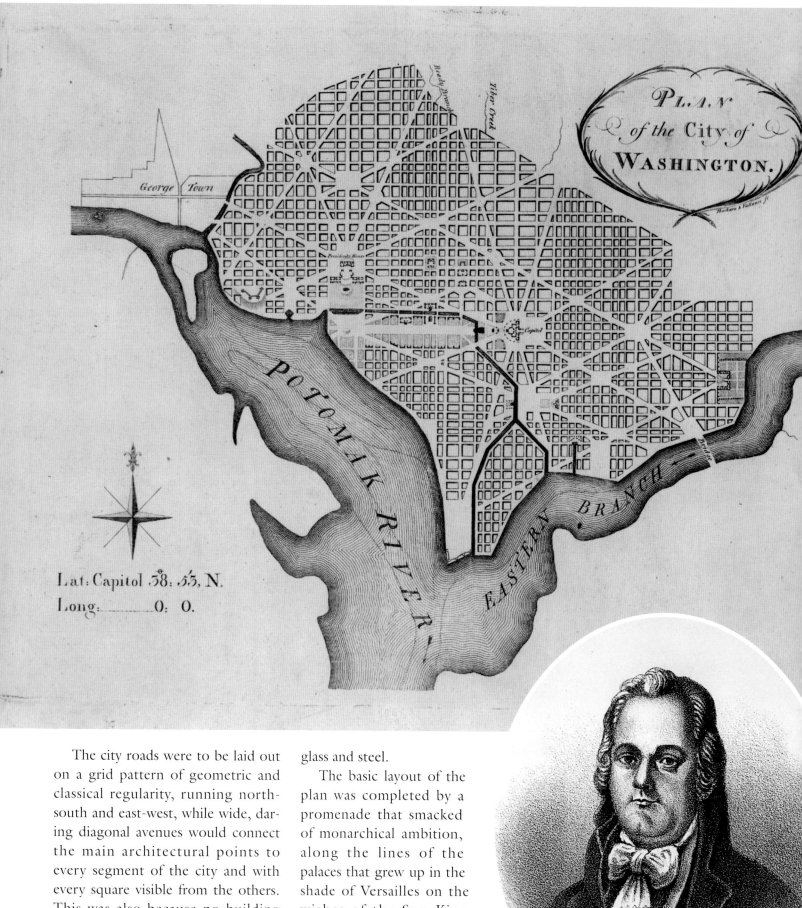

PLAN of the City of WASHINGTON.

George Town

Ready Branch

Tiber Creek

Presidents House

Capitol

POTOMAK RIVER

EASTERN BRANCH

Bridge

Lat: Capitol 38: 53, N.

Long: _____ 0: 0.

The city roads were to be laid out on a grid pattern of geometric and classical regularity, running north-south and east-west, while wide, daring diagonal avenues would connect the main architectural points to every segment of the city and with every square visible from the others. This was also because no building was to exceed the height of the dome of the Capitol. Visitors unaware of this fact will be surprised, usually pleasantly, not to be assaulted by a soaring and vaguely oppressive skyline of futuristic skyscrapers of glass and steel.

The basic layout of the plan was completed by a promenade that smacked of monarchical ambition, along the lines of the palaces that grew up in the shade of Versailles on the wishes of the Sun King, Louis XIV. The transatlantic version of classical and renaissance architecture became The Mall, the cultural heart of the capital. It is a wide, tree-lined avenue of gardens and fountains that runs be-

tween the Capitol and the banks of the Potomac, lined by elegant patrician villas.

The plan was approved by George Washington and received his presidential stamp.

Washington had decided to entrust L'Enfant with the city planning and Andrew Ellicott, a topographer, with the layout for the rest of the district. Ellicott had been born in Pennsylvania in 1754; he traced out the boundaries and directions of the capital's main streets based on the stars and heavens; he was helped in his work by an extraordinary character, the 59 year old Benjamin Banneker. An able, self-taught astronomer and mathematician, Banneker was a landowner born in Maryland to a freed slave. Observing the skies, Ellicott and Banneker recorded the latitude and longitude of the territory and transposed the coordinates onto the map as the basis for the city's layout. Only in this way were they able to found one of the symbols of the city that was closest to George Washington's heart.

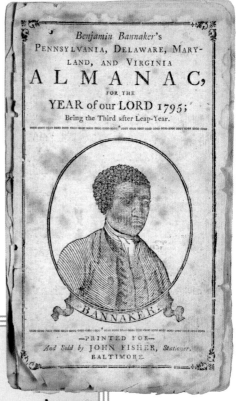

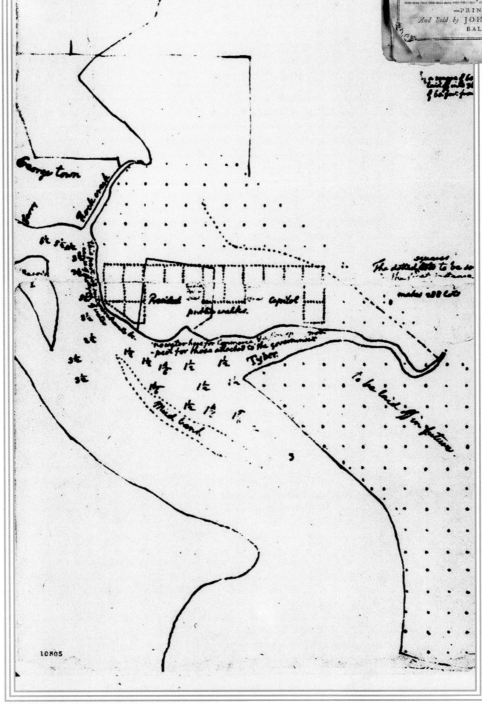

30 top The design for the city of Washington by Pierre Charles L'Enfant (1754-1825) is shown here in the first edition of the document published in Philadelphia in 1792. L'Enfant was the son of a court painter to Louis XVI, king of France, and was the first architect of the American capital.

30 bottom right The late-nineteenth-century print shows Andrew Ellicott (1754-1820), the topographer born in Pennsylvania who drew the plan of the entire Washington district and helped in laying out boundaries and the directions of the most important roads.

31 top The 1795 Almanac of the Firmament by Benjamin Banneker, shows the author on the cover. An astronomer and mathematician, Banneker was the son of a freed slave who, with Andrew Ellicott, prepared the plan of Washington.

31 bottom This 1791 print is an original sketch by Thomas Jefferson outlining the development of Washington. On the left Georgetown is easily recognizable while underneath, on the Potomac, the presidential residence and the Capitol.

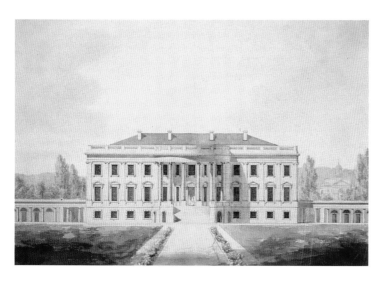

32 top The White House is shown here in an 1807 drawing made from the south side. The residence of the President of the United States' government's was the new American government's first priority; thus it is the oldest public building in Washington.

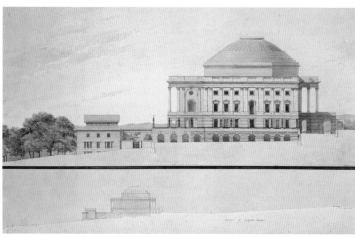

32 center The propylaea of the Capitol are seen from the south side in the 1810 plans by Latrobe. Construction of the building continued during the Civil War; Lincoln wanted the continuity to be a symbol of the Union.

To some, the straight and stately Pennsylvania Avenue that connects the Capitol to the White House is the spiritual center of Washington D.C., a sort of secular *via sacra* (if the oxymoron can be allowed), indeed, for all of the United States. Based on Washington's general specifications, L'Enfant had included it so that the two power centers would have "reciprocity of vision." Separated by almost 1.5 miles of land as the crow flies, the two seats of the nation's principal political activities – the assembly whose task it is to lay down the laws for the people of the United States and the person whose task it is to put them into practice – were to remain in visual contact of one another as a demonstration of the balance of power and control that should always be exercised between a legislature and the executive in a democracy.

It was in the vicissitudes associated with the translation of this highly symbolic project into reality that all the splendors and miseries of the life and

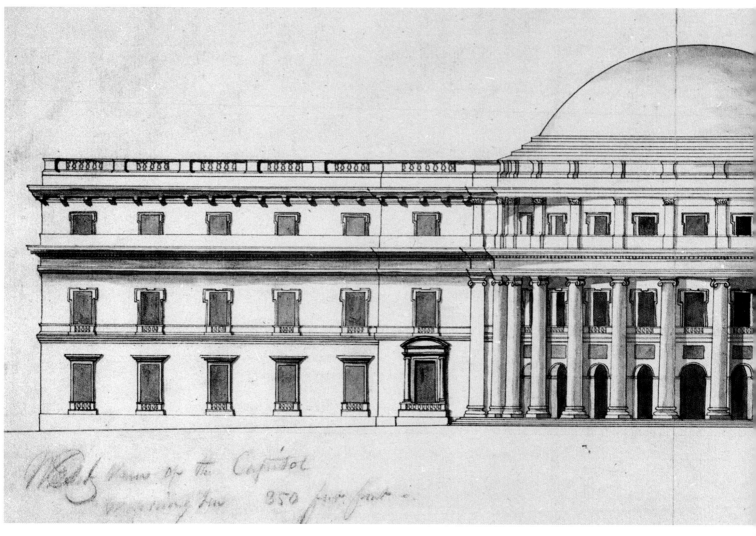

professional career of Pierre Charles L'Enfant were bound up. In 1836, in the fullness of one of his customary and epic bursts of temper, President Andrew Jackson tore into the bureaucrats and architects who for weeks had been unable to agree on where to build the new Treasury. Settling the matter once and for all, Jackson decreed that it should be constructed on the east side of the White House. It may not have been one of his intentions but, in doing so, once the structure was completed, the view that was supposed to unite the Capitol and the President's residence was disrupted.

To his good fortune, the French engineer did not live to see this last abuse as he had died in misery in 1825. The arrogance and haughtiness with which he treated his collaborators and subordinates – ignoring even the instructions of George Washington – forced the President to fire him and send him away from the works in 1792.

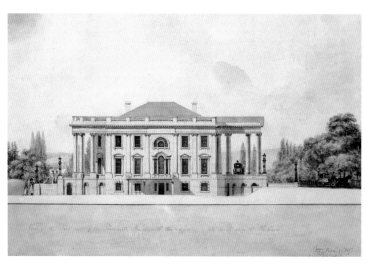

32-33 The photograph shows the design of the east side of the Capitol. In 1791 L'Enfant designed the building of the Congress of the United States to stand on the top of Jenkins Hill, where the councils of the Algonquin tribes were once held.

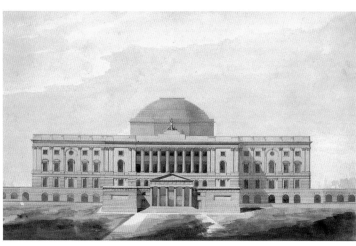

33 top This was Latrobe's 1807 drawing of the President's residence in Washington, burned down in 1814. When it was rebuilt, thick coats of lime and white paint were required to hide the marks of the fire, and thus the White House got its name.

33 center This 1811 watercolor by Latrobe shows the west side of the Capitol. The construction of the city of Washington was underlaid by a historic compromise: in order for the capital to be built on Confederate territory, the South had to pay the North's war debts and accept centralization of state power.

33 bottom This is how the Capitol appeared at the start of the nineteenth century. L'Enfant recognised in Jenkins Hill a splendid and natural "pedestal awaiting a monument." With time it became Capitol Hill.

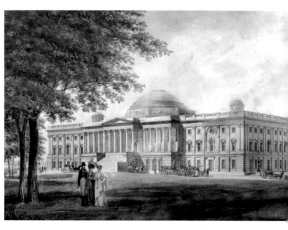

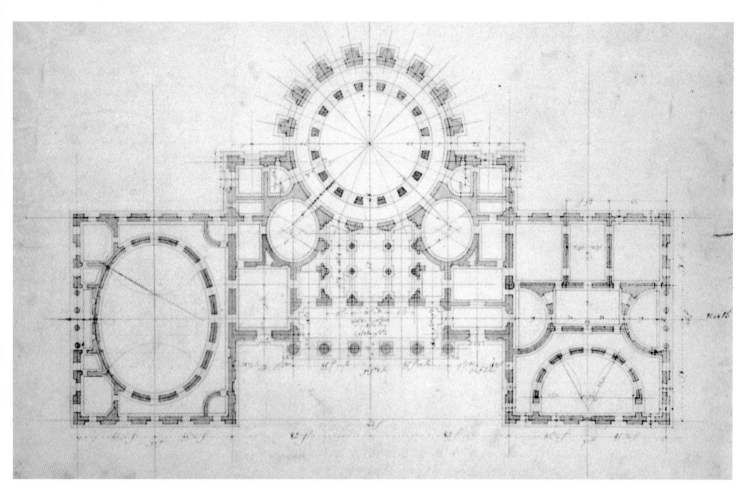

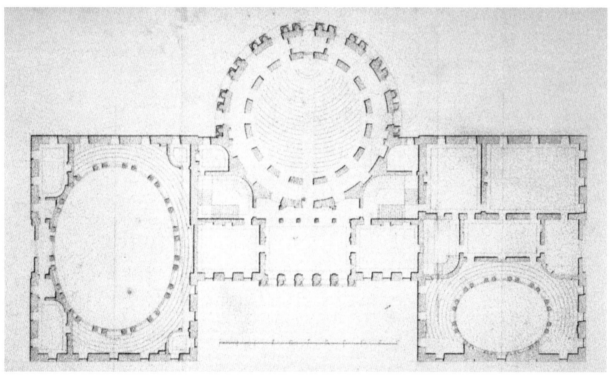

*34 top Stephen
Allet's drawing
reproduces the 1793
design accepted for
construction of the
Capitol. The
competition was won
by William
Thornton, but in the
end there were nine
architects involved.*

*34 bottom This 1793
drawing shows the
Capitol's legislative
chambers. The
original design of the
Capitol was revised on
several occasions; the
American Baroque
dome that crowns the
structure was the work
of Thomas U. Walter.*

*34-35 This is the
design for the
Capitol's terrace. The
dome is one of the
city's and nation's
most famous symbols.*

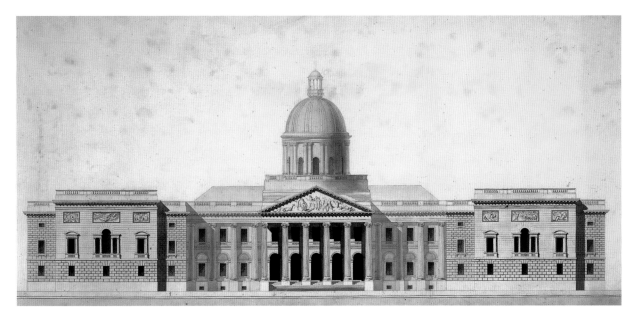

35 top The design by William Thornton (winner of the public competition) was first revised by Benjamin Latrobe (1803-1817) when he raised the dome onto a polygonal drum (the wall on which the dome rests).

Thomas Jefferson had already warned Washington, "So that he can make himself useful, it is absolutely necessary to bend his character." The inevitable consequences soon followed. In the years after his dismissal, L'Enfant was transformed into a pathetic and petulant shadow of his former self, making frequent claims for compensation to every new session of Congress. It was, however, all wasted time. Long after his death, though, the government decided that the time had come to behave in a gentlemanly manner and to settle its accounts with the wretched architect of Washington D.C. In 1909, his unknown and abandoned grave was found and his remains exhumed.

With ceremonial as filled with pomp as it was overdue, L'Enfant was transferred to the Rotonda in the Capitol and, from there, along Pennsylvania Avenue to Arlington Cemetery where he now lies below a marble slab on which his plan for the American capital is carved. But during his journey, his affronted soul would have been made aware of the final indignity: his famous "reciprocity of sight" for which he had suffered and worked so hard no longer existed. This was the final rebuff before being put to his final rest.

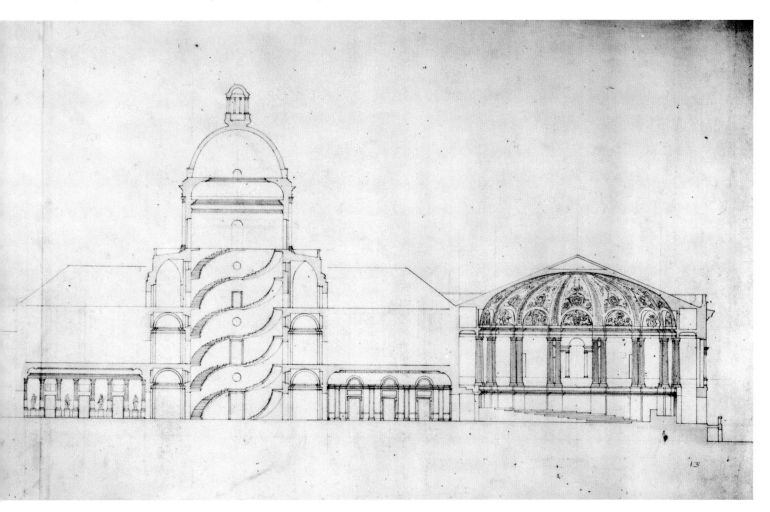

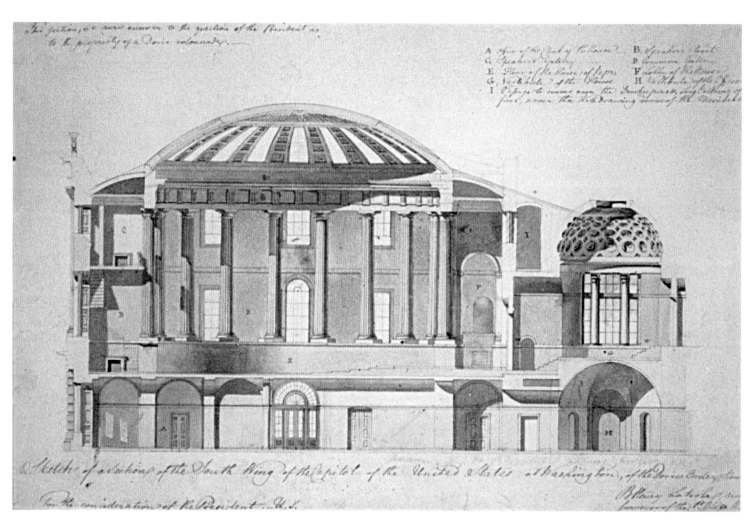

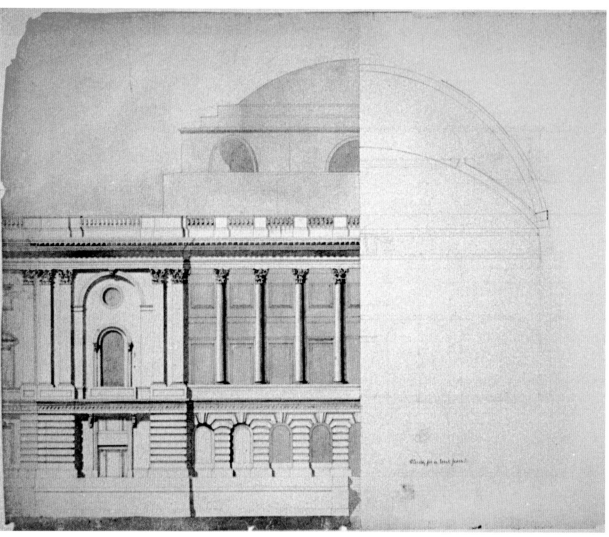

36 top Benjamin Latrobe's drawing for a Doric-style Representatives' Chamber. It was built in 1804 at the request of Thomas Jefferson, a highly educated Virginian enamored of classical antiquity.

36 bottom The Capitol's dome was designed by Latrobe in 1808-1809. The architect asked an Italian sculptor, Giuseppe Franzoni, to carve a large spread-eagle; it was placed in the Chamber but destroyed in the fire of 1814.

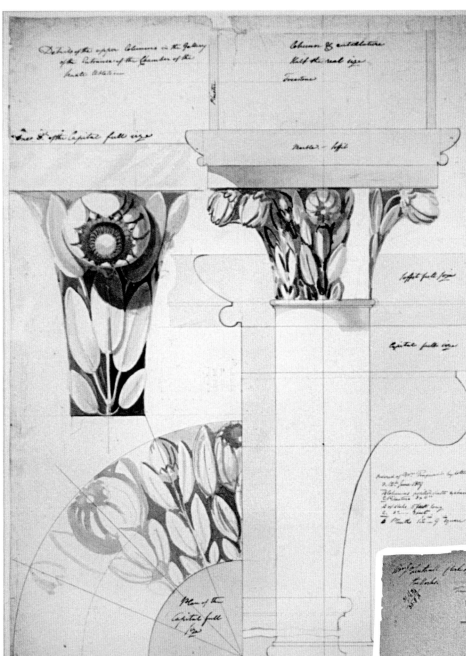

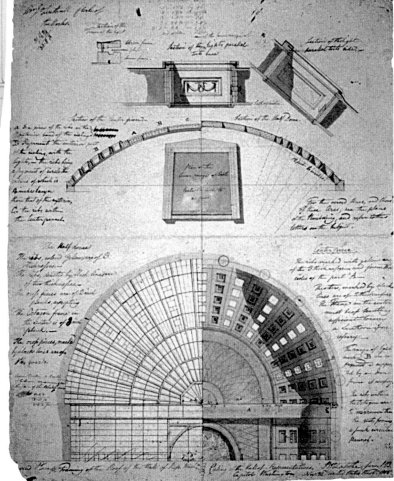

37 bottom left A gigantic statue of the Greek goddess Athena (the Roman Minerva) was proposed by Latrobe in 1811 to represent American Liberty on the east side of the Capitol. This is another link to the concept of the city built on the banks of the Potomac being the 'New Rome.'

37 bottom right The ceiling in the Representatives' Chamber, dated 1805, was designed by Benjamin Latrobe, a very fashionable architect of the period who enjoyed the esteem of Thomas Jefferson.

37 top These sketches of the columns in the entrance gallery of the Senate were made by Latrobe. The north wing of the Capitol was built first to accommodate the entire Congress in its many rooms; the south wing was a later addition.

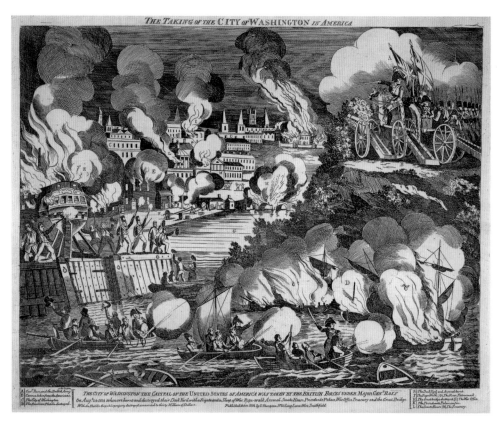

THE TAKING OF THE CITY OF WASHINGTON IN AMERICA

THE CITY OF WASHINGTON THE CAPITAL OF THE UNITED STATES OF AMERICA WAS TAKEN BY THE BRITISH FORCES UNDER MAJOR GEN.L ROSS
On Aug.st 24 1814 when were burnt and destroyed their Dock Yard with a Frigate and a Sloop of War, Rope-walk, Arsenal, Senate House, President's Palace, War Office, Treasury and the Great Bridge.
With the Flotilla, &c. being previously destroyed amounted to thirty Millions of Dollars.
Published Octr 14 1814 by G. Thompson N.o 43 Long Lane West Smithfield.

38 top The capture of the city during the Washington War of 1812 took place on 24 August 1814. In this view of the Potomac River, British forces are in action under General Ross.

38 bottom The British admiral, Sir George Cockburn (1772-1853) in an 1851 painting by Thomas Mackay. Cockburn was responsible for the capture and destruction of the city of Washington in August 1814 during the war between the United States and Great Britain.

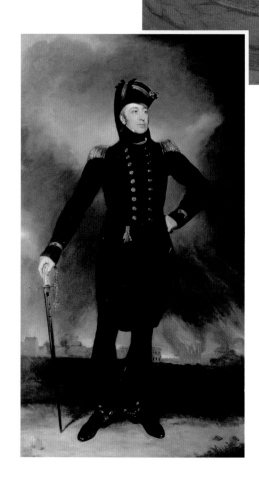

The war with Great Britain that had begun in 1812 was to mark a turning point in the history of the capital. This was a chapter that the citizens of Washington do not remember with pleasure, beginning with the shameful way in which the city was "defended." On 24 August 1814, when General Robert Ross entered Washington at the head of the vanguard of British troops, he was unable even to find an officer to whom to dictate the conditions of the city's surrender. On this occasion, as often happens, greater courage was shown by a woman, Dolley Madison. The First Lady of the time refused to leave the White House until the last moment even though the British fleet had entered Chesapeake Bay and soldiers were marching at a forced pace on the capital. The English admiral, George Cockburn, had promised that he would be visit the presidential residence to pay his respects to the rebellious ex-colony in his own way. Only at the last moment did the daring but stubborn woman decide to abandon her post but not before cutting from its frame the portrait of George Washington that Gilbert Stuart had painted. With the painting rolled up under her arm, Dolley Madison finally repaired to a tent in a U.S. military camp near the capital. Today, that portrait is exhibited in the East Room in the White House – thanks to a courageous First Lady.

With the field now free of the last opposition, the British took their revenge. A man of his word, Admiral Cockburn presented himself on the threshold of the house of the President of the United States with all his general staff, ate and drank from the generous federal supplies and then left his troops to do as they liked. The building was set on fire, trashed and blackened by the smoke. When it was rebuilt after the war, it was necessary to apply thick layers of lime and white paint to hide the

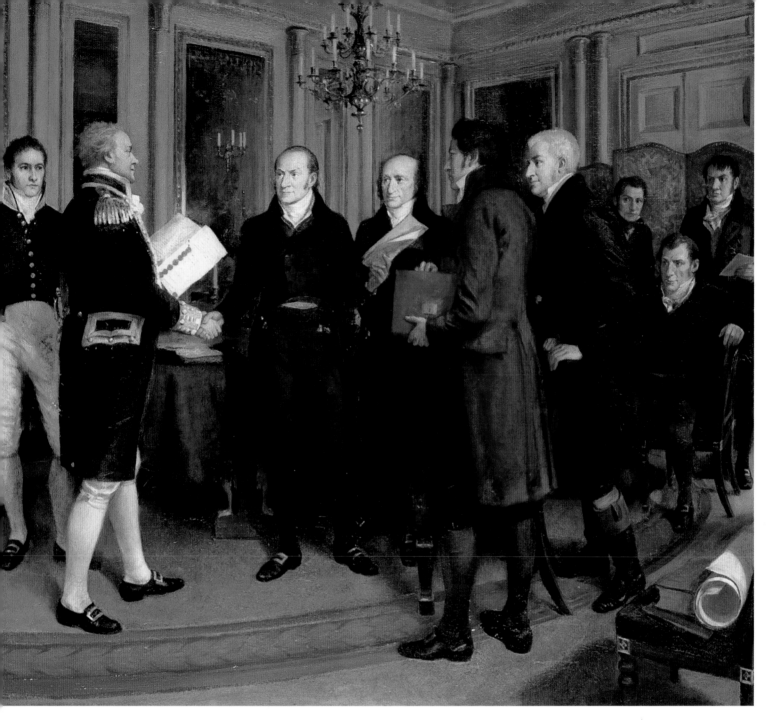

marks left from the British fire. And it was as a result of this, as any diligent American pupil will know, that the building came to be known as the White House.

The same fate was visited on the Capitol where the untiring, mocking and uncontainable Nero/Cockburn, from the Speaker's rostrum in the House, asked his troops to vote on whether to burn the building and its adjoining library. The motion was gloriously and unanimously passed and the aged scientific books were used as torches to put the hated and most significant symbol of American independence to the flames.

38-39 The signing of the Treaty of Ghent (24 December 1814) put an end to the war between the United States and Great Britain that had begun two years earlier. The agreement restored the earlier status quo but opened the path to the conquest of the West.

39 bottom This portrait of Dolley Madison was painted in the first half of the year 1800. During the conquest of Washington by the British, the First Lady abandoned the White House only at the last minute, clutching the portrait of George Washington by Gilbert Stuart under her arm.

The entire city was torched but, to the good fortune of the Americans, that night heavy rains helped to reduce the devastation and a violent storm the next day forced the British troops to milder action. Nonetheless, the wounds inflicted on the city were dramatic.

Congress rejected a motion to abandon the city completely by only nine votes. National pride prevailed in the end; the presidential residence was repaired and assumed its new name, and Thomas Jefferson sold his personal library of over 6000 volumes to what was to become the Library of Congress.

Another tradition was then founded that was destined to be transformed from chronicle to history: given that there was no better place to do it, the new President, James Monroe, celebrated the swearing-in ceremony on the porch where the Supreme Court of the United States now stands, thereby inaugurating the custom of holding the ceremony outdoors whatever the weather.

After the initial difficulties, a change of attitude was signaled when an Englishman, James Smithson, who had never set foot in the United States, left a bequest of half a million dollars to found an institution in Washington "for the development and diffusion of knowledge."

In 1849, the nucleus of what was to become the world-famous Smithsonian Institution was set up in a Victorian, red sandstone building which, with a bit of a cheek, came to be known as "the Castle."

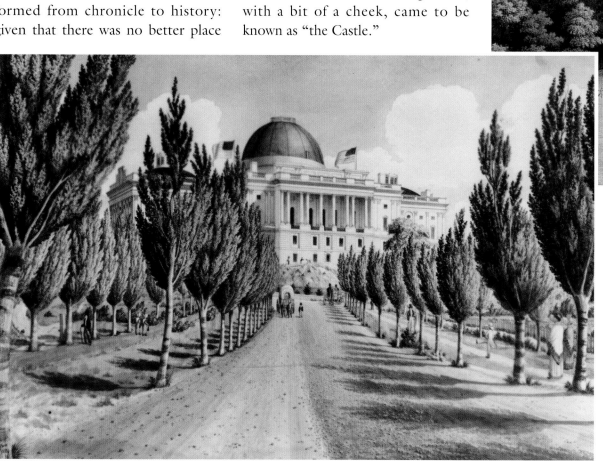

40-41 This 1852 view shows the Capitol and Pennsylvania Avenue, the avenue that was supposed to connect Congress to the White House with the "reciprocity of vision" wanted by Pierre L'Enfant to symbolize the balance of power in American democracy.

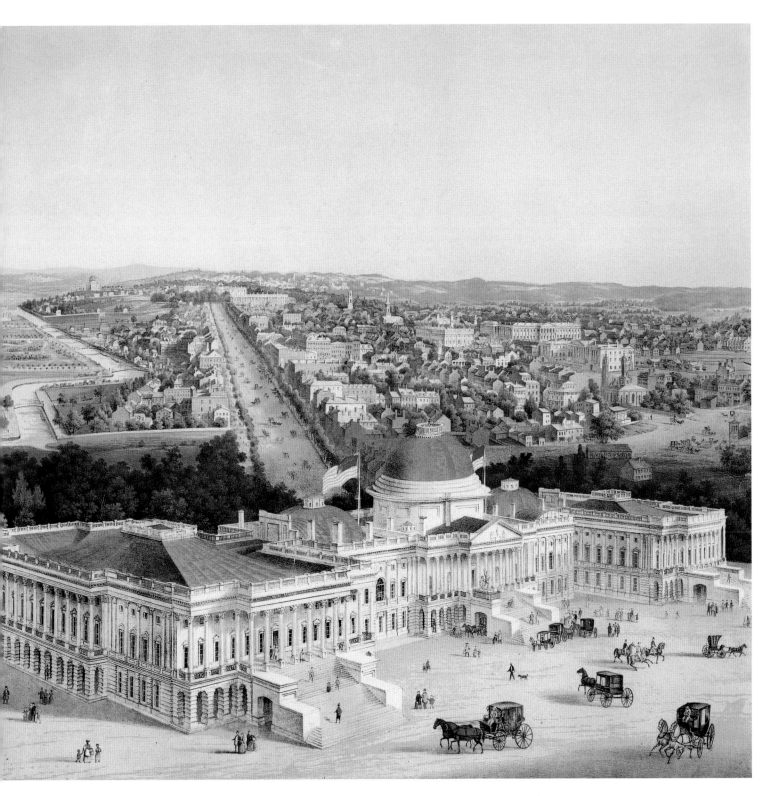

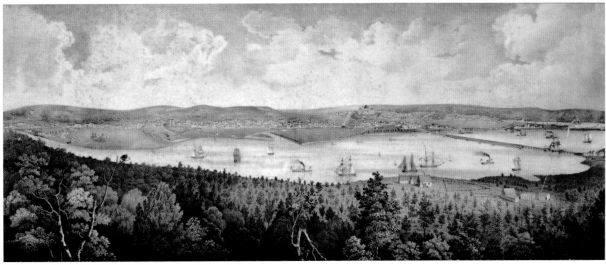

41 bottom A lithograph of the federal capital as it appeared in 1838, seen from the Arlington home of the adopted grandson, George Washington Parke Custis, of the first President of the United States. The district of Arlington is named after this house.

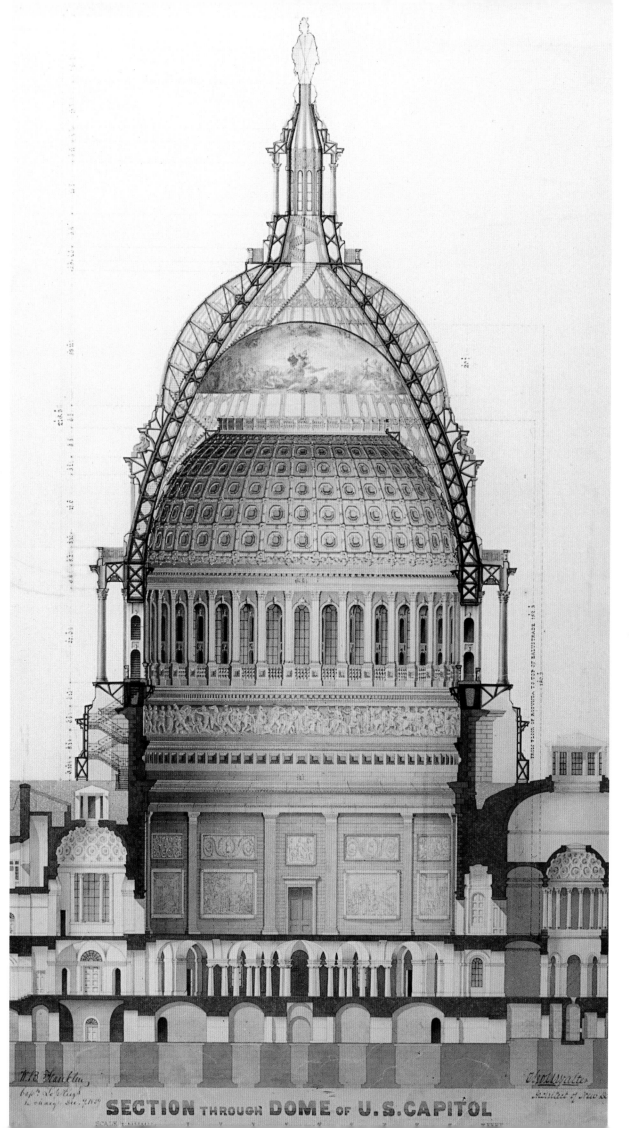

SECTION THROUGH DOME of U.S. CAPITOL

42 The sketch by
Thomas Ustick
Walter shows the
section of the Capitol
dome, built in 1859.
The architect raised
the previous dome to
its present
proportions, design
and size.

43 top The ceilings
of the Capitol are
reproduced in this
engraving from
1832-1834.
Costantino Brumidi
(1805-1880) took 25
years to fresco the
walls and ceilings of
the building's rooms,
offices and corridors,
reproducing the
history of America in
classical style.

43 bottom The
Capitol is shown in a
watercolor from the
second half of 1800.
The dome was made
from cast iron and
then covered with
thick layers of shiny
white paint to give
the effect of marble
and reflect the night-
time illumination.

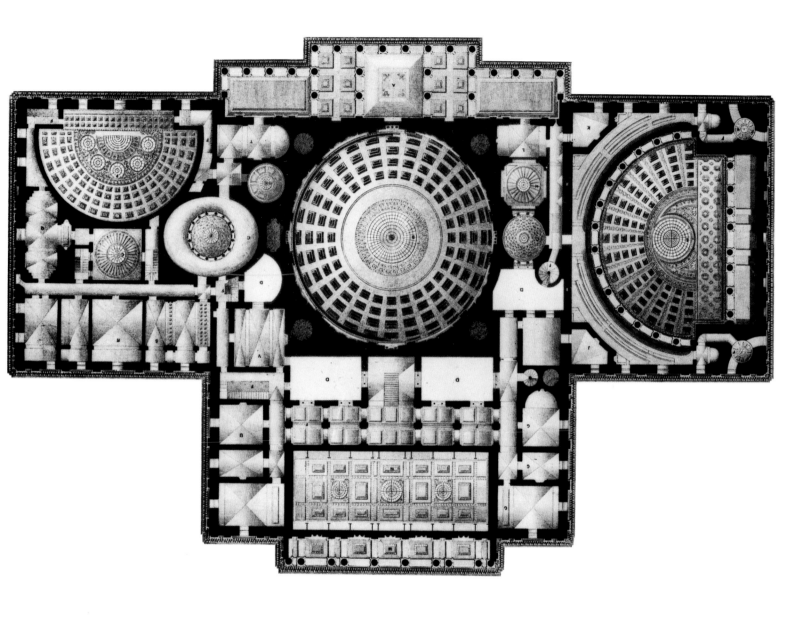

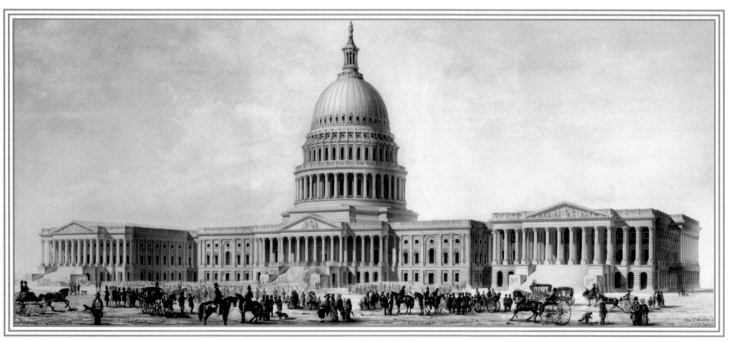

43

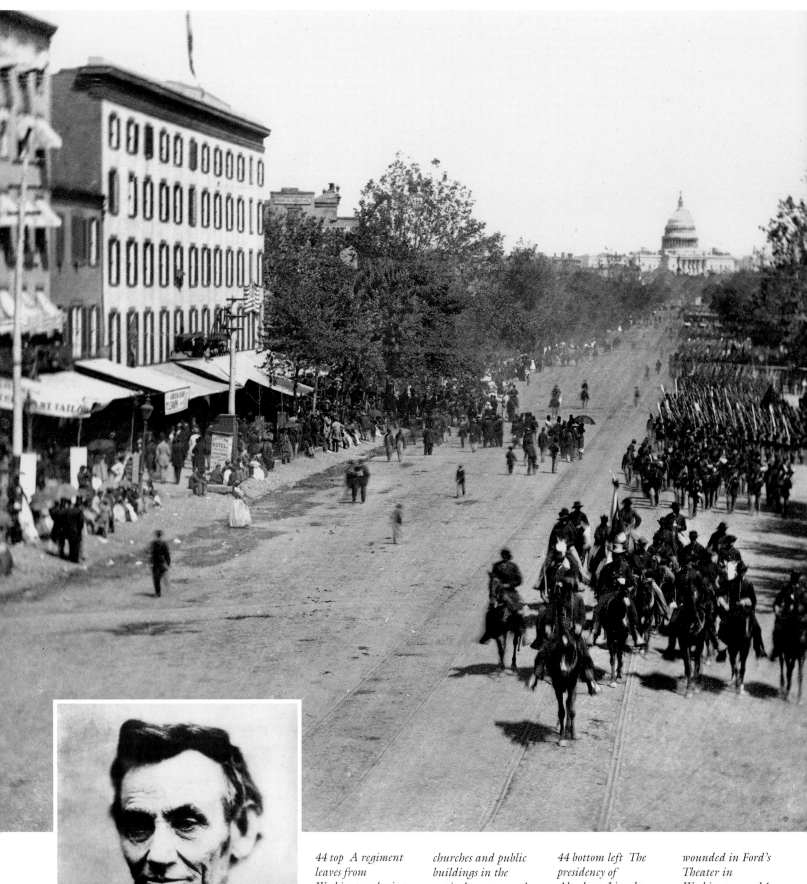

44 top A regiment leaves from Washington during the American Civil War (1861-1865). During that period, churches and public buildings in the capital were turned into field hospitals and the parks into military camps.

44 bottom left The presidency of Abraham Lincoln (1861-1865) was marked by the terrible Civil War. Lincoln was mortally wounded in Ford's Theater in Washington on 14 April 1865 by a fanatic who wanted to avenge the defeat of the South.

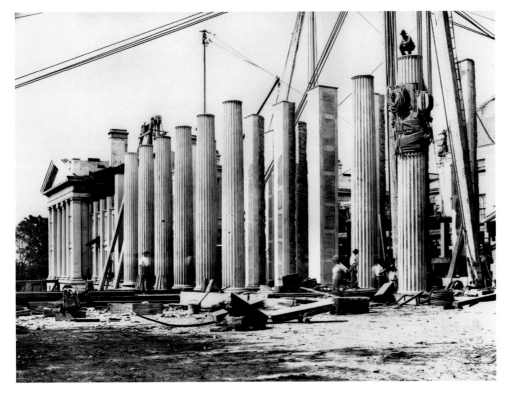

45 top The construction of public buildings in Washington (the photograph shows the Treasury in 1862) has always taken its cue from classical antiquity, following the spirit of the Founding Fathers who were enamoured of ancient Greece and the Roman world.

45 bottom Work on the Capitol dome at the end of December 1857. The models taken by Thomas U. Walter for his design of the dome were the Pantheon in Paris and St. Isaac's cathedral in St. Petersburg. The latter had one of Europe's great cast iron domes.

In the period 1861-1865, the devastating effects of the Civil War slowed the growth of the city and, though spared from physical damage, it was transformed. Churches and institutional buildings like the Capitol were turned into field hospitals where troops injured by the first modern war in history were assembled and treated.

And while Capitol Hill was sorrowfully transformed into a Bloody Hill, even the parks conceived by L'Enfant and Ellicott were used for military camps for the reserve troops of the North who were first required to defend the capital against the raids of General Lee and his flamboyant cavalry officers like Stonewall Jackson and Jeb Stuart, and then thrown into the attack on Virginia and all Dixie with the "infernal columns" of Sheridan and Sherman.

President Lincoln decided not to leave the capital of the Union even during the most dramatic moments of the war and wanted construction of the Capitol to continue uninterrupted, to provide a sign of continu-

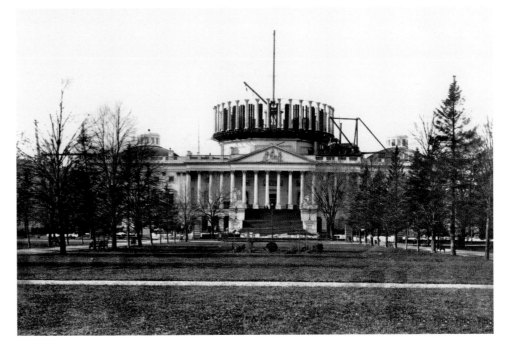

ity and trust in the Federation that George Washington and the thirteen rebel colonies had so much wished for. His determination was rewarded in 1863 when the dome of the building was completed and saluted by a salvo of 35 cannon shots – the only blank shots fired during the war.

It is not surprising that the last act of the Civil War was marked with the blood of the man who, more

than any other, had fought to maintain the federation of the United States. On 14 April 1865, the sixteenth President, Abraham Lincoln, was mortally wounded by a bullet fired into the back of his neck from a Derringer at close range by John Wilkes Booth, a fanatical southerner, as the President was sitting in a box in Ford's Theater, close by the White House. Lincoln died at 7.22 the following morning.

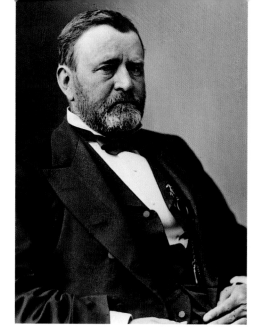

One of Lincoln's successors, the victorious general of the North's armies, Ulysses S. Grant, was responsible for a sudden acceleration in the ambitious plans for reconstruction of the city. Grant appointed a capable and brilliant – perhaps too brilliant – property speculator to head the committee of public works. His name was Alexander "Boss" Shepherd. The city underwent a remarkable series of improvements between 1871 and 1874 with the construction of dozens and dozens of miles of paved and lit roads served by a modern drainage system, and the planting of tens of thousands of trees in the parks and main streets. But in the end, Shepherd's plan collapsed as a result of corruption and various episodes of incompetence, leaving the district's coffers empty but saddled with debts for twenty million dollars. A string of furious private citizens, who had made fiscal contributions to the beautification of Wash-

ington, were left with empty wallets. In order to solve the crisis, it was decided that the funds required to finance the beautification of the federal capital would be equally shared between all citizens of the Union, thus wisely proportioning the costs for the required splendor among the national resources of the United States. But it was not all Shepherd's fault, or rather, not his alone. The Grant administration would never have passed into history as one of the country's most honest and administratively accurate. And perhaps somewhere lost in these shady events lies one of the keys to the drama of General Custer at Little Big Horn in June 1876. . . . but that is another story.

It was during Grant's period in Washington that the mysterious "lobbyist" came into being, a term that has been widely used in the political and judicial accounts of the last decades. Why has this term been giv-

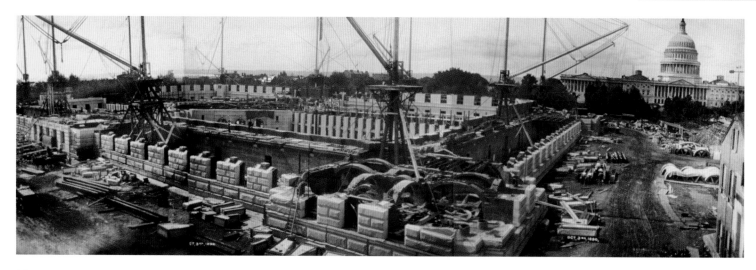

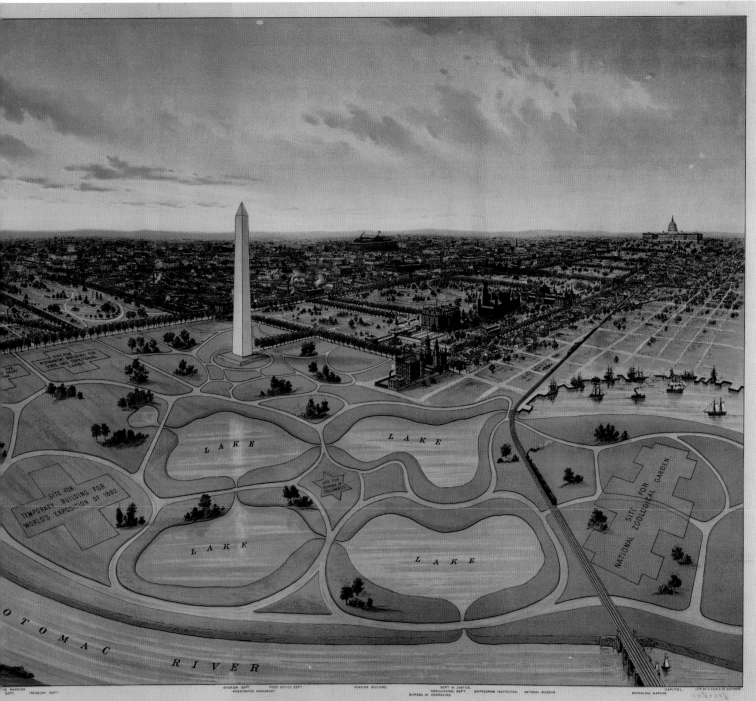

BIRDSEYE VIEW OF THE NATIONAL CAPITAL
INCLUDING THE SITE OF THE PROPOSED
EXPOSITION OF 1892 AND PERMANENT EXPOSITION OF THE THREE AMERICAS.

46-47 The general view of Washington was taken toward the end of the nineteenth century. At the start of the twentieth, the McMillan Commission prepared the Big Plans, which were quickly approved and implemented.

47 bottom The Washington Memorial was erected by the Grant administration: it stands 558 feet tall in the shape of an Egyptian obelisk lined with marble, and is one of the focal points in the American capital.

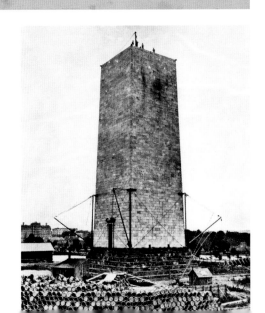

en to those men and women who, legally or more often illegally, exert pressure so that laws are passed that are favorable to particular groups of industrial, financial or commercial groups, when they might instead be more correctly and more simply be called "operators"?

The answer lies in the Willard Hotel at 1455 Pennsylvania Avenue NW, less than a stone's throw from the White House. The original hotel was knocked down in 1901 to make space for the present building, and it had the dubious honour for more than a century of being the center of a group involved in political and financial corruption that became both the burden and the delight of American politicians. Even Ulysses S. Grant did not turn up his nose at accepting a cigar and a few glasses of whiskey from this obscure and pestilential underworld of wheeler-dealers out to encourage examples of governmental "goodwill," who, in return for favorable provisions within public laws, would be rewarded with suitcases of cash. Since the meetings were mainly held in the lobby of the hotel, one day the exasperated Grant addressed the horde of postulating demons pejoratively by the brilliant neologism "lobbyists." The new term caught on thanks to muckraking journalists of the period who were happy to dip their bread and pens in the mud of the capital's political scandals, though they were more looking for a scoop than attempting to restore public confidence in politicians.

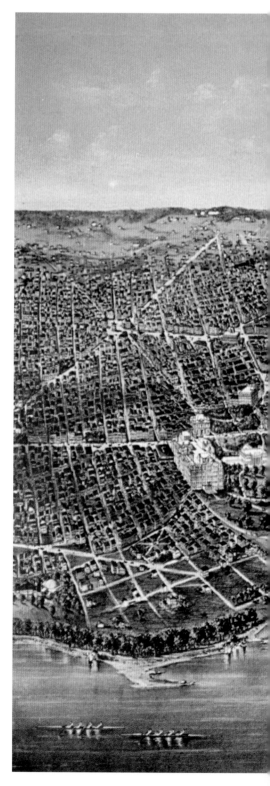

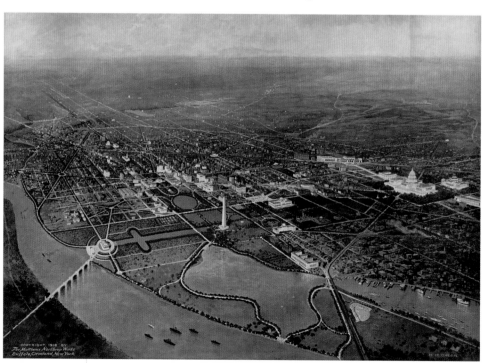

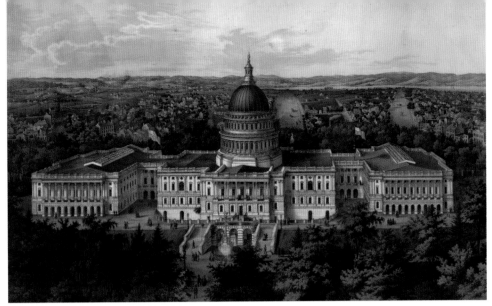

49 top Washington seen from the east side of the Capitol in an 1871 print. In the background, Maryland Avenue can be seen to the left of the Capitol dome, and, to the right, Pennsylvania Avenue and the White House.

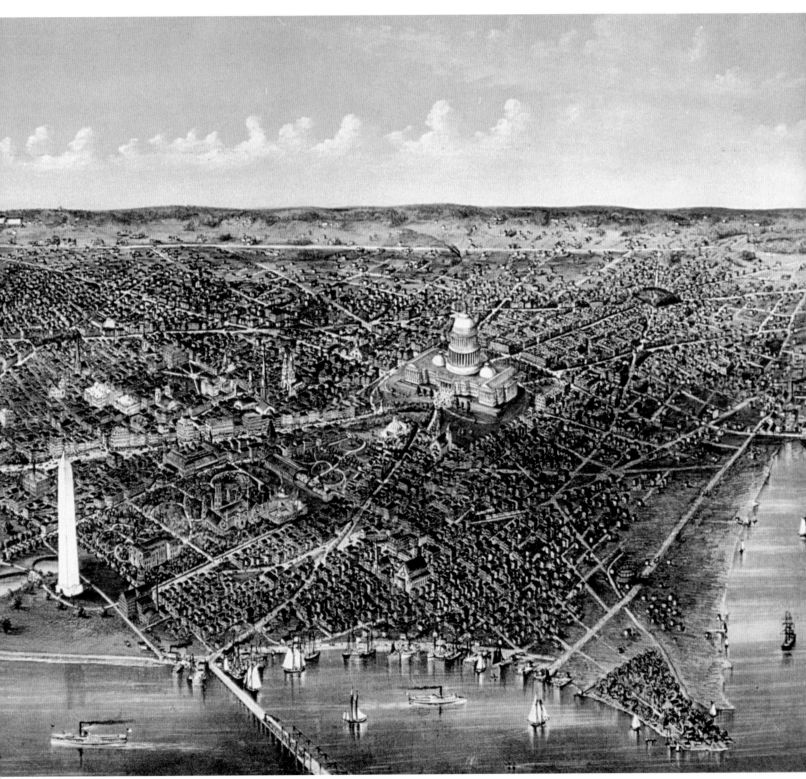

Shepherd's plans were taken up once again in 1900. That year, the meeting of the American Institute of Journalists provided the decisive stimulus to the Senate's decision to prepare a master plan for the development of an integrated system of parks in the capital. The president of the senatorial committee of the District of Columbia, the Michigan Senator James McMillan, presented a proposal that was approved on 8 March 1901. The plan went much further than the matter of the layout of the Mall area and the parks. Recognising the importance of the plan conceived by L'Enfant, strong emphasis was placed on the need to build new works and buildings for the beautification of the capital in the spirit of the original plan drafted by the Frenchman. The McMillan commission brought together a group of brilliant minds to work on the problem: the landscape architect, Frederick Law Olmsted, the sculptor, Augustus Saint-Gardens, and two architects, Charles McKim and Daniel Burnham. The group was then sent to Europe for six weeks on full expenses to study the city plans of the main capitals of the Old World. On its return, Burnham showed the spirit and dynamism of the committee in its report to McMillan by exhorting the leaders of the public sector to

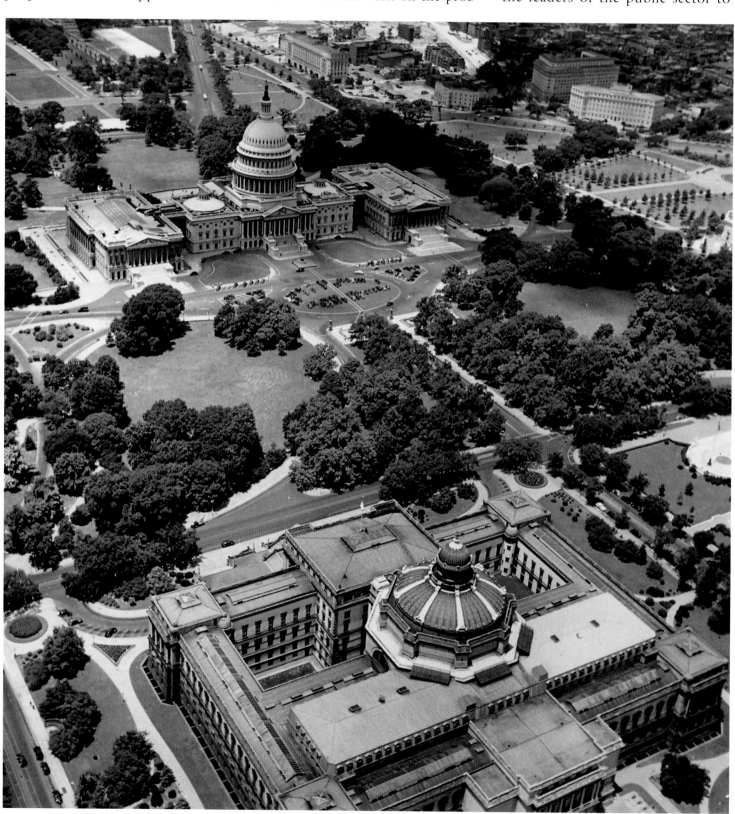

think on a large scale. The so-called "big plan" was submitted, quickly approved and put into operation. Nothing was left to chance. The Committee of Fine Arts, set up in 1910, was made responsible for approving and controlling every new building and work of art related to the new urban landscape. Parks, gardens, fountains, the Lincoln and Jefferson Memorials, the rebuilding of the Mall, Union Station and the whole face of the city was renewed and changed. The rapid urban growth had not taken into account the requirements of Mother Nature. With the swift deforestation taking place and the very boggy land, the worst aspects of the unfavourable local climate were being exacerbated: tropical humidity in summer and an intense winter freeze. Right up until the 1940s, the capital of the U.S.A. maintained the customs, atmosphere and rhythms of life of a city in the Deep South although it was forced to deal with the crises of the period: entry into World War I in 1917, the Depression that began in 1929, and the environmental disaster of the Dust Bowl. But the era of drastic changes was only just arriving.

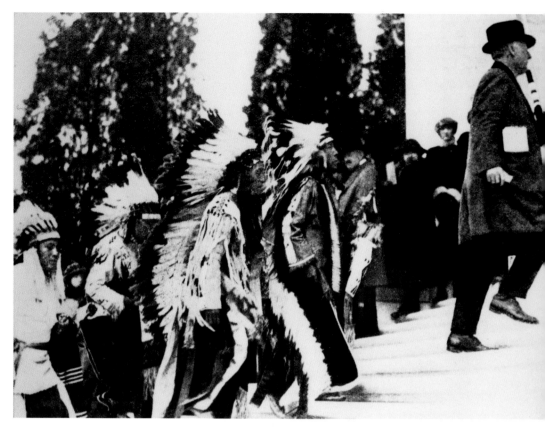

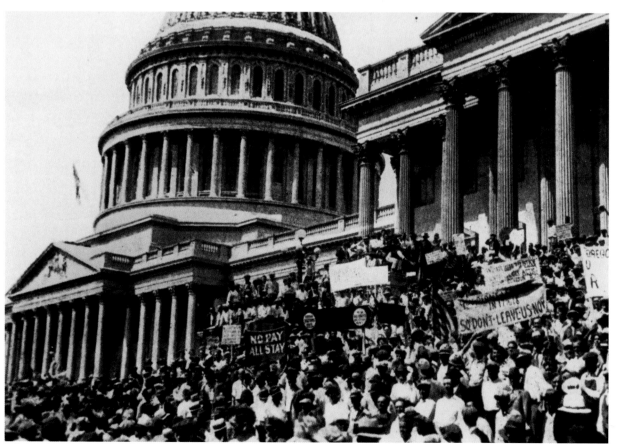

50 *The aerial photo from 1939 shows the Jefferson Building in the Library of Congress and, in the background, the east side of the Capitol. To the right, the north wing of the Senate, to the left, the south wing of the Chamber.*

51 top *Once the civil war in the western territories was over, in 1921 a delegation of North American Indians visited the National Cemetery of Arlington to pay tribute to the tomb of the Unknown Soldier.*

51 center *On 1 December 1921 the inauguration speech for the monument to Dante Alighieri was given in the presence of President Warren G. Harding and the European delegations that met in Washington for the disarmament conference.*

51 bottom *A protest on the steps of the Capitol by survivors of World War I during the Depression. This harsh period began on Black Tuesday, 29 October 1929.*

As for all American society, World War II marked a turning point for Washington too. It was then that the United States leapt onto the world stage, first as the "arsenal of democracy," then because it commanded the world's most powerful army. The capital found itself thrust into the vortex of world affairs, whether it liked it or not, after having been just a somnolent and lazy small town of the American South. It was a constant, regular and unavoidable process that overturned long-established customs. It was Franklin Delano Roosevelt, America's best-loved president who threw off a memorable line on the vices and qualities of the North and South of the U.S.: "Washington? A city of southern efficiency and northern charm."

Everything had to change. Set against the background of the frightening prospect of nuclear war, the destiny of the world was being decided here. Washington is where the United Nations was planned and where the baton of Anglo-Sax-

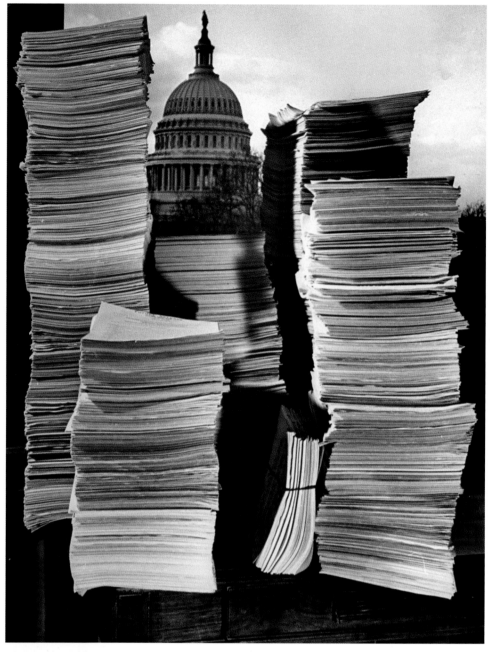

on world leadership was handed over. And it was in this city that profound, radical and even epochal changes in American society took place. A tangible sign of this is that 70% of Washington is inhabited by Americans of African origin, and most of them living in very low socio-economic conditions.

The black community has been present in Washington since the early nineteenth century and even as early as 1840 – almost thirty years before the abolition of slavery – the free blacks exceeded the number of slaves by 3 to 1. A great wave arrived during the 1950s when the invention of cotton-picking machines made thousands and thousands of farm laborers redundant.

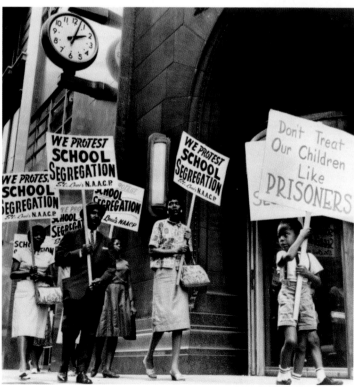

52 top The files of 544,056 victims of the war in Vietnam are piled on a table in the Library of Congress. The victims represent the dead, wounded, missing and prisoners.

52 bottom A protest against racial segregation. Even during the 1960s and the Kennedy presidency, blacks had to fight hard to break down the barriers of apartheid that existed in the southern states.

Washington became an irresistible magnet and an obligatory destination. The black minority was still strongly discriminated against and in many states of the deep South a sort of American apartheid was in force that was often strengthened and often legitimised by strict state legislation. But in the terrible cauldron of World War II, the blacks – fighting side by side with whites – found that the colour of their blood was no different, and in the comradeship of the trenches and battle, of death and sacrifice, they recognised they had the same duties and rights as their colleagues, whose skin was less affected by melanin in the surface layers. The movement became irresistible. As national capital, Washington was the first city to offer equal pay for government employees whatever the colour of their skin. Consequently, the descendants of the slaves who had been dragged from Africa were able to climb rapidly up the steep social ladder in Washington before anywhere else. This was a clear sign of the social climate that exists in this area of the Potomac.

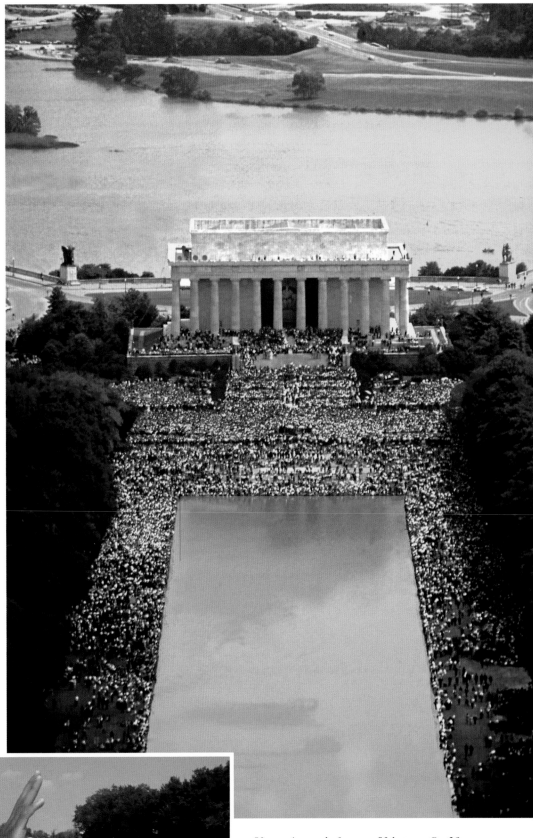

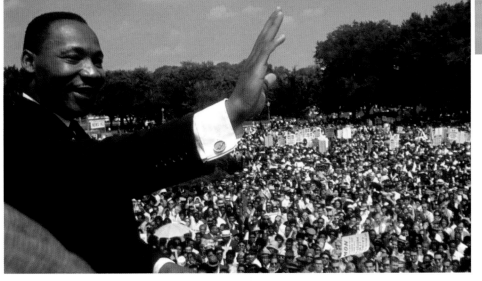

53 top A crowd of 200,000 took part in the Freedom March led by Martin Luther King in August 1963. This was the occasion on which the anti-segregation leader made his famous speech: "I have a dream . . ."

53 bottom On 28 August 1963, Martin Luther King saluted the crowd gathered in The Mall on the day of the march in Washington demanding civil rights, equal opportunities and freedom. The massive demonstration has passed into history as the Freedom March.

54 On 12 September 2001, the day after the attack on the Twin Towers in New York and the Pentagon in suburban Washington, a group of aid workers unrolled a gigantic American flag beside the dreadful wound in the walls of the American military establishment.

54-55 On 11 September 2001, the largest terrorist attack in history was launched at the United States. Three airliners were hijacked and flown into carefully chosen objectives. The World Trade Center collapsed in New York; in the Washington area, the Pentagon was hit.

And today? After the fall of the Berlin Wall, the United States is no longer a superpower: now, it is, in the words of Lester C. Thurow, the world's only hyperpower. And Washington, D.C., its capital, has been transformed into a rainbow of colors, cultures, flavours and atmospheres. It boasts languages that range from ethnic to diplomatic, an army of ambassadors, elected politicians, guards and thieves, businessmen, cinema stars, TV and publishing moguls, bureau-

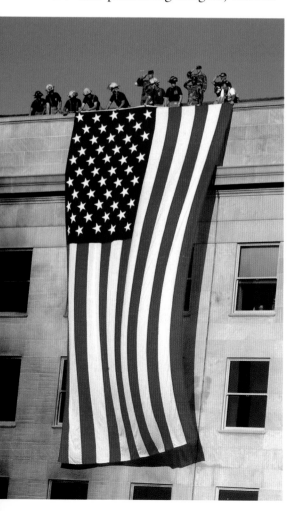

crats, administrators and lawyers who parade every day with the ordinary public and the lobbyists in the oldest and most modern heart of the nation. Scandals, senatorial committees, the Pentagon, the Smithsonian, museums, Arlington national cemetery, the rich and famous, workers and the Washington Monument. Is it Sodom and Gomorrah or the "New Rome"? Marble, baking asphalt, the FBI and the Oval Office. High officials and the homeless in the only city in the world where the neighbor of the President sleeps on a hot air grill over the subway system. This too is part of the Potomac fever that grips everyone involved with the city.

This 'Potomac fever,' is the magic of the fascinating and captivating city of Washington. Then came the cries, the terror and death. On 11 September 2001, the United States was struck by a terrorist attack that nobody expected. The attack came from the sky when three airliners were hijacked and flown into the most recognised symbols of the 'American way of life.' The collapse of the Twin Towers in the WTC in New York reverberated, like the echo of a nightmare, in the capital. One side of the Pentagon, the heart of the U.S. military defense, was struck and ripped open. The United States and Washington had lost their innocence, but not their determination to keep moving forward, against all odds and in the face of all opposition. God bless America.

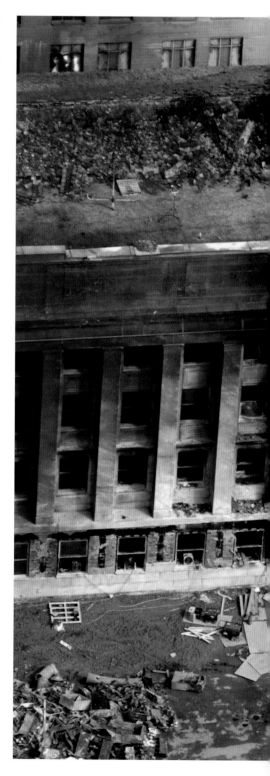

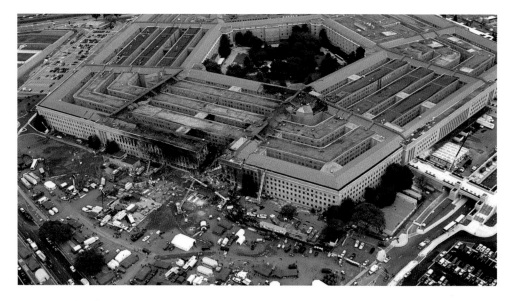

*55 top With the
attack on the
Pentagon, the
United States'
defense system was hit
hard. The massive
building is organized
in sectors and levels to
offer the maximum
safety and protection
to staff.*

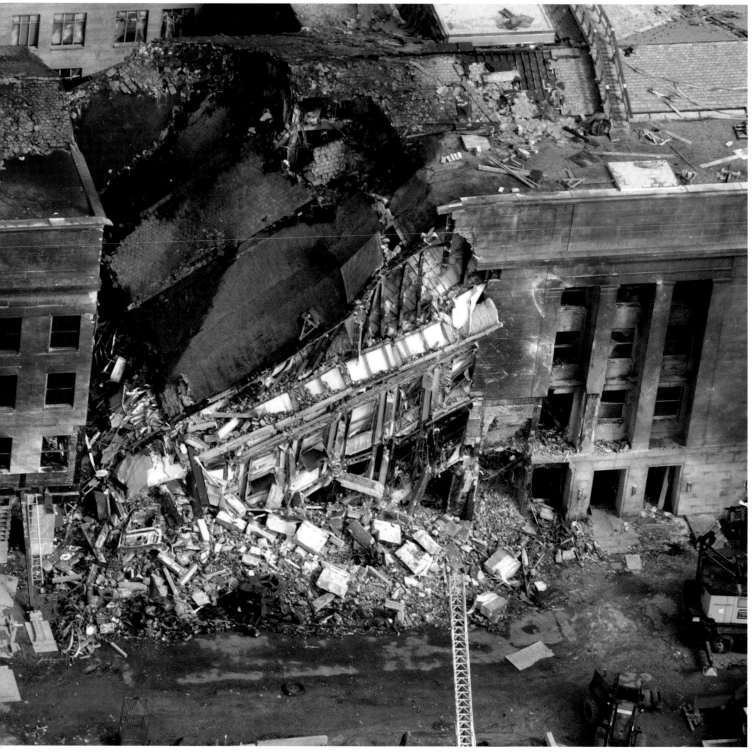

THE MALL

56 The Mall is a green strip of history and culture that runs through the center of the American capital. It is over 1.8 miles long, 656 feet wide and runs from

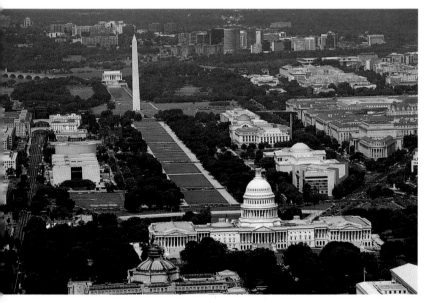

the Potomac River to the Capitol. More than any other place, it is the heart of Washington, where the museums, institutions, and most important monuments in the city are located.

At the western end of Constitution Avenue – the large avenue that runs down the north side of the Capital toward the Potomac – there stands the most ingenious and unexpected horoscope in the world. It provides an unusual, and mostly unknown, way to begin a visit to the intellectual and cultural heart of the capital of the United States.

From the end of the summer to spring, the National Academy of Sciences, at 2100 C Street NW, hosts a series of concerts open to the public and given by local musicians, some of whom are members of the prestigious National Symphony Orchestra. Not all the spectators in the 700-seater auditorium pay more than cursory attention to the bronze statue of Einstein sculpted in 1979 by Robert Berks. The father of modern physics is shown seated informally, as was his custom, on a semi-circular bench made of white granite. In his left hand he holds sheets of paper bearing the results of his most important discoveries, such as the equivalence of energy and matter, and the theory of relativity. Before him, the polished marble floor reproduces with extraordinary exactness the heavens as they were at midday on 22 April 1979, the day of the statue's inauguration.

The small stainless steel studs in the floor represent the positions of the sun, moon, planets, asteroids, almost 3000 stars and 10 quasars as they were at that moment. Einstein looks at them pensively and a little amazed – as the lines on his forehead show – his right foot almost distractedly touching one of the splendid giants of the skies, Boötes.

In the artistic semantics of Berk's monumental sculpture, together with a panoply of other arcane meanings, the pose of the intellectual giant in front of the vastness of the heavens represents man's reach toward the infinite in his search for knowledge, a necessary and decisive leap of his understanding, and an alteration in his relationship with the universe.

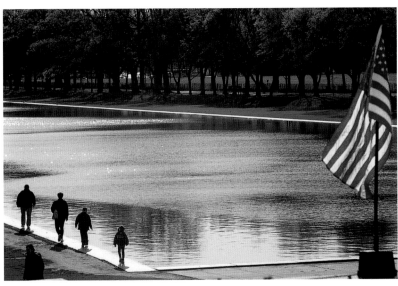

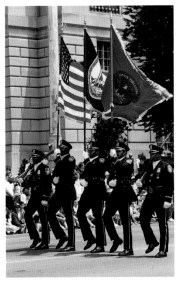

57 left The Reflecting Pool in front of the Lincoln Memorial was a meeting place for all the large protests that took place in the 1970s.

57 right The Independence Day parade takes place along Constitution Avenue on America's national holiday.

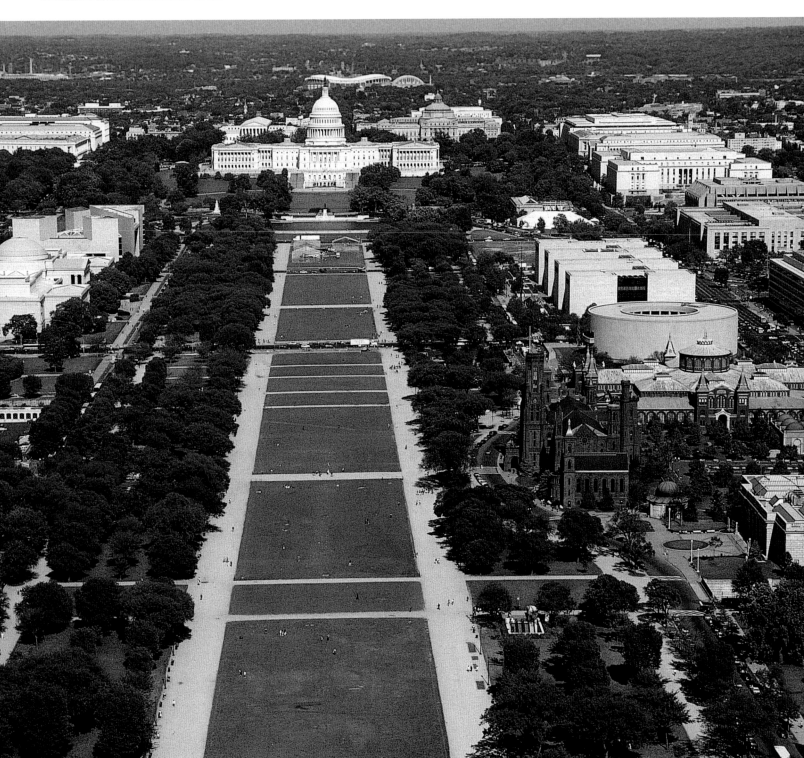

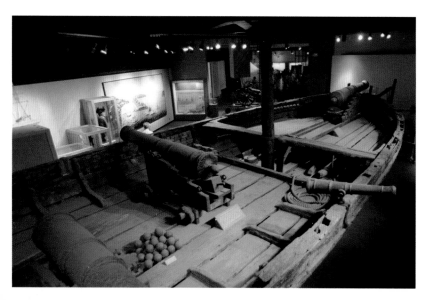

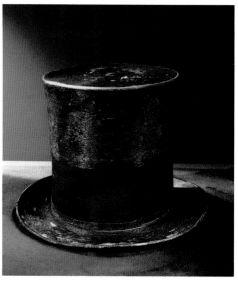

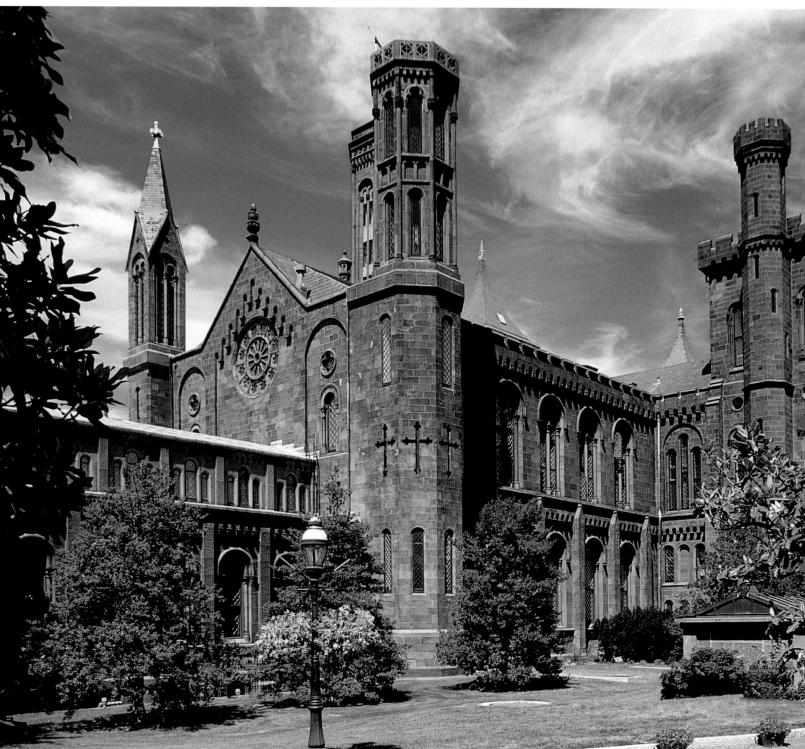

*58 left The
Philadelphia was a
nippy gunboat that
took part in the
American
Revolution. It was
restored in 1935 and
is now kept in the
National Museum of
American History.*

*58 right The
National Museum of
American History
also has the top hat
worn by Lincoln on
the evening he was
assassinated at Ford's
Theater.*

*58-59 The Castle is
one of the
Smithsonian's main
buildings. Today it is
the information
center of the world-
famous cultural
institute. For tourists
it is also a reference
point when exiting
the subway system
station.*

The mysteries and suggestive power of Berk's work are the start of the discovery of the Mall in Washington. The Mall is an pleasantly tree-lined avenue about 295 feet wide that lies between Constitution and Independence Avenues and which has become the center of the city; it runs for about 2.5 miles from the Capitol to the Lincoln Memorial and is home to the main museums of the Smithsonian Institution. The Smithsonian has fourteen theme-based collections of international importance; it is, quite frankly, impossible that anyone could not find something here that is of interest. It has been calculated that it would take two and a half years non-stop observation to see everything the Smithsonian has collected and catalogued. Usually the time available is somewhat less, so that it is necessary to make a choice from the huge range on offer in order to avoid a hurried dash.

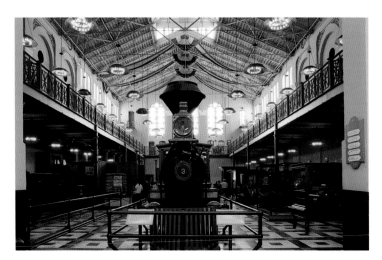

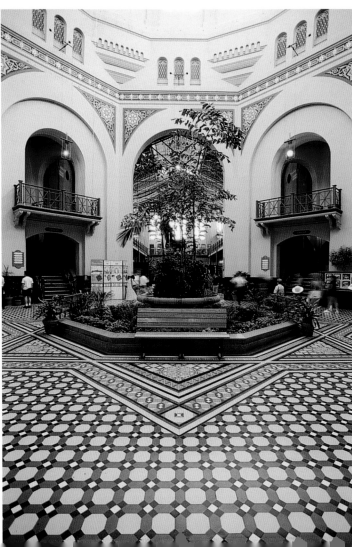

*59 top The Arts and
Industries Building
is a museum that was
built to provide a
home to the 60
wagons' worth of
goods remaining
from the 1876
World's Fair in
Philadelphia, which
nobody else wanted.*

*59 bottom The east
and west rooms of the
Arts and Industries
Building contain
gigantic steam
locomotives, Gatling
guns, massive electrical
generators, printing
machinery and all the
state-of-the-art
scientific gizmos of the
late nineteenth
century displayed at
the World's Fair in
Philadelphia.*

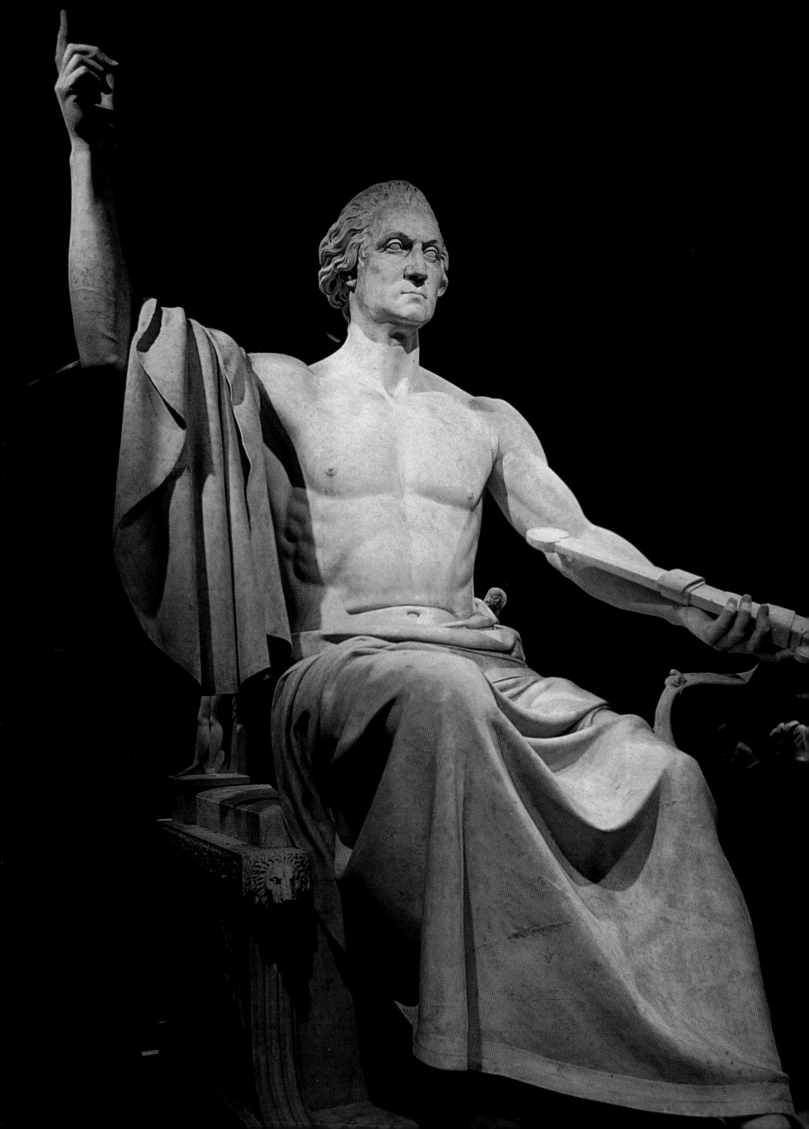

60 *This improbable and somewhat controversial sculpture of George Washington – somewhere between Canova's image of Napoleon and Phydias' Zeus – was the work of Horatio Greenough in Florence between 1832 and 1840. For its critics, the pose of the U.S.'s first President is too imperial and unsuitable to the "first democracy in the world."*

61 top left *This is the bell on the Franklin, a U.S. navy ship. The rooms in the National Museum of American History cover both the sacred and profane, from the first national flag to the leather jacket worn by Fonzie in Happy Days.*

The nearest collection to the White House, the National Museum of American History, is one that should not be missed. Its statute declares that it should concern itself with everything related to daily life in the American past and with the external agents that have contributed to forming the character and culture of the United States. The vast field the museum covers has resulted in a truly enormous collection of objects, which includes such items as George Washington's false teeth, everyday objects used a century ago, relics of the Civil War, the leather jacket worn by Happy Days' Fonzie, the gown worn by Judge Sirica (of Watergate fame), and Foucault's pendulum in the First Ladies' Room. There is also the unfortunate and embarrassing statue of George Washington sculpted by Horatio Greenough in his Florence studio between 1832 and 1840, in which the eponymous hero of the capital and American independence was immortalised somewhere between Canova's nude Napoleon and Phydias' Zeus. So that it could be taken into the Rotonda of the Capitol, as planned, the entrance had to be widened, but when it was finally set in place, the floor began slowly, inexorably and dramatically to give way. Quickly relegated to a room on the east side of the Capitol, the statue was passed on to the Smithsonian in 1908, perhaps more as a poisoned chalice than a national heirloom. The disconcerting miscellany of objects requires an extraordinarily efficient and enthusiastic job of archiving by the staff to prevent the museum being crushed beneath a taxonomic mountain. The collection was begun in what used to be called the U.S. National Museum and included a large section on natural history. This too made it the favorite repository of those trying to get rid of unwanted objects, mementoes, heirlooms and, frankly, rubbish: from the collection of Patent Office models to the remains of items considered too valuable to throw out at the end of the Philadelphia Centennial Exhibition. The bric-à-brac that came to be deposited in what was quickly referred to as the "national attic" required the drastic and abundant creation of new departments.

61 bottom left *Two of the most popular collections in this deposit of American history are the one in the First Ladies' Hall, dedicated to the wives of the American Presidents, and the one on the third floor, devoted to the graphic and typographic arts (see photograph).*

61 right *This machine, patented by a New York company, once produced pins. The gigantic Aladdin's cave that is the National Museum of American History contains a myriad of objects, from Mohamed Ali's boxing gloves to the robe worn by Judge Sirica in the Watergate case.*

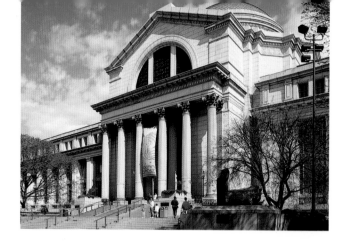

62 top This is the entrance and gold dome of the National Museum of Natural History, the most complete of its kind in the world. With 120 million items, it is another of the Smithsonian jewels located on The Mall.

The first to develop its own character – thereby reducing the all-encompassing nature of the U.S. National Museum – was the National Museum of Natural History, which today is the largest of its kind. It has over 120 million items, from dinosaur eggs, to Ice Age mammoths in the entrance, to the legendary 45.5 carat Hope diamond with its troubled history. Stolen from an Indian temple in the seventeenth century, it carried with it an evil curse, like a Dantesque revenge, until in 1958 its last owner, the jeweler Harry Winston, decided to entrust it to the Smithsonian. However, it is said that the leg of the unfortunate mailman whose task it was to deliver the problematic gift was crippled in an accident, his dog and wife died shortly after, and his house was burned down in a mysterious fire. But curses and jinxes apart, the National Museum of Natural History is a setting for adventures set against the background of history and nature.

The collection of fossils traces natural history back to its origins: algae from 3.5 billion years ago, giant squids, dramatic coral reefs and the inevitable skeletons of the giant lizards that set off the dinomania following films like *Jurassic Park*. If you are the kind of person who did not take a bath for a month after watching *Jaws*, then don't enter the room dedicated to these fascinating predators. The jaws of the fearsome *Carcharodon megalodon* may give you nightmares that not even Freud could cure you of. This terrible flesh and bone embodiment of all the sea monsters of antiquity (clearly not born from our unconscious . . .) sinuously powered its 40 feet of permanent hunger and ferocity through the sea ten million years ago, with its strings of teeth over twelve centimetres long. It was nothing like that underweight goldfish seen in *Jaws*.

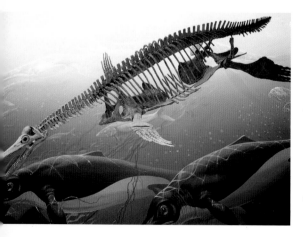

62 bottom One of the many thousand things in the National Museum of Natural History: a trip back in time through the geological periods to discover how the world was and how it will be in the future. Typical exhibits are dinosaur eggs, cursed diamonds, fossilized seaweed and a collection of gemstones and minerals

62-63 The rotunda at the entrance to the National Museum of Natural History is dominated by the towering silhouette of an African elephant. Monsters that trouble our dreams are an inheritance from the real world of our ancestors; their fossilized remains can be seen in this museum.

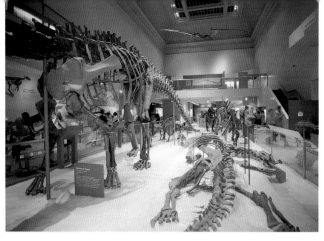

63 *The dinosaurs halls are enjoying the current season of "dinomania." The Carcharodon Megalodon – 40 feet long, with many rows of teeth, each several inches long-is a popular exibit.*

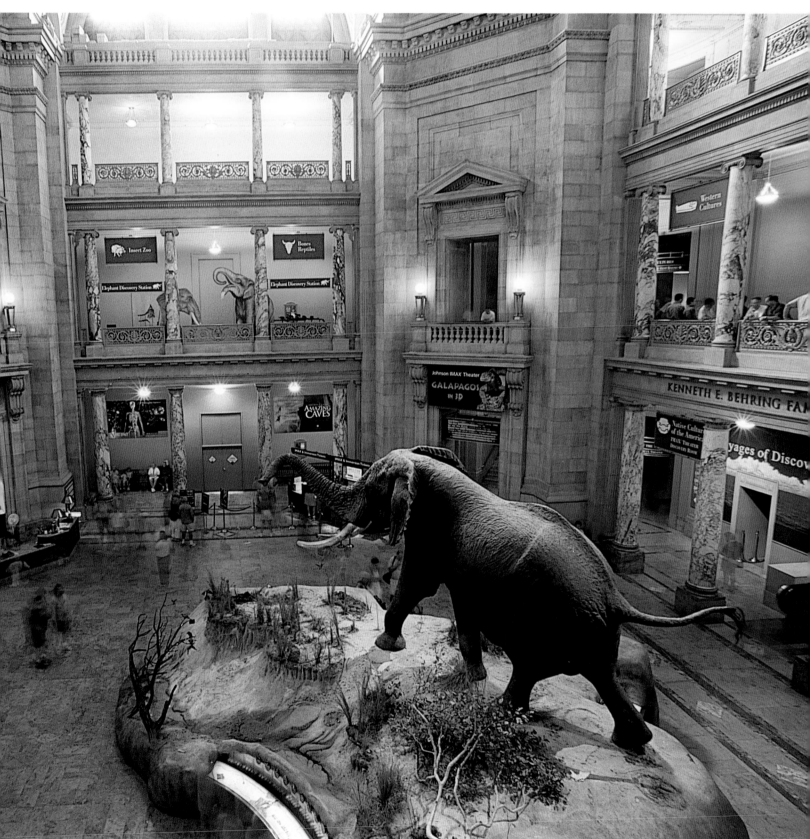

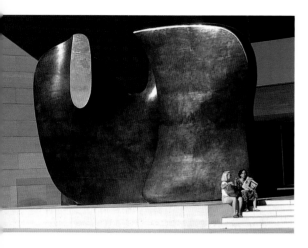

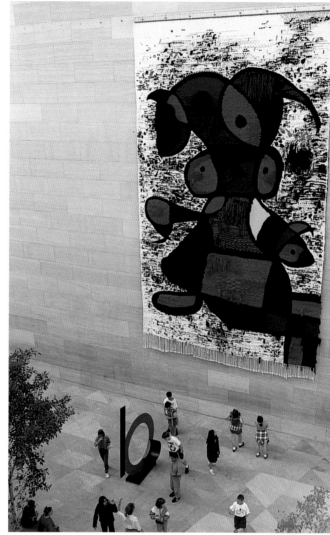

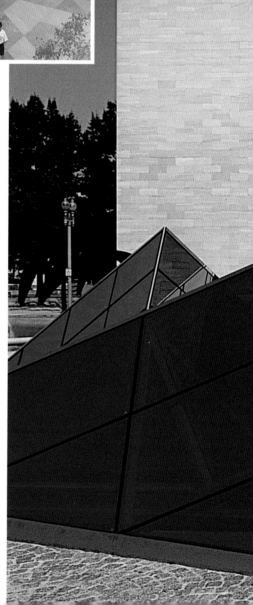

Continuing towards the Capitol, you come to the National Gallery of Art, which is affiliated to but not part of the Smithsonian. It is divided into two sections, the West and East Buildings. The former was designed between 1939 and 1941 by John Russel Pope, who could boast fourteen monumental buildings in the capital alone. For some, the West Building is a Neo-Classical masterpiece, for others it is an architectural relic of an age unable to come to terms with glass and steel modernity. It was certainly the last public building in Washington to be modelled – more psychically than physically – on a patrician design. On the other hand, when it was inaugurated, it seemed to be an ideal compromise between the extraordinary cultural deposit it houses, and the highly unusual modesty of the philanthropist who donated it to his fellow citizens without linking his name to his collection in order to glorify his family name to posterity. Andrew W. Mellon was a billionaire with a taste for the great masters of painting; he left his country 121 of the most famous and important masterpieces in the history of art in the most magnificent gift ever made by an individual to a government. Such paintings as *The Adoration of the Magi* by Botticelli, *St. George and the Dragon* by Raphael and *Ginevra de' Benci* by Leonardo, together with a wide selection of works by such artists as Dürer, Rembrandt, El Greco, Goya, Rubens, Bosch, Renoir, Cézanne and Monet are worth some concession surely. However, a surfeit of Old Masters can be cured by crossing to the East Building where you may suffer a heavy attack of culture shock. Here, there is a sudden change of atmosphere, perspective and culture, starting with the forms and structure of the building designed by I.M. Pei, with glass walls and an ultra-modern four-story atrium. Here, the art of the twentieth century is already old.

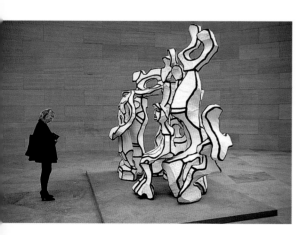

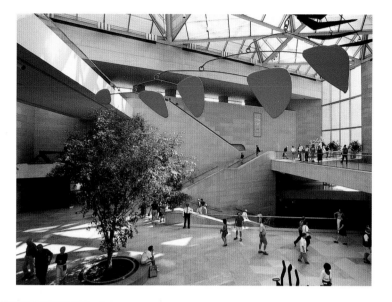

64 bottom The East Building of the National Gallery of Art is an extraordinarily interesting museum whose main focus is on contemporary art. The sculpture in the photograph is by Jean Dubuffet.

64-65 The unmistakable lines of the East Building: this is the most important building in Washington to openly declare its affiliation to twentieth-century architecture. Today it has become one of the most distinctive symbols of the American capital.

65 Walls made of glass, air and sun enclose an ultra-modern four-story atrium. This structure designed by I.M. Pei in 1978 is an ideal location for works of contemporary art by artists that have influenced an era: Matisse, Picasso, Miró, Warhol, Lichtenstein, and others.

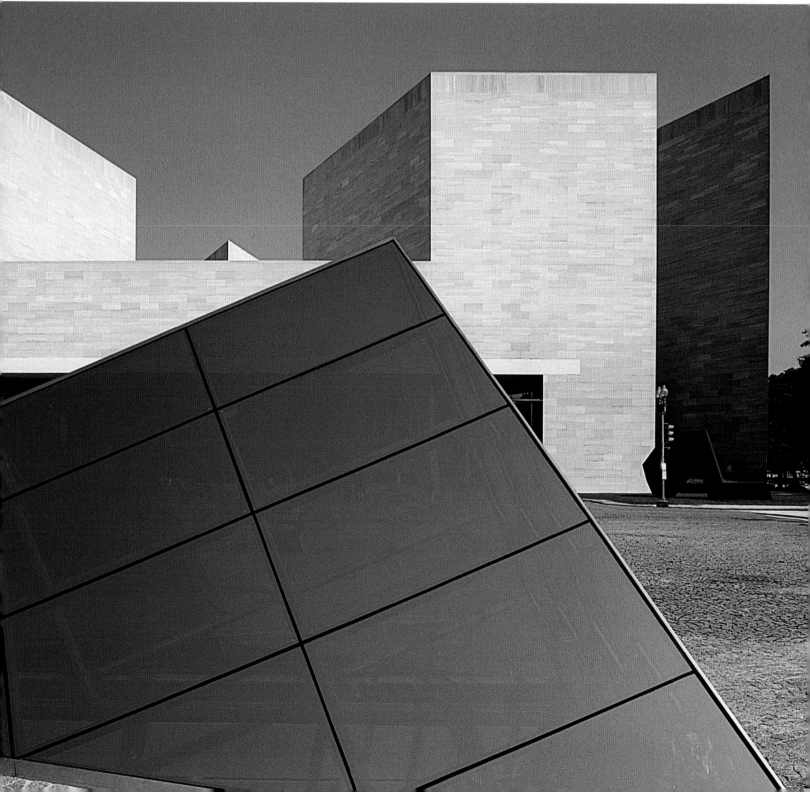

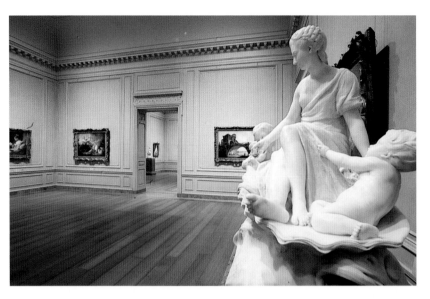

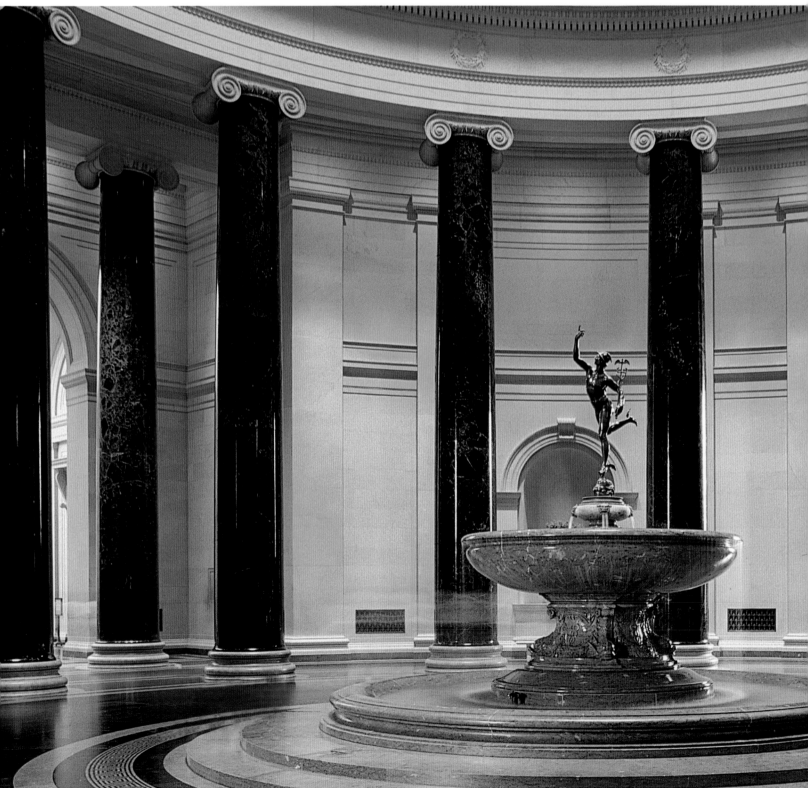

66 top left The extensive art collections on display in the West Building of the National Gallery of Art include fine sculpture, furniture and decorative objects made from bronze, porcelain and glass.

66 top right and 66-67 The impressive Neo-Classical rotunda at the entrance of the West Building in the National Gallery of Art. The division of this museum into two sections was a far-sighted decision by Andrew W. Mellon, a patron of the arts who loved the great masters and who donated his 121 masterpieces to the nation. When Mellon inaugurated the National Gallery in 1941 (what is today the West Building), he wanted the land to the east of the building reserved for future expansion. No-one then imagined that in 30 years the space available would all have been used and a new building required.

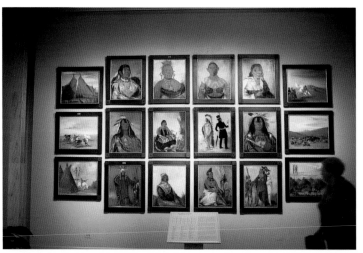

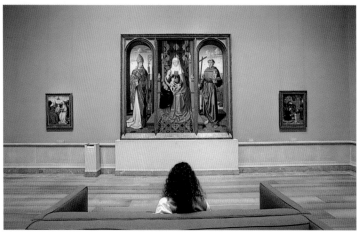

67 Two rooms in the West Building of the National Gallery of Art. The gallery is dedicated to the collection and display of European and American painters active between the 13th and 19th centuries. The collection is housed in a Neo-Classical building designed between 1939 and 1941 by John Russell Pope and was the last public building in Washington to be designed as a patrician palace. Andrew Mellon's collection includes the Adoration of the Magi by Botticelli, St. George and the Dragon by Raphael, Ginevra de' Benci by Leonardo as well as works by Rembrandt, Vermeer, Dürer, Rembrandt, El Greco, Goya, Rubens, David, Bosch, Renoir, Cézanne and Monet.

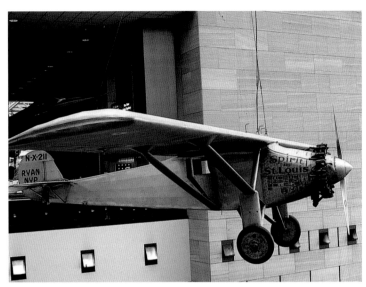

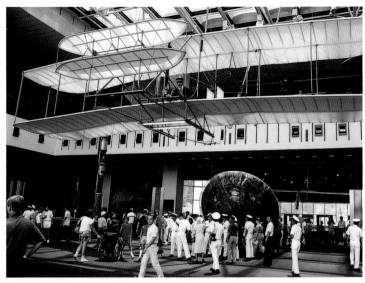

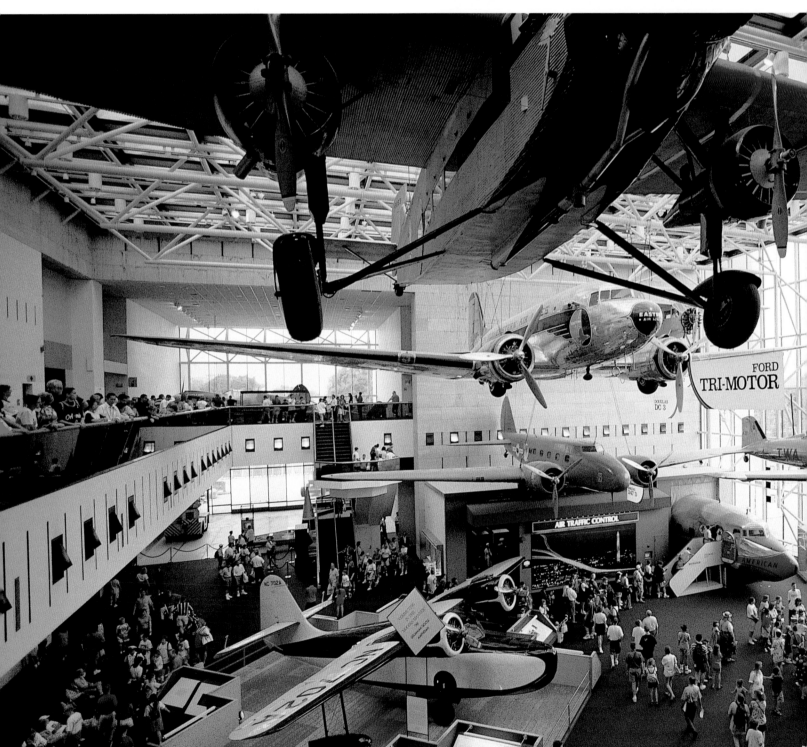

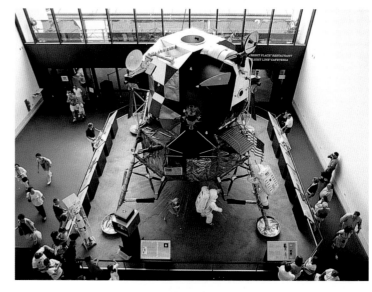

Opposite the West Building of the National Gallery of Art stands the National Air and Space Museum. Opened in 1976 and dedicated to the adventure of flight and space exploration, it became an immediate success. With more than ten million visitors each year, it is far and away the most popular museum in the world.

Some believe its formula of adventure and a subject that is closer to the present than the past is responsible; most of the visitors who crowd this exceptional collection actually witnessed many of the things illustrated, described and explained.

The 23 galleries dedicated to flight, from the successful attempt by the Wright Brothers in the clumsy *Kitty Hawk* in 1903 to the first landing of man on the moon just 66 years later, are passed through in a single brief visit.

From the 59 second long jump, rather than a take-off, of the Wright Brothers' flight to the weightless bounds of Neil Armstrong on a summer night in 1969. Landmarks on the journey are the transatlantic flight of Charles Lindbergh in the '*Spirit of St. Louis*', the first plane (the X-1) to break the sound barrier, the flight of the '*Enola Gay*', the bomber that dropped the atom bomb on Hiroshima, and the space program represented by the Gemini and Apollo capsules.

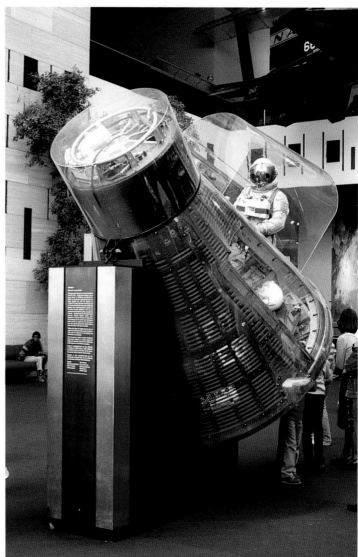

The history of flight is supported by the wide assortment of film recordings in the Imax projection room and the multimedia shows in the Einstein Planetarium.

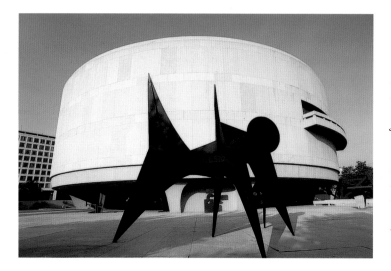

70 The Hirshhorn Museum & Sculpture Garden is the result of the combination of a Latvian immigrant, the discovery of large uranium deposits and a passion for art. Joseph Hirshhorn was 6 years old when he arrived in America. At 52 he was one of the richest men in the world and an important art collector.

71 top The controversial doughnut designed by Gordon Bunshaft that houses the Hirshhorn Museum. Its critics say that the concrete and granite building does not match the architecture and atmosphere of the Mall, and a circular art museum has yet to be seen. In fact, the structure provides a natural circuit for the visitor to follow.

Having gone as far as possible toward the Capitol, we return toward our starting point in the Mall. After the Air and Space Museum, another obligatory stop is the Hirshhorn Museum and Sculpture Garden in which there is an unexpected marriage of uranium and works of art. Joseph Hirshhorn was six when he arrived on Ellis Island as an immigrant from a Latvian ghetto with his mother and a string of relatives. At seventeen, he had his first success in the financial field and, at 28, was fortunate enough to sell all his stocks and shares a week before the Wall Street crash in 1929. By the age of 52, he was the owner of the largest uranium deposits in the world. As an undying commemoration of himself, he constructed a much debated concrete and granite

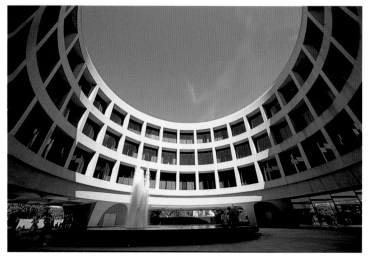

71 centre In 1966 Hirshhorn donated the world's largest art collection to the nation: 4000 paintings and 2000 sculptures. Today the museum and garden exhibit works by the most important modern and contemporary artists, including, Henry Moore, Rodin, Giacometti, Brancusi, Calder, Warhol, and Georgia O'Keefe.

doughnut of a building that houses the largest collection of works of art ever assembled by an individual: over 4000 paintings and 2000 sculptures that he donated to the United States in 1966 "as a small recompense for what this nation has done for me and others like me, who

came here as emigrants." The museum and its splendid garden offer works by all the major artists of the nineteenth and twentieth centuries, for example, Henry Moore, Auguste Rodin, Alexander Calder, Andy Warhol, Jackson Pollock, Willem de Kooning and Georgia O'Keefe.

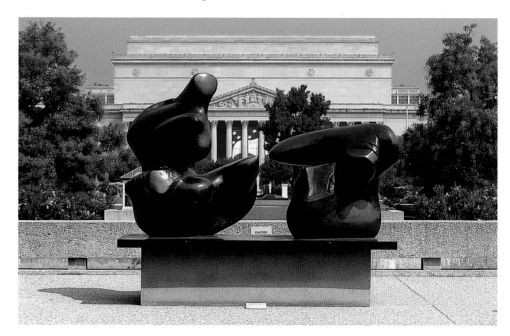

71 bottom The Hirshhorn Museum & Sculpture Garden has almost twice the number of works purchased by New York's Museum of

Modern Art in 50 years of existence. The collection offers a cross-section of the trends and directions in contemporary art.

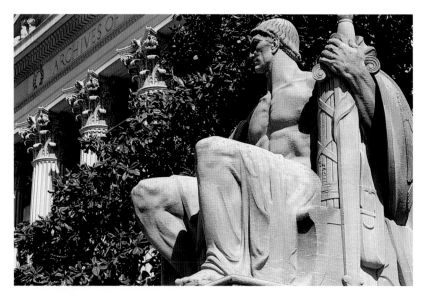
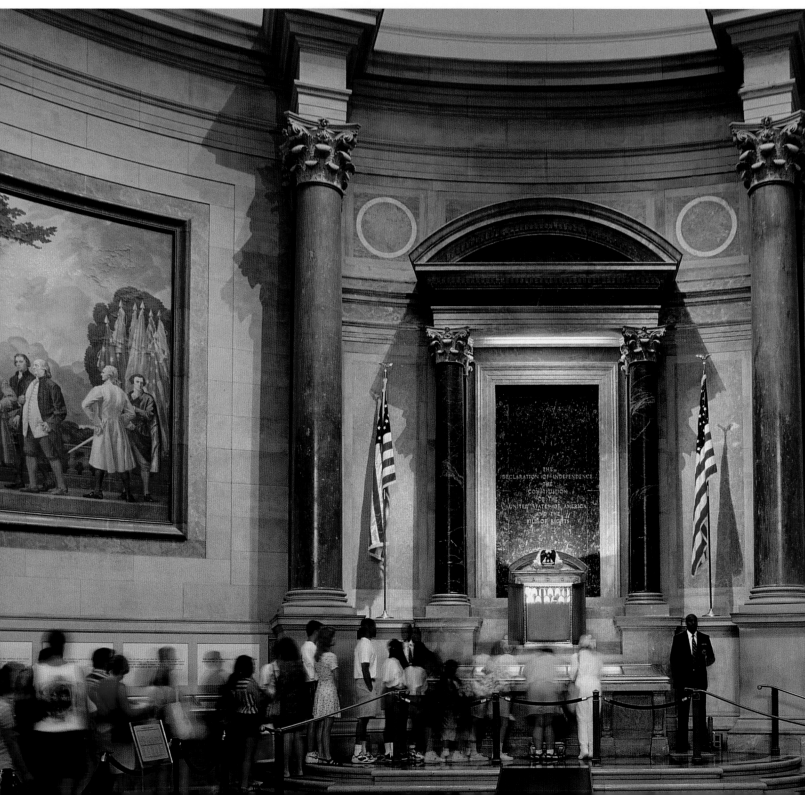

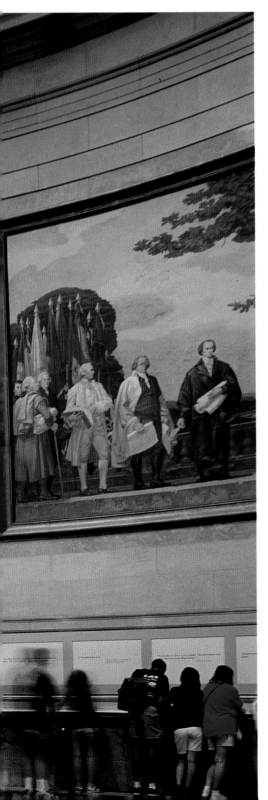

There is plenty more of the Mall to see, but that is enough to give an idea of what it has to offer. The best time is in the early morning when it is still free of the hordes of tourists and visitors, and when a walk through its gardens and parks is a joy to remember.

At the junction of Constitution Avenue and 7th Street, practically behind the National Museum of Natural History and the National Gallery of Art, you will find the National Archives, which are home to the documents that were fundamental to the founding of the United States of America: the Declaration of Independence, the Constitution of the United States, and the Bill of Rights. They are held in the building's rotunda where they lie in bronze containers pressurised with helium, and protected by three sheets of bulletproof glass,

but it is a trying task to read the old and 'sacred' parchments. Those in the know suggest you time your visit close to closing time (for most of the year 5.30pm). This way you will be able to follow all the procedures in which the documents are solemnly lowered into an atomic bombproof armoured crypt 32 or so feet below ground that was built in 1952. The National Archives have a collection of billions of documents from the two hundred-year history of the United States, plus a copy of the 1297 version English Magna Carta, which is a *sine die* loan from the controversial billionaire, Ross Perot. The Archives are the "nation's memory" and are often used by those investigating their genealogy; it was here that Alex Haley began his search for his bestseller *Roots*.

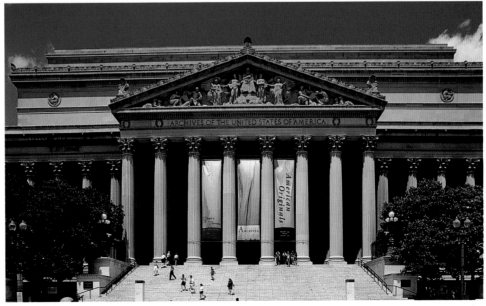

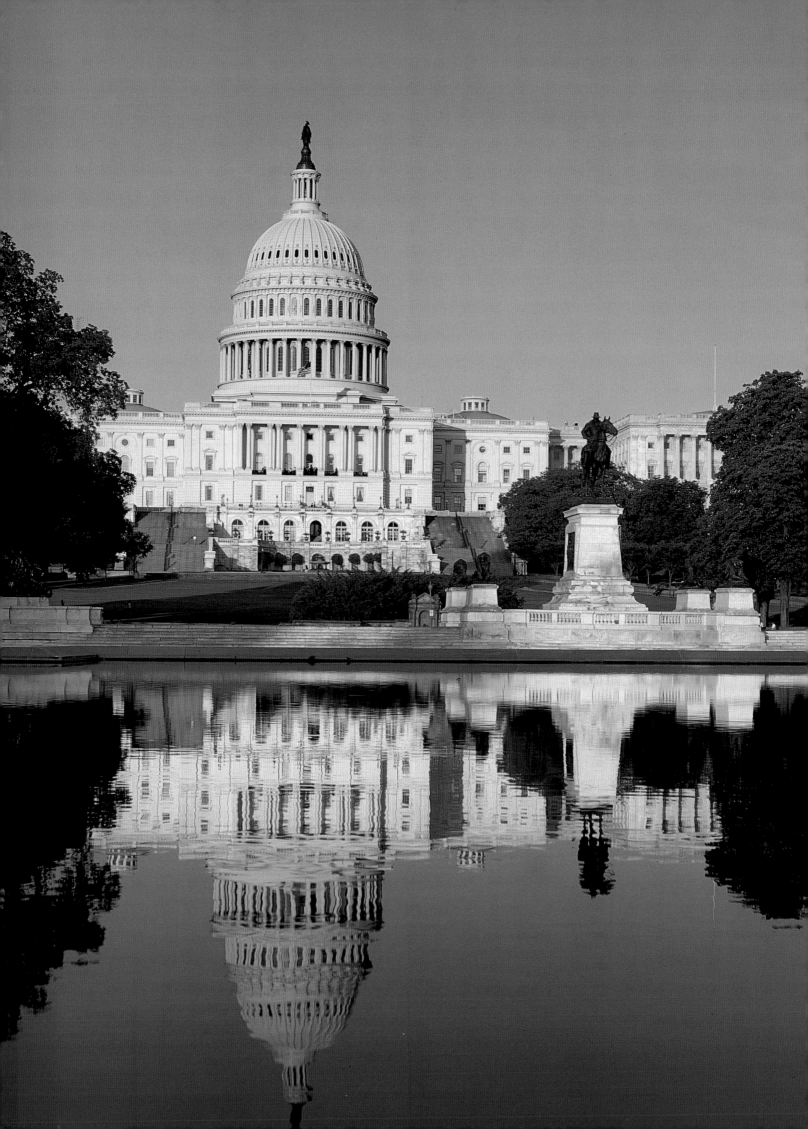

*I*f The Mall is Washington's cultural center, Capitol Hill is its political equivalent, at least as far as the legislative and judicial branches are concerned. The executive branch will be dealt with later. Senators, deputies, lobbyists, government functionaries, judges, ushers, tourists, students, bohemians, occasional visitors and idlers are all part of the galaxy of individuals who frequent the hill to the east of the Potomac. Yet they represent a particular cross-section of the capital. Tree-lined avenues, chic restaurants, fashionable bars and Victorian villas with large gardens are all part of the setting of the darker side of life in the city. No-one has yet worked out the sociological reasons why the capital has the highest murder rate in the country. Certainly, the lethal and widespread trafficking of drugs plays its part, like in all large modern cities, because this is how lowlife criminals are able to come out from the cracks and enter the mainstream of city life, even taking a place in "normal" society without problem, perhaps even at high levels. This was demonstrated in 1990 with the embarrassing arrest of Mayor Marion Barry for his use of the highly dangerous drug, crack.

On the other hand, "the Hill" is the central point around which the city hinges, where all the diagonal avenues meet below the dome of the Capitol. A city of extremes, Washington D.C. represents the miseries and the splendors of city life in America. The established manner for tourists to approach the symbol of independence is down the Mall, which, consequently, gives the impression that the Capitol faces west, toward the Potomac. Instead, the large building actually faces east towards the rising sun, in the manner that typified pagan, classical and imperial customs. The 20-feet-tall bronze statue of Liberty on the dome confirms the fact.

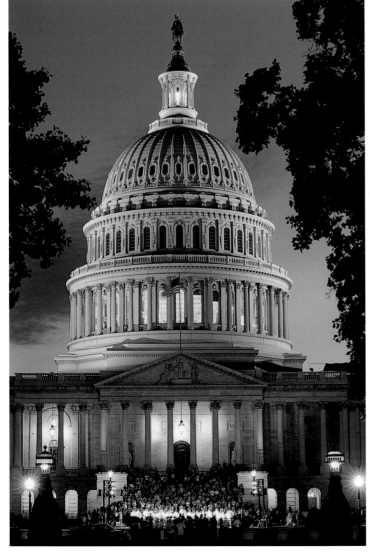

74 The building seen in the Capitol Reflecting Pool to the west of the Capitol is the home of the nation's supreme legislative body.

75 With the White House and Statue of Liberty, the dome of the Capitol is one of the United States' national symbols. The foundation ceremony is commemorated in a bronze plate fixed to the door of the Senate in which George Washington – wearing Masonic clothes especially for the occasion – places the first stone on 18 September 1793, "the thirteenth year of American independence." The site was chosen by the French architect Pierre L'Enfant on Jenkins Hill.

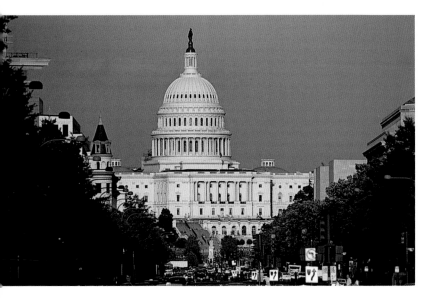

76 *Pennsylvania Avenue – America's Main Street – and the Capitol: the heart of the world's only superpower. After the Oklahoma bombing that cost the lives of 168 people, the Clinton administration decided in May 1995 to close the three blocks of Pennsylvania Avenue in front of the White House to traffic to prevent the approach of a terrorist vehicle to the White House. Skaters and hockey players are strongly in favor but shop-owners consider the barriers a sort of "Berlin Wall." The solutions employed to ease resulting problems for traffic and business, (e.g. removal of road blocks and construction of a multi-lane tunnel below the controversial area) were dramatically upset by the attacks on the Twin Towers and Pentagon on September 11, 2001.*

At times, the statue is called "Armed Liberty" as the female figure wrapped in light drapes holds an unsheathed sword in her right hand and a shield in her left. Armed or not, this symbol of proud independence is redolent of classical and Neo-Classical taste. As E.J. Applewhite wrote in his book "Washington Itself," of which every newcomer to the city should keep a copy at hand, there is an interesting and instructive story attached to her head-covering.

Originally, the statue's creator, Thomas Crawford, had planned to give the figure a Phrygian cap, being one of the recognised signs of the initiates of the Mysteries of Eleusis, and which later passed (how is not of relevance here) to the freed slaves of Rome. From there it was transformed into the *bonnet rouge* worn by the French *sans culottes* of 1789, whose aim was to guillotine France of its aristocratic head and establish a republic. But when the model of the sculpture happened to be seen by Jefferson Davis, the situation became complicated. At the time, Davis was the Minister of War during the Pierce administration (1853-1857) but was soon to become President of the secessionist Confederation of the South. When he saw the figure planned to crown the Unionist Capitol, Davis was incensed by what he considered to be nothing less than an invitation to rebellion by the slaves of the South. It was of little importance to him whether Uncle Tom, at the end of his working day in the cotton fields, read scholarly tomes of classical and modern history or not: the Phrygian cap, or red beret, as you will, had to go. Crawford had no choice but to improvise a makeshift plumed helmet that, many believe, makes the figure resemble an Indian warrior. One of the aims of the Civil War was to do away with absurdities of this nature for ever: but at a high price.

Another example of Washington's high-flying ideal to be the "New Rome" can be seen in an elaborate fresco by Costantino Brumidi painted inside the Capitol dome. Brumidi was an immigrant – obviously with Italian origins – who, with a certain scorn for a sense of proportion, called his work '*The Apotheosis of Washington*'. Called 'the Michelangelo of the Capitol' with a cheek equal to the subject of his most important work, Brumidi spent more than a year on his back to complete it. The Baroque allegory celebrates the heavenly enthronement of (George) Washington, transformed into a sort of patron divinity of the nation and surrounded by thirteen Olympian gods: the same number as there were rebel colonies.

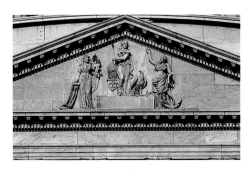

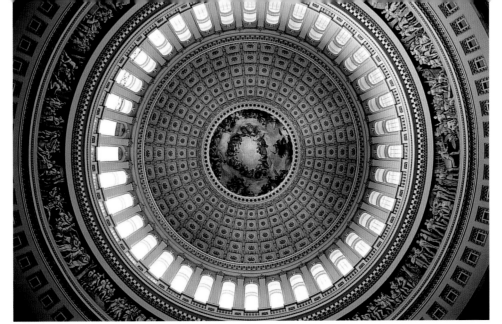

76-77 An American flag flies in front of the entrance to the monumental Capitol Building, a universally recognized symbol of the American superpower.

77 The immense internal volume of the Capitol dome is evident in this photograph taken from the entrance rotunda. The fresco that decorates the dome is by Costantino Brumidi, and is called the Apotheosis of Washington. It is a Baroque allegory that celebrates the heavenly enthronement of the first President of the United States.

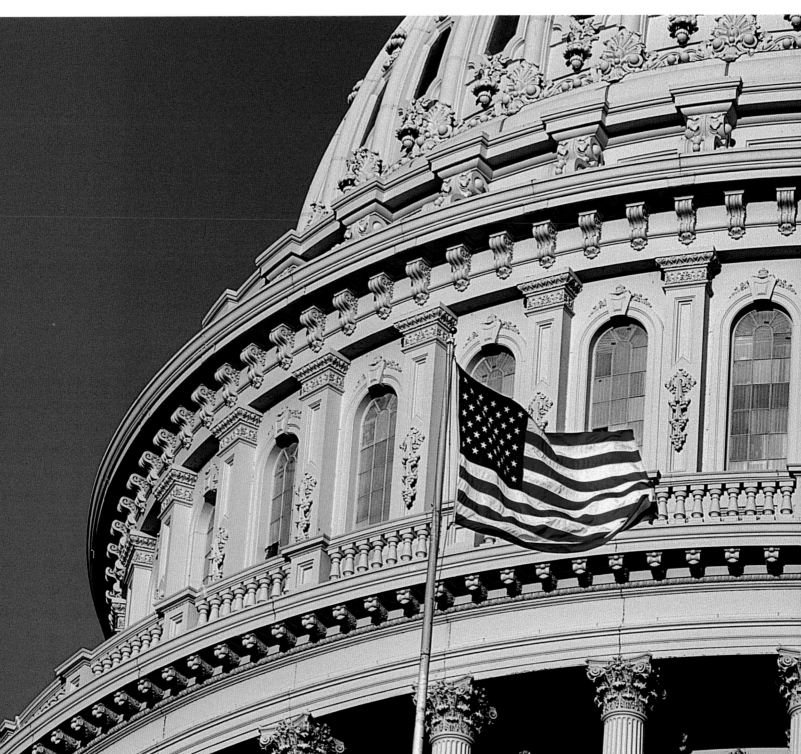

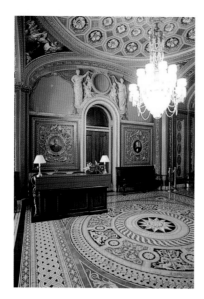

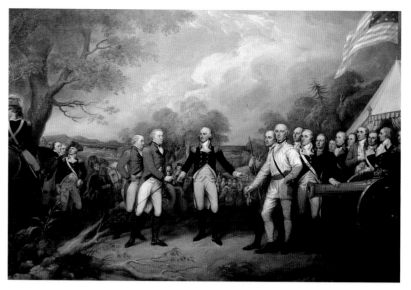

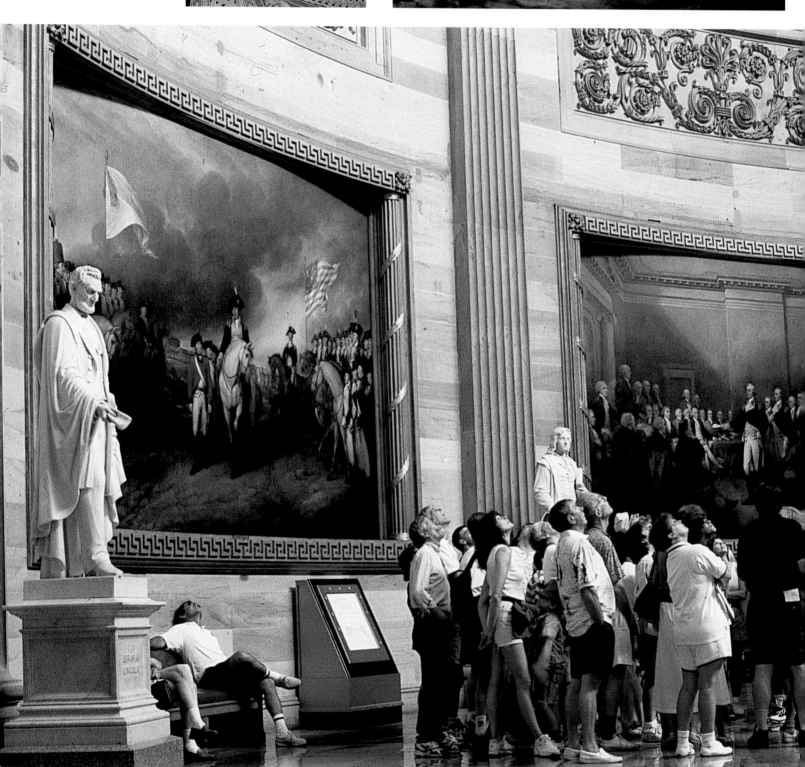

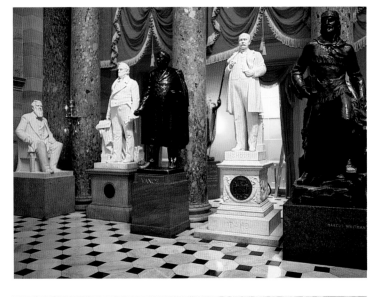

Yet it is all of the Rotunda – 98 feet or so wide – that celebrates the history and greatness of the United States: from its bronze doors, which record the most important events in the life of Christopher Columbus, to the eight gigantic oil paintings on the walls that represent and mythicize the fundamental episodes of the country's history, from the presentation of the Declaration of Independence to the astronauts of the Challenger. Nothing is left to chance. Empty spaces await the deeds of future heroes, while one of the figures of a marble group of suffragettes still waits to be completed, for she will represent the first US's female President (perhaps she will bear the name Hillary).

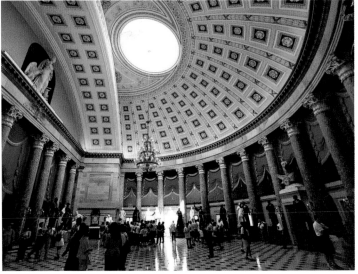

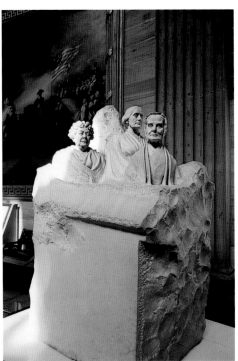

The more critical liken the huge dome, 180 feet high, that dominates the urban landscape to a chocolate-covered cherry with the statue of Liberty as the stalk. For those who have a more responsible sense of institutions, the Capitol is the temple of democracy. The thirty-minute guided tour is obligatory but only the real enthusiasts find the time to sit in on the boring legislative debates, surrounded on all sides by the hearings of the various senatorial committees; these latter are sometimes more lively and even fiery, especially when the famous and infamous are called to testify.

80 top A wide colonnade and a Neo-Classical pediment are the characteristic features of the Senate Building. When debates remain in session by night, a brazier burns on the roof of the Capitol; by day, sessions are signalled by a large flag.

When they were added to the main block in 1857, the buildings on either side of the Capitol were constructed to house the Chamber of Representatives and the Senate. Today the Representatives assemble in the south wing and the Senators in the north wing. In other words, as one looks from the Mall, the Senate lies on the left of the dome and the Chamber on the right. The former is the largest legislative assembly in the world. It is protected by walnut panels and severe grey marble columns. On the other side of the third floor, Senators are constantly under the scrutiny of the busts of the first twenty Presidents of the United States who sternly keep watch from the niches in the ceiling.

The Supreme Court is the most important court of justice in the United States. It is composed of nine justices, appointed for life, who have control over the legislation approved by Congress and are invested with the right to declare anti-constitutional actions, regulations or procedures in other sections of the government. Since 1935, the Court has issued its deliberations in a building that resembles a Greek temple that stands to the east of the Capitol, beside the Library of Congress. Up until that time, the judges had been moved around the Capitol – first in the Supreme Court Chamber and then in the much appreciated Old Senate Chamber – and not everyone appreciated the enforced transfers. Justice Louis Brandeis was against the move as he thought that the severe hall where the Supreme Court was to meet to consider its difficult decisions contributed to "making us feel humble." The judgment of his colleague Harlan Stone was more caustic when he said that the new hall, with its pink marble columns and heavy crimson drapes, made the judges dramatically resemble "nine black cockroaches."

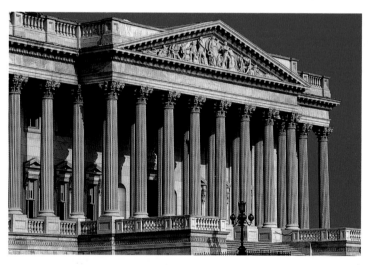

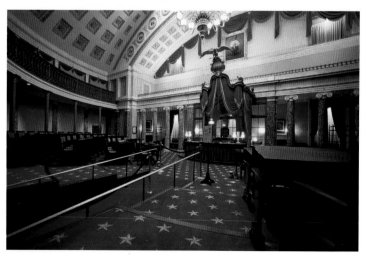

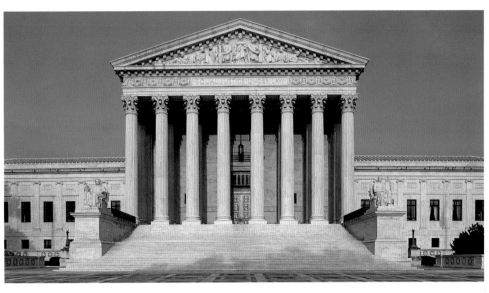
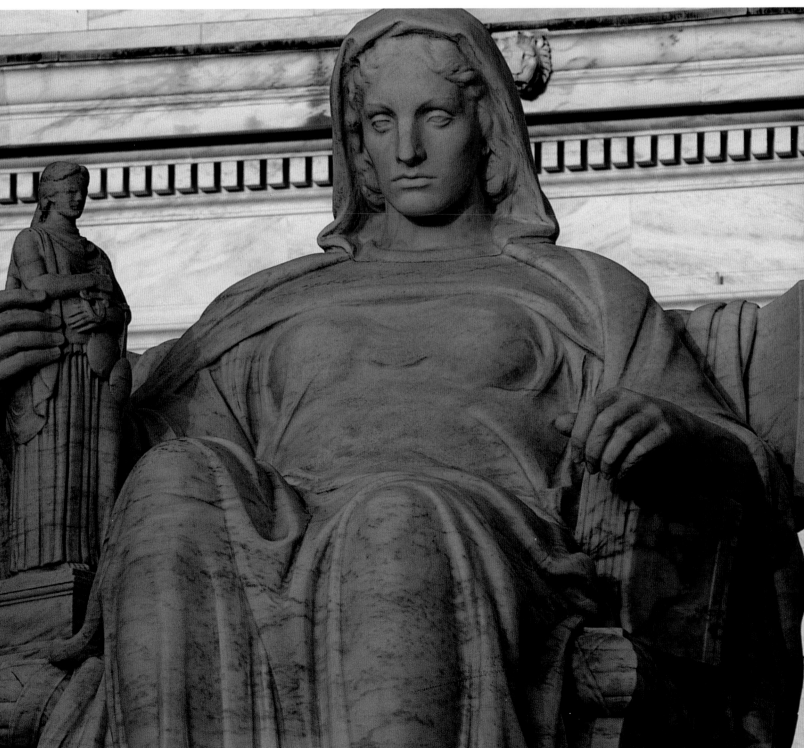

82 top and 82-83
The Library of
Congress holds the
documents and texts
associated with the
history of the nation
and of knowledge so
that the men and
women of the United
States are fully
aware of their
historical and
cultural identity.

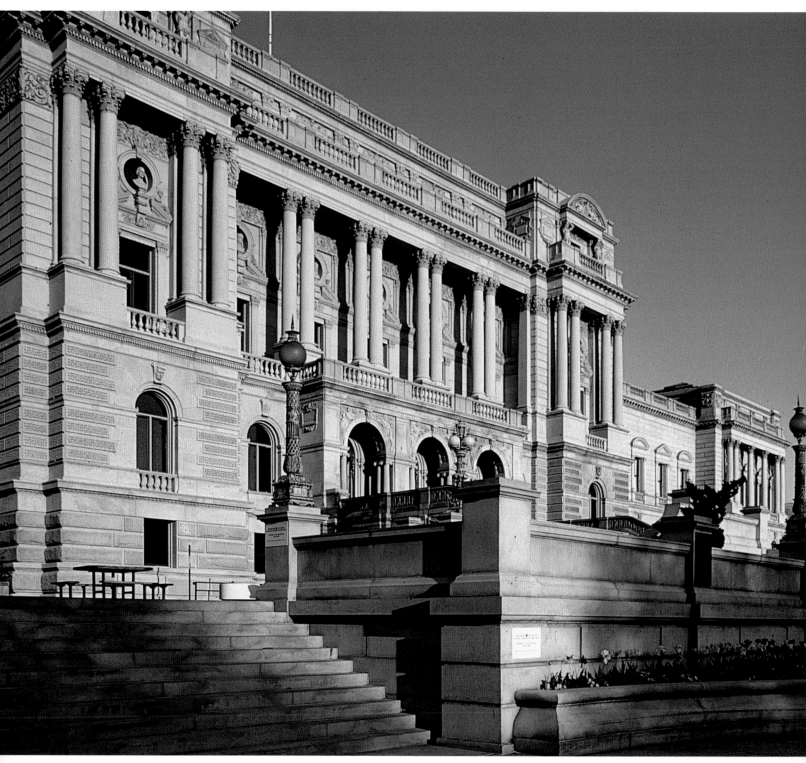

Standing in front of the Capitol is the massive structure of one of the most important temples dedicated to human culture and knowledge. The Library of Congress was established in 1800 to acquire, catalog and conserve all those books that might be necessary to the drafting of legislation by the Congress of the United States. To call it a library is to do it an injustice: this institution alone accounts for 15% of the $1 billion annual budget allocated to the running of Congress. It contains over 100 million articles in three buildings, starting with the original Thomas Jefferson Building, then followed by the James Madison Memorial and the John Adams Building. Between them, these three hold 17 million books, 48 million manuscripts, 13 million prints and photographs, 2 million audio supports and over 700,000 film recordings, plus a huge number of letters, maps, documents, musical scores and even a collection of musical instruments. It is striking just looking at the octagonal main reading room, with its simple but magnificent mahogany desks arranged in a circle around the central distribution outlet, the focal point of a compass that seems to embrace the whole of human knowledge. Or almost.

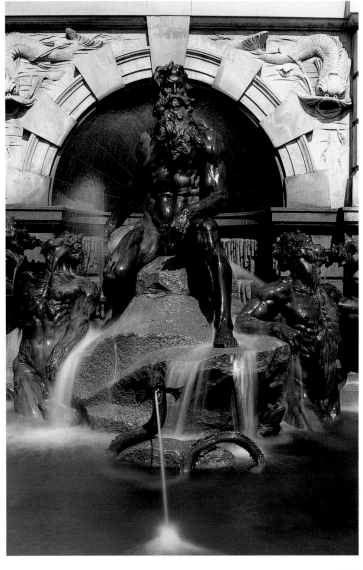

83 The Court of Neptune was sculpted by Roland Hinton Perry and completed in 1898. The monumental work stands in the west façade of the Library of Congress. The imperious Baroque Neptune stands over 10 feet tall and is surrounded by ranks of tritons, nymphs on horseback and sea-snakes.

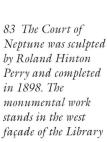

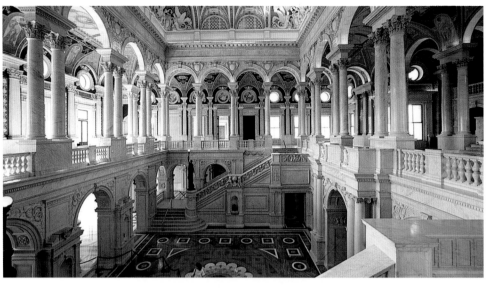

84 and 84-85 The Great Hall in the Thomas Jefferson Building is the heart of the Library of Congress. It was opened in 1800 with a collection of reference texts for consultation. Today it includes a copy of nearly all the books published in the United States.

85 top The octagonal Reading Room in the Library of Congress has a ring of plain mahogany desks around the distribution desk.

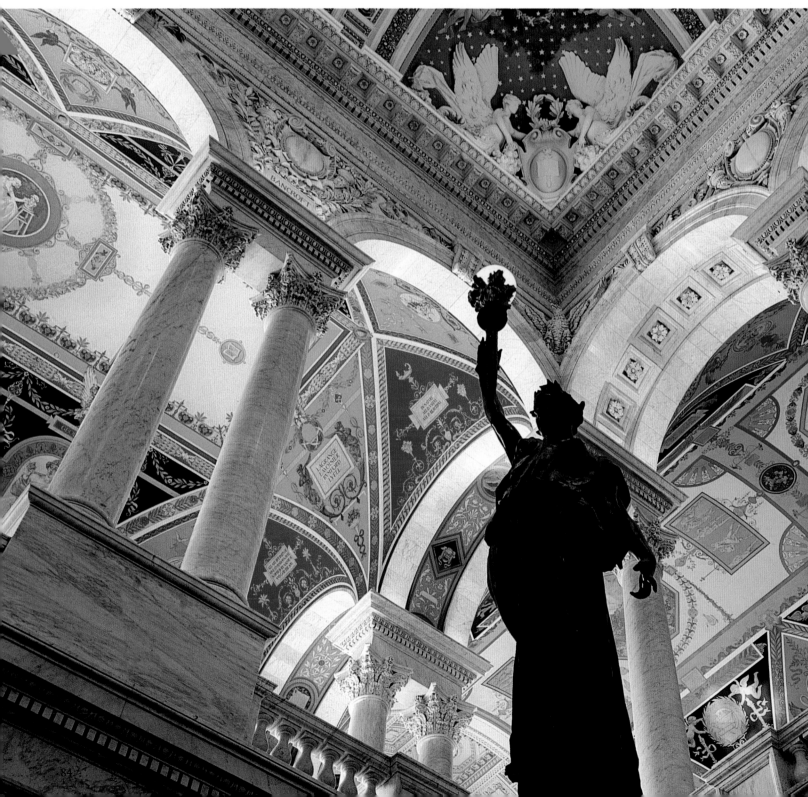

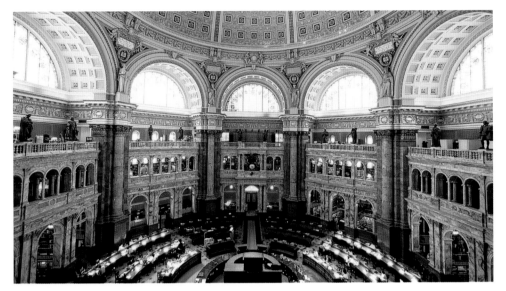

Since spring 1977, the Great Hall in the Thomas Jefferson Building has been where a series of unique items from the heritage of the Library are exhibited: the American Treasures of the Library of Congress. These gems from the material history of the United States include the original draft of the Declaration of Independence handwritten by Thomas Jefferson (with corrections in the margin by Benjamin Franklin and John Adams), the telegram sent by Wilbur Wright to his father to announce the success of the first flight of an object heavier than air, and, with that pinch of sensationalism that American society always enjoys, the contents of Abraham Lincoln's pockets on the evening he was shot.

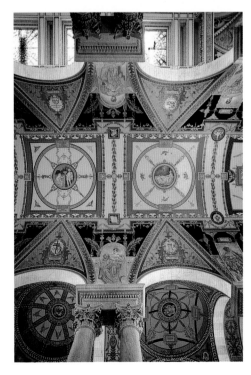

86-87 The Main Reading Room is one of the most important study and research centers in the world. As can be easily imagined, keeping this immense collection up to date and accessible is a complex and costly task. So that Representatives, Senators, officers, students, researchers and the public can read, see or listen to 17 million books, 48 million manuscripts, 13 million prints and photographs, 2 million sound recordings and over 700,000 visual records available, not to mention letters, maps, documents, music scores etc., the Library receives 15% of the $1 billion annual budget for support of the Congress.

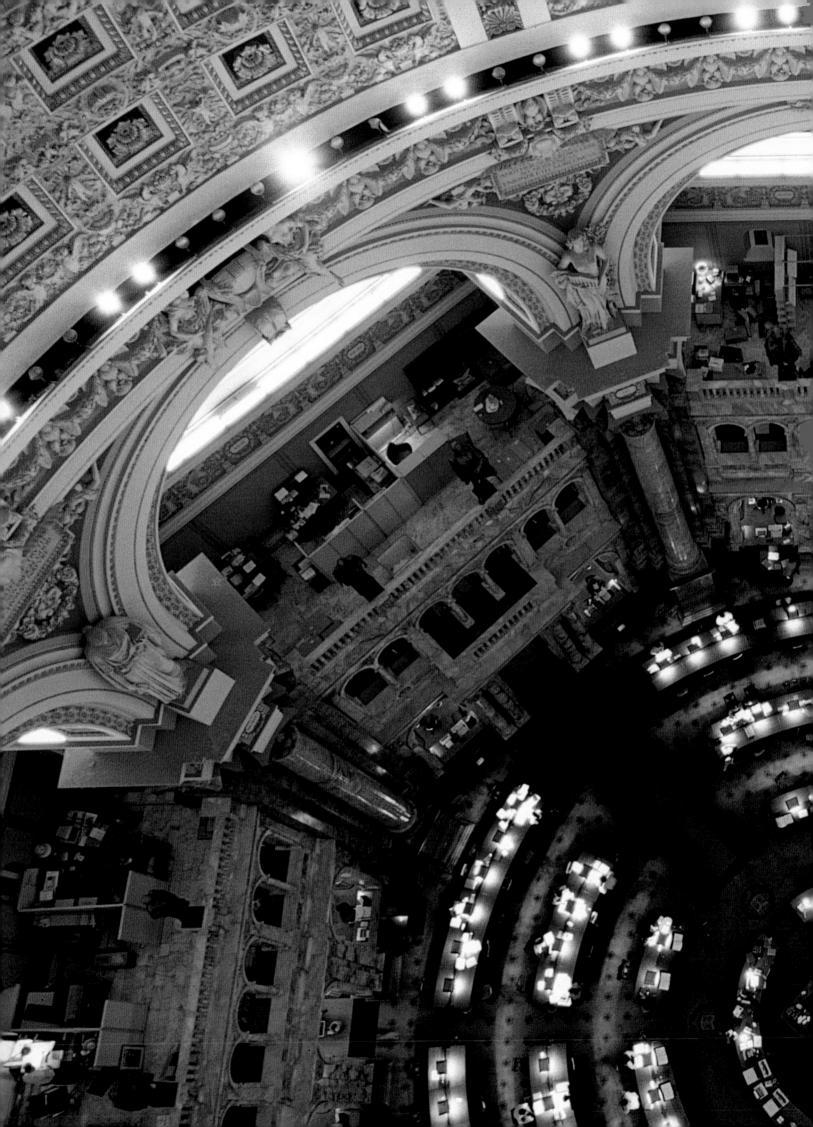

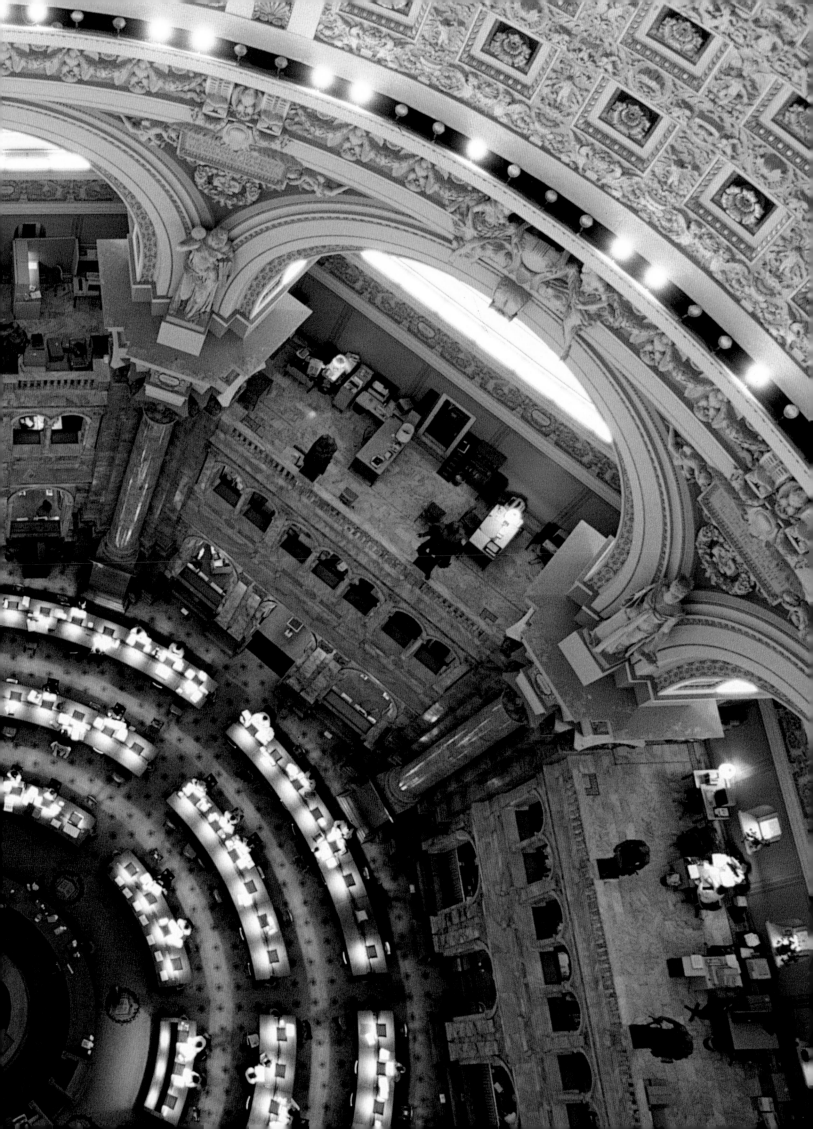

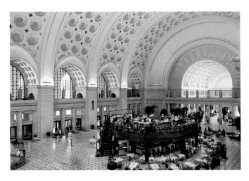

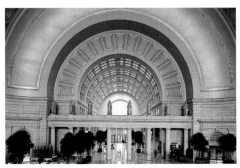

At first, the visitor may be left a little confused, and justly so. I mean to say, a railway station modeled on the Arch of Constantine and Diocletian's Baths! However, it is important not to fall into the trap of making judgments based on current thinking. Union Station, to the north of the Capitol on the axis of Delaware Avenue, was built between 1903 and 1908 on the basis of the designs by Daniel Burnham, the architect who was involved in the McMillan Commission. His instructions for the beautification of Washington – "Do not think in terms of small projects. They do not have the magic to spark the imagination of man" – were followed to the letter. Union Station was one of the Commission's "big plans" and was built to celebrate America's passion for travel, movement, adventure and the unending search for new spaces, whether geographic, cultural or psychic. This is a typically Western restlessness of the soul which found, and finds, its epic and modern *chanson de geste* in the Far West. Considered in this way, the re-dundant Baroque allegory is no longer surprising even if its forced cerebralism is evident. As, for example, in the sculptures by Saint-Gaudens (the son of another member of the McMillan Commission) that adorn the Ionic columns of the portico, and where Prometheus (the guardian divinity of fire), Archimedes (the father of mechanics) and Thales (the precursor of modern electric energy), together with other abstract figurations (Liberty, Imagination and Agriculture), clear the way for the progress of the American railway industry.

When it was built, Union Station was the largest railway station in the world, and it was used as a symbol of that new and ultra-modern Age of the Train that contributed decisively to the economic development, and shaped the principal cultural character, of the United States. The railways – that disrupted the long-established migration routes of the buffalo and the hunting grounds of the tribes of the Great Plains – were one of the main causes of the long and tragic Indian wars. Burnham's station is part of a logical and temporal continuation that includes the futuristic Dulles International Airport, designed in 1962 by Eero Saarinen to mark the transition from the cumbersome locomotive to the commercial jet airliner.

With the decline in rail travel and transportation, Union Station too began to enter an unstoppable period of decline until, in 1981, after a section of the roof fell down caused by the infiltration of water, the station was closed to the public. But in that same year, Congress passed a law to return one of Washington's best-loved and significant symbols to its original splendor. After a vigorous and expensive restoration (it cost $150 million in all), Union Station reopened its doors in 1988. Today it is a magnet to the young, especially on the long afternoons of the weekend. There is a nine-screen cinema, over one hundred shops, restaurants, video-game parlors and fast-food outlets, all in a three-floor shopping mall as up-to-date as can be. Prometheus, Archimedes, Thales and Burnham look on in silence. *Sic transit gloria mundi...*

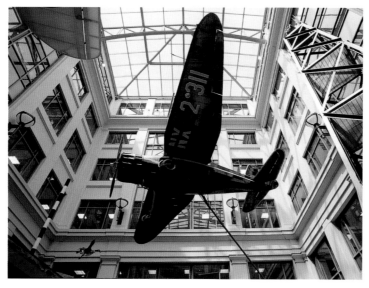

90 top and bottom left Several mail aeroplanes hang from the ceiling in the National Postal Museum, part of the Smithsonian Institution. The museum contains the largest stamp and postal collections dedicated to the USA, with over 16 million items from 1673 to the present day.

Before leaving Capitol Hill, there is one other stop to be made. Next to Union Station, at 2 Massachusetts Avenue, another offshoot of the Smithsonian is the National Postal Museum, a center that attracts even those not addicted to stamp collecting. Here you will find displayed the philatelic and postal collection of the United States, begun in 1673 and consisting of over 16 million items which, just for a change, form the largest and most important collection of its kind. One of the most striking sections is the central gallery where three aeroplanes used in the postal service of the early twentieth century are suspended from the ceiling, 98 feet up. At the time it was almost a science fiction replacement for carrier pigeons, and a reckless, dangerous profession that, not unexpectedly, attracted men who were to make flight and adventure a symbol of courage and progress. Two names in particular stand out, one on either side of the Atlantic: Charles Lindbergh and Antoine de Saint-Exupéry. The winged postal couriers took the place of another postal legend in the hearts of the American public, the Pony Express. This landbound service in fact only lasted a few months as it was quickly replaced by the first transcontinental railway, but the adventure of those young cowboys who galloped from station to station, changing to fresh horses in order to take the post to the outposts of the Far West, entered the American legend. Here too, thanks to extraordinary figures – both good and bad – such as Buffalo Bill. Postal videogames and nickelodeons (the precursors of the cinematograph that cost a nickel to operate) that show short,

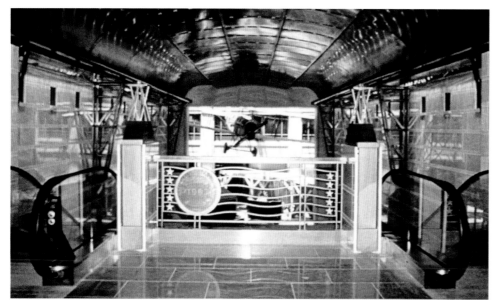

90 bottom right The National Postal Museum also contains the first federal American stamp, the 5 cent Franklin, plus objects dating from the Pony Express. though an American legend, the Pony Express lasted only a few months before being replaced by the first transcontinental railway.

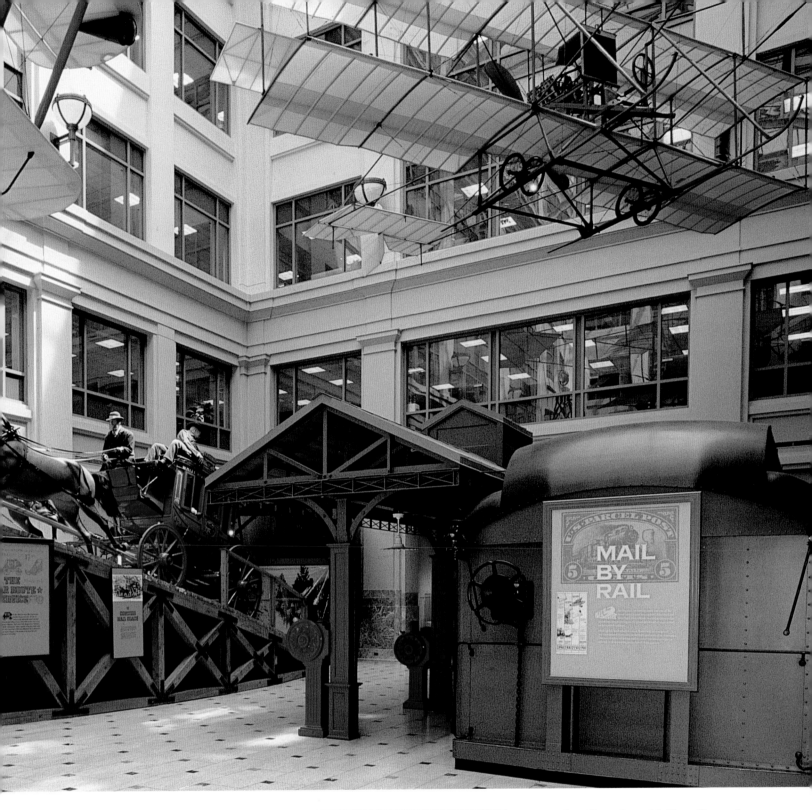

rudimentary films of spectacular railway incidents or the ever-appreciated hold-ups of trains carrying valuable cargoes in the Wild West. In addition, the colorful collections of stamps dedicated to every kind of event make this small, packed museum a really worthwhile attraction.

90-91 The ceiling of the central gallery in the National Postal Museum also displays three aircraft from the early twentieth century used in the postal service. The risky method of delivering the post (instead of using carrier pigeons) attracted men like Charles Lindbergh and Antoine de Saint-Exupéry, who made flying a symbol of courage and progress.

91 Short films and stamps that have made history, like this one, dedicated to Pocahontas, the Indian princess who saved the British colony of Jamestown at the start of the seventeenth century, make this museum well worth a visit.

THE WHITE HOUSE

92-93 and 93 The White House is the official home of the President of the United States of America. The building was designed by James Hoban, a self-taught architect originally from Ireland whose design beat those of his 52 competitors. The building was roundly criticized by Benjamin Latrobe, a highly rated American professional who nastily described Hoban's work as the mutilated copy of a poorly designed building near Dublin. In fact, experts agree that the White House closely resembles the home of the Duke of Leinster in Dublin.

92 top A view of Lafayette Square, a small and attractive park in front of the White House with a statue of General Andrew Jackson. Erected in 1853 in the centre of the park, this was the first American equestrian monument. The square was originally an open air market and a military camp; it got its modern name in 1824 when Marquis Marie-Joseph Motier de Layfayette (1757-1834), a hero of the American Revolutionary War, visited Washington. Today the park is used as a site for demonstrations against the policies of the various incumbents of the White House, and as an outdoor dormitory for the homeless.

92 bottom An attractive view of the White House in the snow of a cold Washington winter.

The residence of the Executive, the presidential palace, the home of the President and the oldest building in Washington. It was the priority of architects and builders as soon as construction of the capital was got under way and it has had a series of names but, as a result of the fate that mocks man's best aspirations and desires, it was to become known to the world by the name given to it following a catastrophic event. Torn apart by the English fire of 1814, it was referred to as the "White House after generous coats of plaster and white paint to cover the black wounds produced by the perfidious Albion."

What most strikes the visitor who enters the doorway of 1600 Pennsyl-

vania Avenue NW, is the impression of a patrician and relaxed rusticity. This is certainly not a surprise. The round-the-clock journalists who stand in front of its doorway have made the official residence of the President of the United States and his family internationally known. Nonetheless, the White House is surprising for its air of an Irish country house, and its tangibly casual, country atmosphere. It is a little like the Sphinx of Giza which, who knows why, always seems larger than it actually is.

However, the building has not always been liked by everyone. The design was by James Hoban, a self-taught Irishman whose project won out over those of 52 competitors, including one by Thomas Jefferson, who had the good manners to present his under a pseudonym. Hoban won the respect of Washington but the undying professional envy of Benjamin Latrobe.

This latter American architect was audacious enough to declare in 1806, uncaring of the anger caused or his possible commitment of *lèse majesté*, "George Washington certainly knew how to give his country freedom but he was absolutely ignorant in the question of art. So no-one should be surprised if the project chosen for the President's residence was the plan of a carpenter that is not even original, being a mutilated copy of a poorly designed house in the area around Dublin."

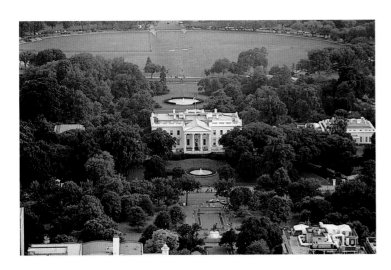
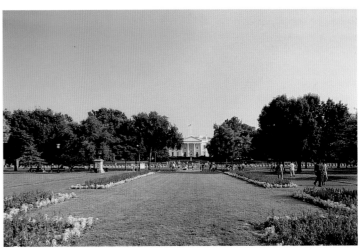
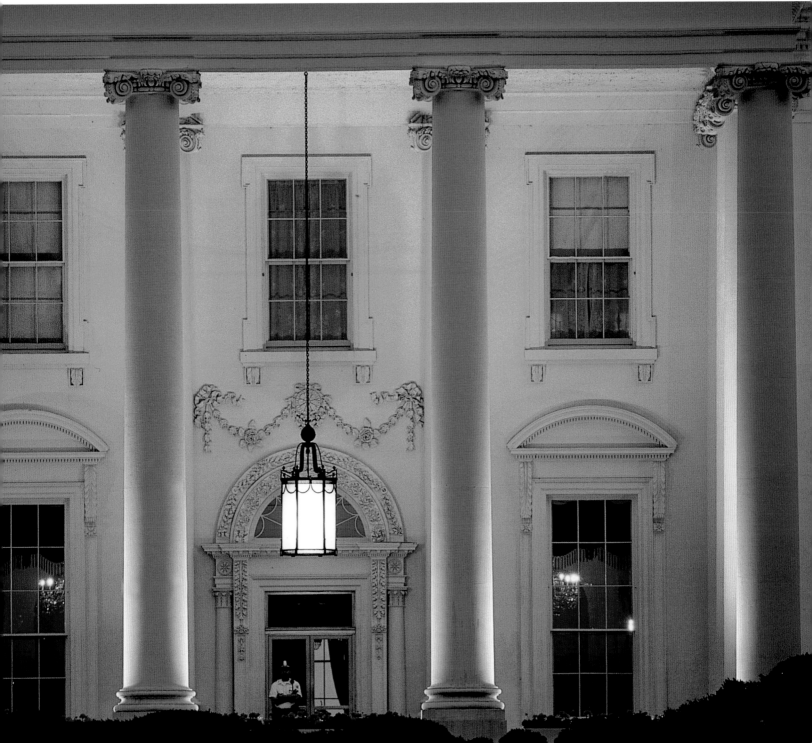

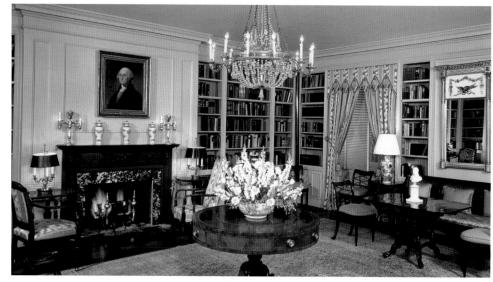

94 top The interiors of the White House are not exceptionally magnificent though they maintain a simple elegance. The building has always required a great deal of maintenance, and the Truman family were forced to move elsewhere while rebuilding work went on from 1949-1952.

94-95 The Blue Room is one of the best known in the White House. What strikes the first-time visitor to 1600 Pennsylvania Avenue is the relaxed rusticity of the building, far removed from the pomp and luxury of its European equivalents.

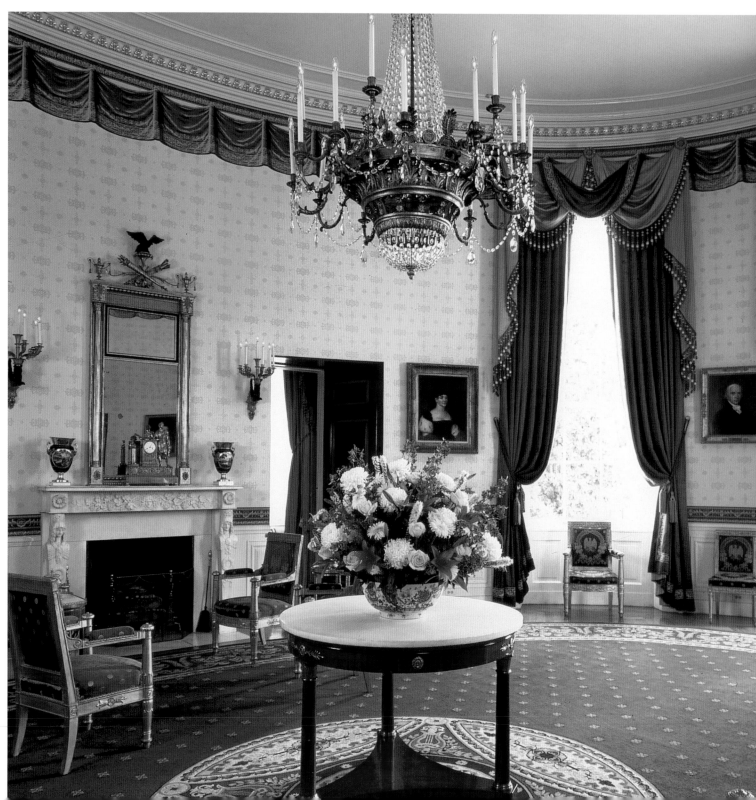

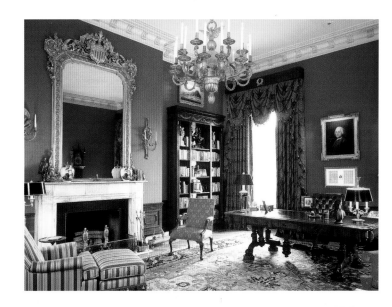

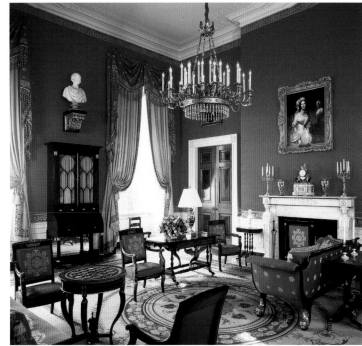

During one of his regular conversations around the fireplace, Franklin D. Roosevelt said, with his mixture of populist charm and upper-class accent that was irresistible to the American public in the 1930s and 40s, "I never forget that I live in a house that belongs to the whole of the American people." Ownership aside, often the tenants of the American people's house have made it a point of honor to leave an indelible mark of their passing but, naturally, always at the expense of the owner. Thus Jefferson, once he had crossed the threshold, and with the help of the bilious Latrobe, took the satisfaction of adding the east and west terraces in the original design that had been rejected by the examining commission presided over by Washington. Artistic improvement or acts of private interest? The precedent had been made and it was followed by a tide of similar actions. John Quincy Adams overhauled the gardens, Andrew Jackson installed running water, Franklin Pierce central heating, Rutherford Hayes the first telephone, James Garfield the elevator, Benjamin Harris electric light, and Herbert Hoover air conditioning. From this moment on, the only "improvements" were for personal gratification: FDR had a swimming pool built for the only physical exercise allowed him following paralysis of the legs from polio, Harry Truman added a much-debated arcade on the second floor on the south

side, and, in 1961, Jacqueline Kennedy, with the help of a Fine Arts committee she had established herself, overhauled the interior, the garden and the entire atmosphere of the White House. She had a grace and glamor that was unusual for the presidential residence, accustomed as it was to the plump, matronly First Ladies of earlier years. Her sophistication had been learned on the banks of the Seine, and her natural elegance, white gloves, deliberately simple clothes, and single string of pearls were one of the characteristics of the brief season of the New Frontier. It can be said with bipartisan objectivity that, since then, no-one has equaled her style. The first George Bush, more modestly, had a

95 The Treaty Room and the Red Room are in the White House wing that is open to the public. Tours are only held in the morning, from Tuesday to Saturday. Tickets (free and valid only for the day of issue) are available from the White House Visitor Center in the Department of Commerce at 1450 Pennsylvania Avenue. The Visitor Center is also a miniature museum that offers information to visitors and shows an interesting introductory video to the White House.

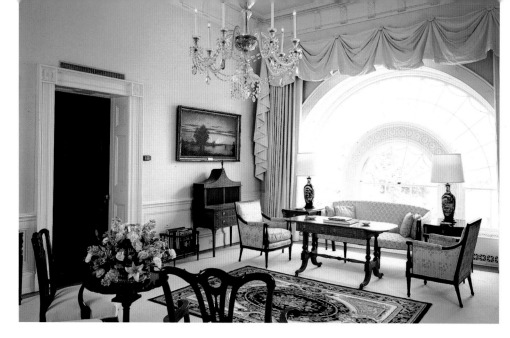

96 top The East
Sitting Room is a
pleasant drawing
room in the East
Wing that has a large
window. As soon as
building work began
in the capital, the
home of the President
became the most
urgent priority. As a
result, it is
Washington's oldest
building.

96-97 The yellow and
white Center Hall is
used as an
antechamber by guests
and foreign
dignitaries waiting to
be received in the
Yellow Oval Room.

96 bottom left One of
the most famous rooms
in the President's home
is the Lincoln
Bedroom, where Bill
Clinton used to receive
his closest friends: these
included many
Hollywood stars, such
as Kevin Costner, Kim
Basinger and Candice
Bergen.

96 bottom right
Meetings between the
President, the Secretary
of State and the other
highest officials in the
American executive
have been held in the
Cabinet Room in the
West Wing since 1902.
This is also the room
where sessions of the
National Security
Council are held.
The large oval table is
watched over by the
fathers of the nation,
George Washington
and Benjamin
Franklin.

horseshoe throwing ring laid out while Bill Clinton installed a jogging track. George Bush II, for the moment, has not made any proposal.

An important function is performed in the shadow of the White House and the Capitol, important to both Washington and its citizens: it concerns home rule, which, just in its name, conjures up the idea of a colonial past, of a struggle for anti-imperial independence, with more than a dash of hyperbole to kindle the spirit, to simplify problems and to make finding a solution more difficult. The fact is that Washington D.C. is not a city, nor is it a state; it is a hybrid institution, neither fish nor fowl. The situation is one that can easily irritate the citizens of a district subject to a great deal of stress. No taxation without representation, thunders the American constitution, but the electors in the capital are able to vote only to elect a President (since 1964), not a legislature, for which their delegate has no voting right. Quite simply, Washington is

under the protection of the Capitol and it is Congress that decides the budget. 'D.C.' is a sort of Indian reservation, the residents murmur with a bitter smile, generously mixing the above hyperbole with reality. But, they say in the Capitol, the administrative past of a city that is the capital and the legislative, judicial and executive centre of the United States is anything but clear, from the problematic exploits of Alexander "Boss" Shepherd in the 1870s to those of former Mayor Marion Barry more recently.

As always happens, besides the petitions of principle of the political world, things are also made complicated on purely party lines. Other factors contribute to oppose the promotion of the District to the rank of a state. The city traditionally votes for the Democrats and, on these grounds, a further two senators for the left could upset the established balance. Home rule or no home rule? That is the question.

In the meantime, Washington is

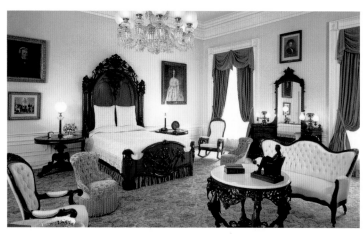

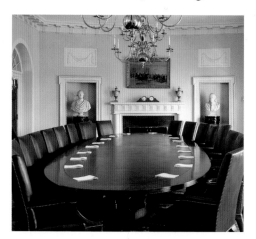

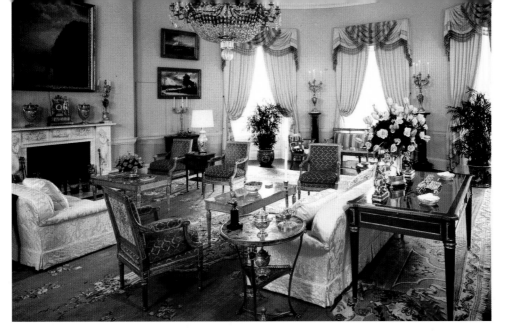

97 top The Yellow Oval Room has been a sort of audience room since 1801. The dominant color of the curtains, fabrics and furnishings has given the room its name. The style is Louis XVI, which was adopted during the last restoration in the Kennedy era.

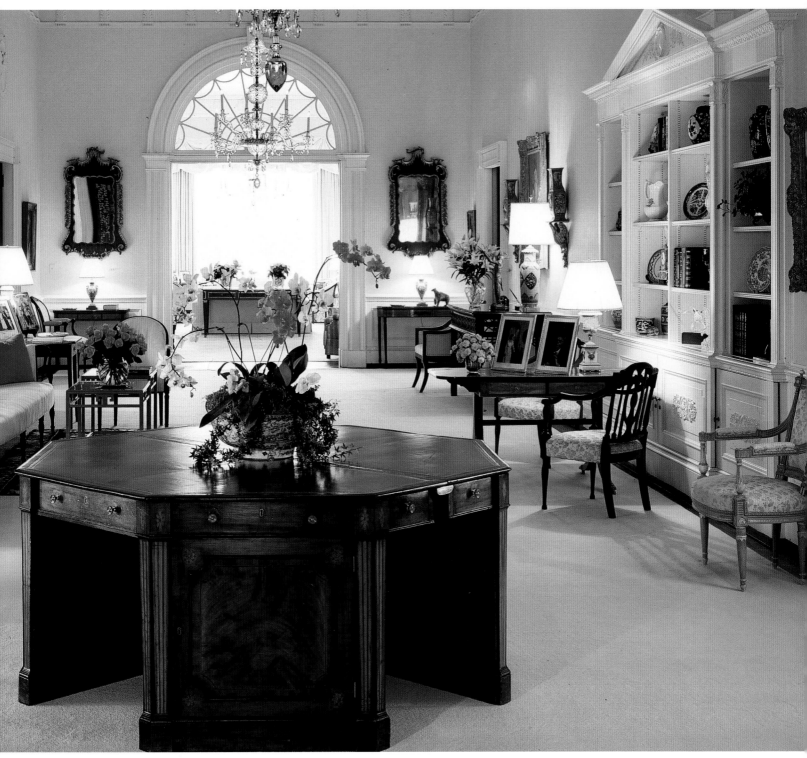

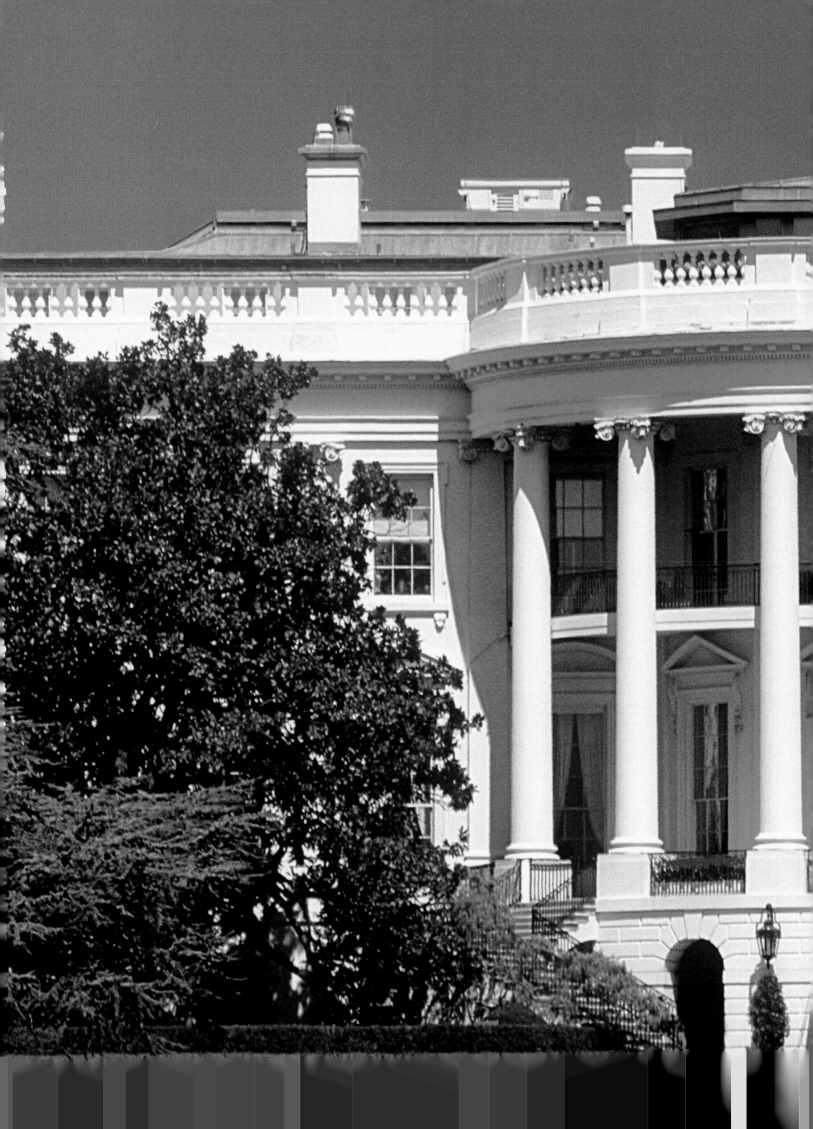

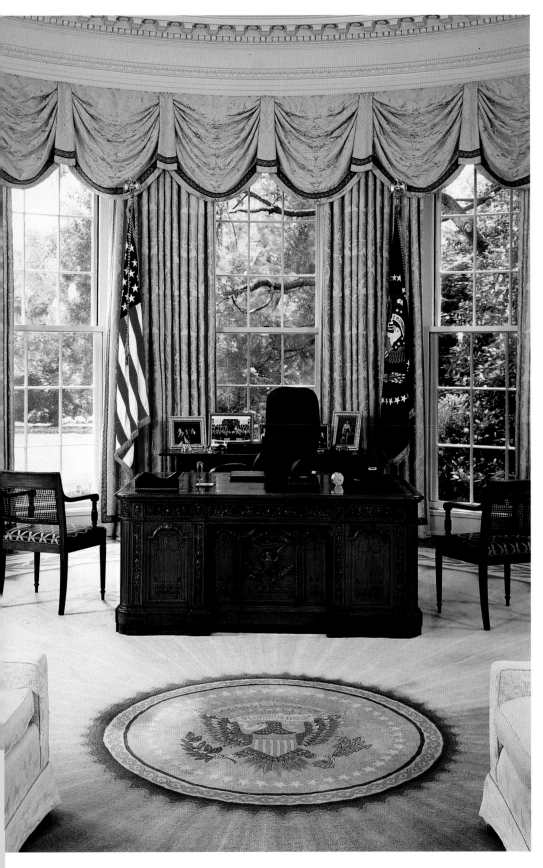

always in the top ranks of the American cities with the best quality of life, despite a record-breaking crime rate and an administration under guardianship that has difficulty in overcoming the administrative and logistical problems typical of all major cities, even when it is not obliged to deal with problems directly related to its status and the burdens of a capital at the center of the pressures of the modern world. For example, the closure to traffic of Pennsylvania Avenue since 1995 as far as the White House for fear of a terrorist attack. Is this yet another contradiction, another sociological headache without a solution? Not really. A glance at the statistics that describe the quality of life – work, climate, environmental setting, arts, recreational activities, public areas, transportation system etc. – quickly reveals that Washington, D.C. deserves its placing near the top of the tree, home rule or not.

98 The Oval Office is the workroom of the President of the United States and the ultimate 'power room.' This room is the setting for the decisions that shape the history of the country and the world.

99-102 A view of the façade of the White House. Burned down in 1814, the home of the U.S. President was reborn as the White House after thick coats of plaster and white paint were applied to hide the black marks left by the blaze begun by the British army.

103 The Entrance Hall of the White House is decorated with the seal of the President of the United States, a symbol of almost absolute power. The opportunity to visit the interior of the building stresses the image of politics in the United States, that of an institution transparent to one and all.

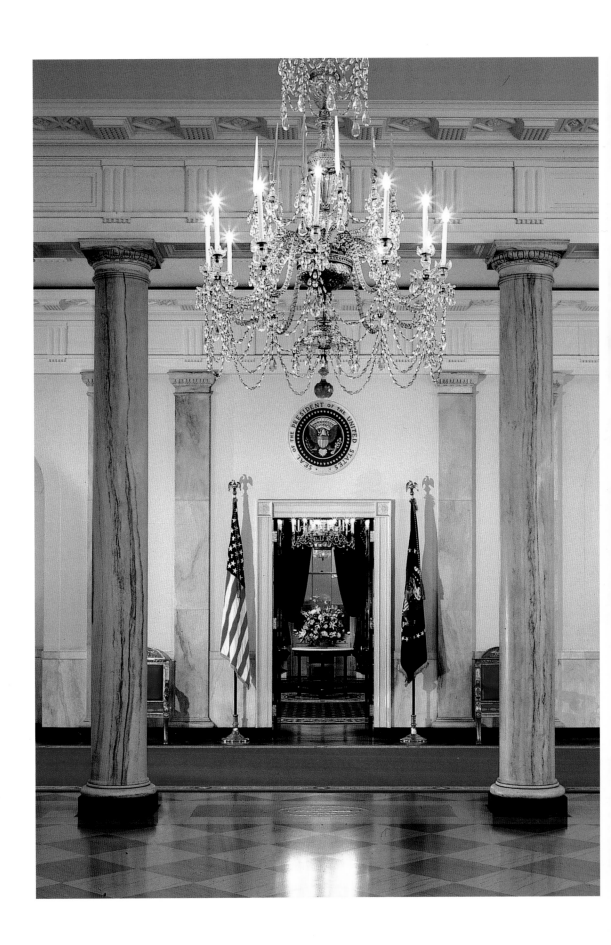

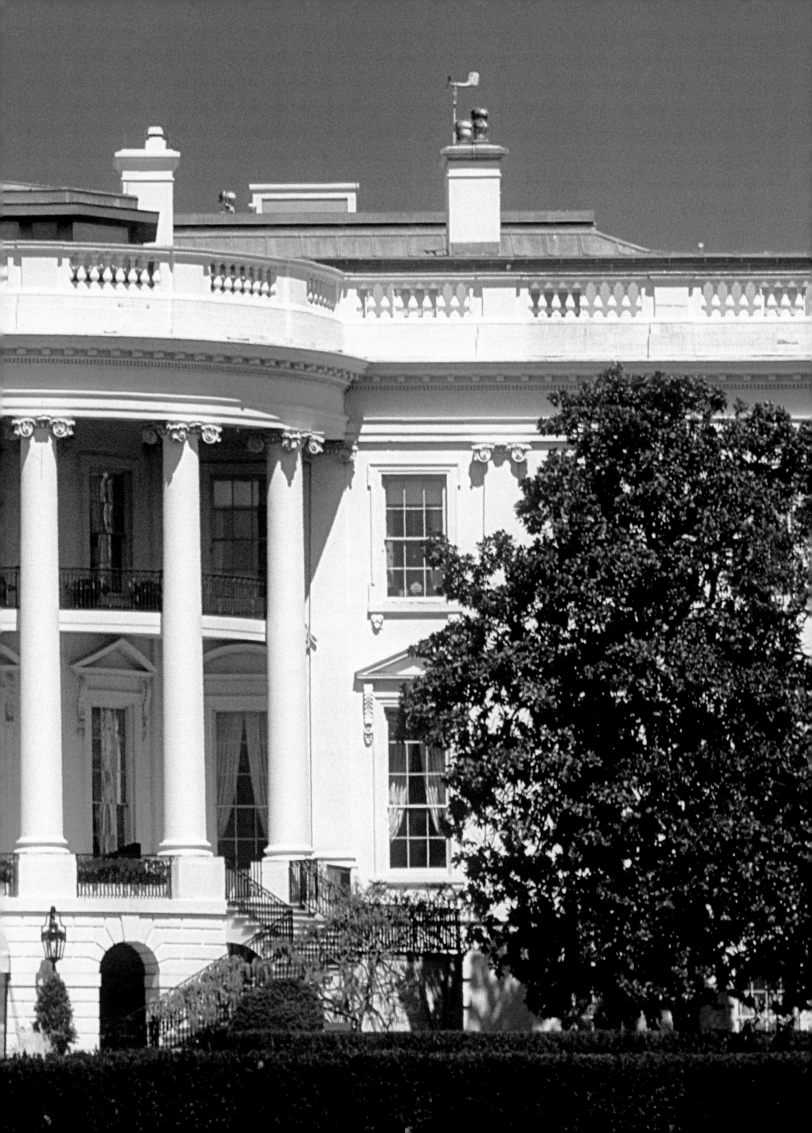

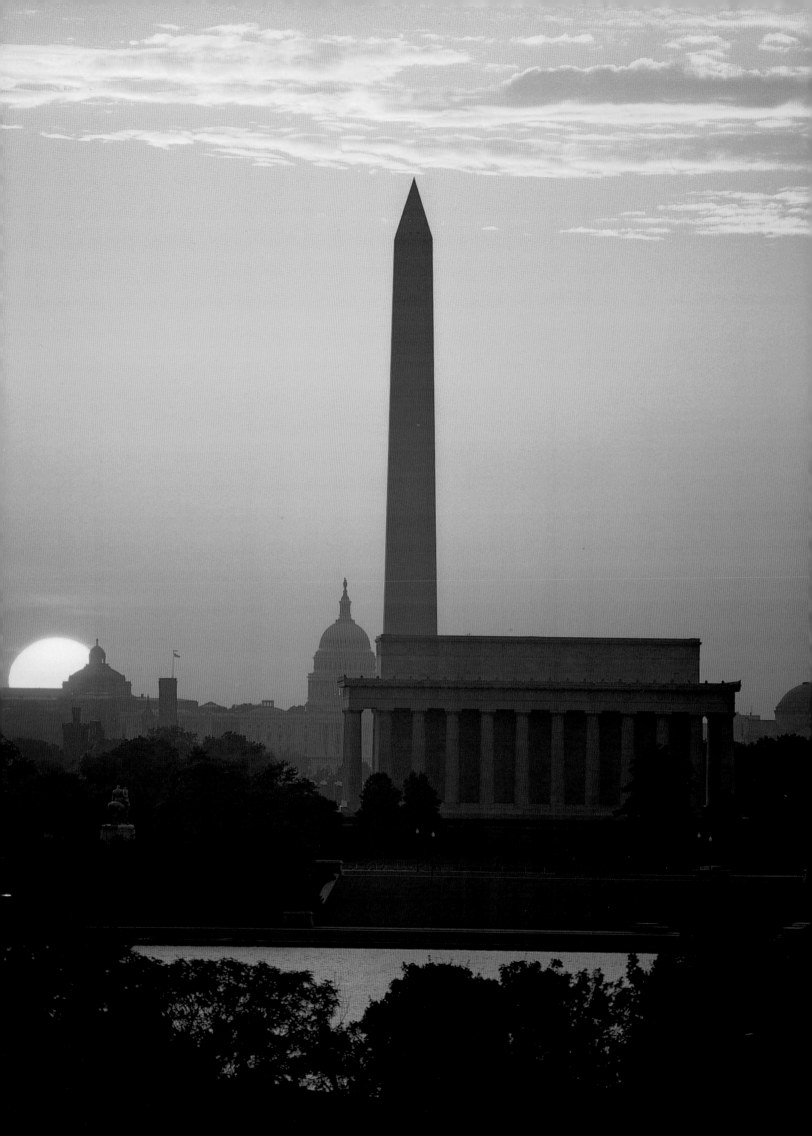

Washington has been the setting for a great deal of historical events, perhaps the most important of the modern age. The various phases of history are alluded to by the names of the tenants of 1600 Pennsylvania Avenue, some of whom, in fact, never seem to have gone away. Since the end of the 1930s, it has been rumored that the ghost of Abraham Lincoln is still present in his old study in the White House. Even such stalwarts as Eleanor Roosevelt and Harry Truman claimed it to be true. Perhaps it is to provide some relief to these unquiet souls that Washington teems with monuments to its best-loved presidents.

Almost perfectly aligned with the White House is the Washington Monument. Like all memorials in the capital, it is a cenotaph, i.e., a funerary monument that does not contain the mortal remains of the hero being celebrated. With the Capitol and the White House, this is the third of the three focal points of the city, and its 1830 square feet represent to Washington what St. Peter's in Rome, the Eiffel Tower in Paris, or Big Ben in London mean to their respective nations. L'Enfant's idea was to set it on the exact intersection of the western axis of the Capitol and the southern axis of the White House to attest to the sacrosanct nature of the topography of the federal capital. Unfortunately that exact site was not suitable for the construction of such an imposing monument, due to the bogginess of the terrain, and the memorial had to be shifted by a few dozen miles – or so the story goes. Scholars, however, suggest other reasons, which are just as interesting but have more character.

Whatever the reason, the Washington Monument has an unmistakable Egyptian, and vaguely incongruous, silhouette of a tapered marble-lined obelisk. The blocks it is built from are 15 feet thick at the base and only 18 inches at the top and over one million visitors a year take the lift to the top for an all-round view of the city. Construction of the monument was neither easy nor quickly carried out. The funds set aside for its construction soon ran out and, in 1848, Mark Twain ridiculed the squalid, 131 feet tall stump as the remnant of a broken industrial chimney. Thanks to the action of President Grant, new funds were found in 1876 and completion of the monument was entrusted to the Engineering Corps of the army. Tackling the problem with a typically military mentality, nothing was left to chance, and the American ambassador in Rome inquired about the classical proportions of all bona fide obelisks: the height should be ten times the width of the base, and the small pyramid at the top – the pyramidion – should have sides angled at 60°. By 1888 the monument was ready to be opened to the public, and it was immediately greeted as a huge success.

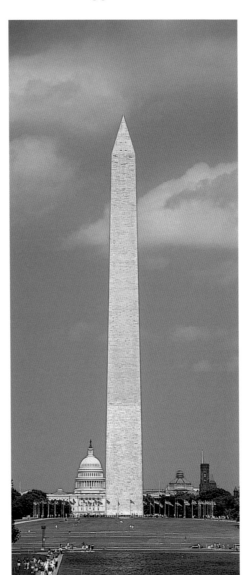

106 left A postcard of Washington: the Tidal Basin, the Jefferson Memorial and the cherry trees in flower.

The first cherry trees were brought from Japan during the Taft presidency (1909-1913) but the

Department of Agriculture ordered their destruction when it was confirmed they were infested with parasites.

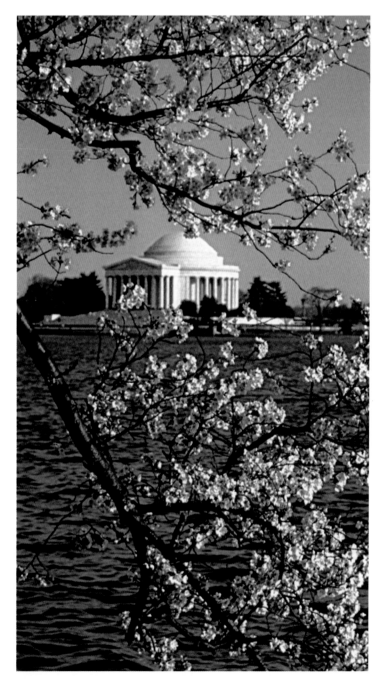

To the south of the monument, on the other side of the Tidal Basin, the Jefferson Memorial is dedicated to the main drafter of the Declaration of Independence and third President of the United States, who was also a political genius and an eclectic scholar like no other. Standing on the reclaimed soil of the Potomac marshes, the monument was modelled on the Parthenon in Rome, the sacred building of the civilisation that was so dear to the heart of Jefferson. Today, his monument is one of the favourites of the city's inhabitants. Franklin D. Roosevelt, whose conscience was certainly not as enlightened environmentally as ours today, had all the trees between the Memorial and the White House uprooted so he could draw inspiration from it each day. In spring, the setting around the Tidal Basin and Jefferson's Neo-Classical monument, framed by cherry blossom, is one of the most photographed in the capital.

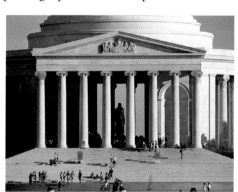

106 right The design of the steps and the pediment of the Jefferson Memorial indicate the desire to

build a monument modeled on the Pantheon in Rome, a temple built over 2000 years ago.

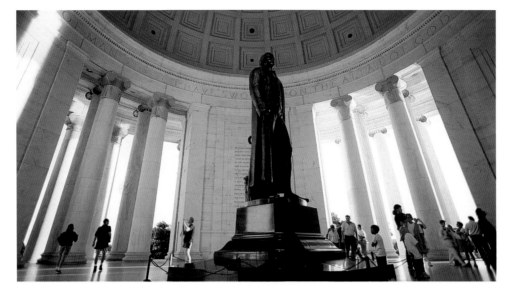

107 A 20-feet tall statue by Rudolph Evans of the author of the Declaration of Independence stands inside the Jefferson Memorial. Jefferson is shown wearing the fur-trimmed overcoat given to him by the Polish general, Kosciuszko, who was a hero of the war against the British.

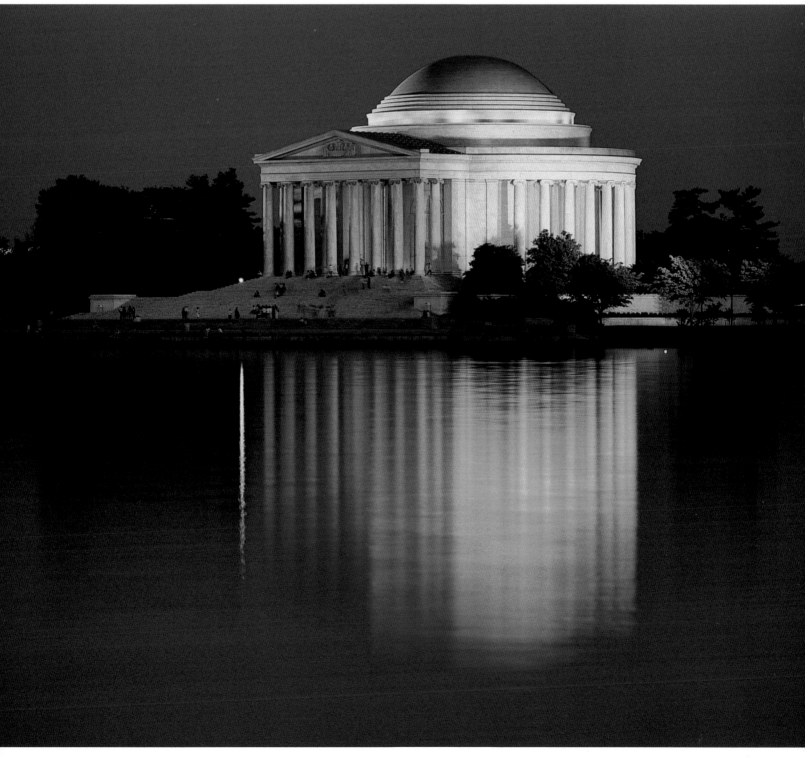

108 left The Franklin Delano Roosevelt Memorial is an open-air monument dedicated to the only person elected four times to the nation's highest office. Granite walls, trees, waterfalls, fountains and a series of bronze sculptures commemorate events from his terms of office between 1933 and 1945.

108-109 One of the statues that commemorate FDR, here with his dog Fala. Associations of persons with physical disabilities have criticized the President for never appearing in the wheelchair which he began using after a bout of polio at the age of 39.

In May 1997, Clinton inaugurated another monument in West Potomac Park in memory of one of America's most famous Presidents. The Franklin Delano Roosevelt Memorial was erected on a site that had been chosen with unusual foresight in 1901 by the McMillan Commission, which, at the time, of course had no idea to which illustrious American citizen a cenotaph might be raised on the spot. The FDR Memorial consists of a park with trees and a granite wall, waterfalls, fountains and a series of bronze sculptures that celebrate the most important events during his long presidency from 1933-1945, an unequaled record comprising four successive election wins. It is still too early to say whether this memorial will be taken quite as much to the hearts and minds of Washington's inhabitants and visitors as the Lincoln Memorial which receives six million visitors a year.

108 right Four 'open air rooms' in the Franklin Delano Roosevelt Memorial are dedicated to FDR's various presidential mandates – from the Depression to World War II – which are illustrated by ten bronze statues.

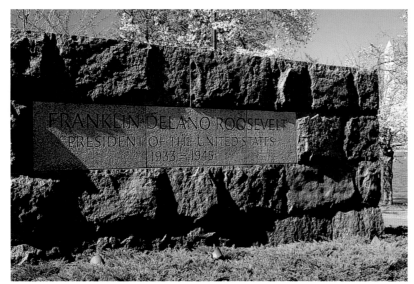

109 FDR is still one of America's best loved and most criticized Presidents. His supporters remember the vigorous policies he implemented to combat the Depression, while his detractors claim that unemployment levels remained extremely high right up to World War II.

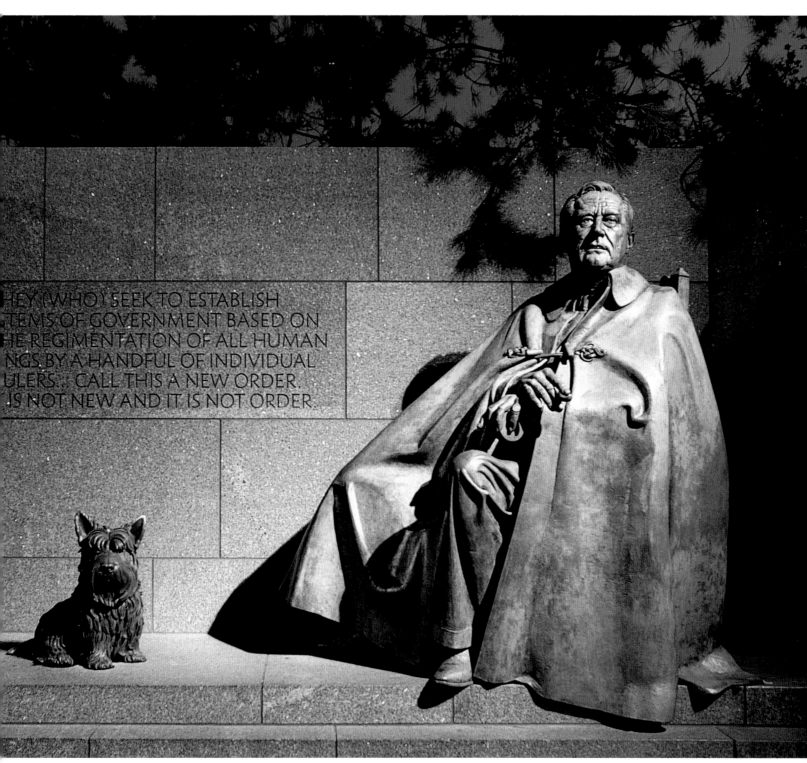

HEY (WHO) SEEK TO ESTABLISH
TEMS OF GOVERNMENT BASED ON
HE REGIMENTATION OF ALL HUMAN
NGS BY A HANDFUL OF INDIVIDUAL
ULERS . . CALL THIS A NEW ORDER.
IS NOT NEW AND IT IS NOT ORDER.

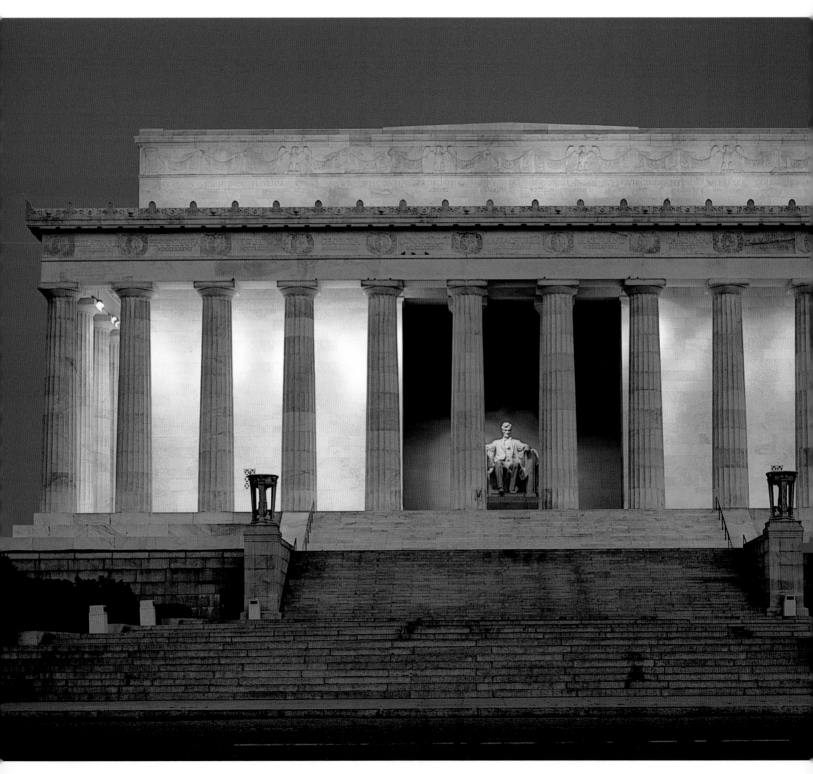

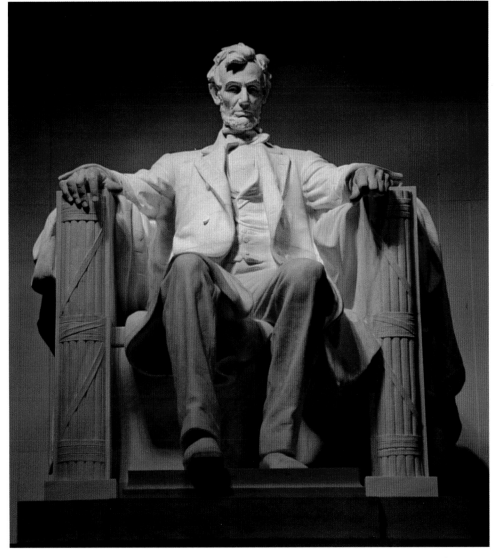

110-111 *The Lincoln Memorial is built in the form of a Neo-Classical temple similar to the Parthenon. The 36 Doric columns symbolise the 36 states of the Union at the time of the death of Honest Abe. The Union was an ideal for which he lost his life.*

111 *The statue of Lincoln in the Lincoln Memorial is by Daniel French. The abolitionist and strenuous defender of the Union is portrayed like a Roman general, sitting on a throne that has arms decorated with the fasces, symbols of political power. He is marked by an air of controlled tension as seen in the position of his hands.*

Such a large number is one of the reasons for visiting it in the evening, when the hordes of noisy sightseers have turned their attention to the cold buffets on offer in the hotels. The Lincoln Memorial has entered the American collective conscious as a historical and emotional milestone. It can be seen on the back of the five dollar note where the portrait of a frowning Lincoln by Daniel Chester French is also given. The marble statue is second in fame, affection and sentimental impact only to the Statue of Liberty in New York.

At 19 feet in height, it took thirteen years of work. The President is shown seated, in deep thought, in the central chamber of the Memorial gazing out towards the Washington Memorial and the Capitol. Seated on a throne with the arms decorated by two Roman fasces the President emanates an air of controlled tension and ready strength; this effect is reinforced by the pose of the hands, of which the left is relaxed but the right is clenched, filled with an energy almost ready to explode. The area at the base of the memorial has often been chosen for important gatherings, in order to reflect the message the President gives out. Representative of all such meetings is the one held on 28 August 1963 when Martin Luther King spoke to over 200,000 people, mostly black americans, at a peaceful demonstration, and where he gave one of his most famous and passionate speeches in his rich, vibrant baritone voice: "I have a dream . . ."

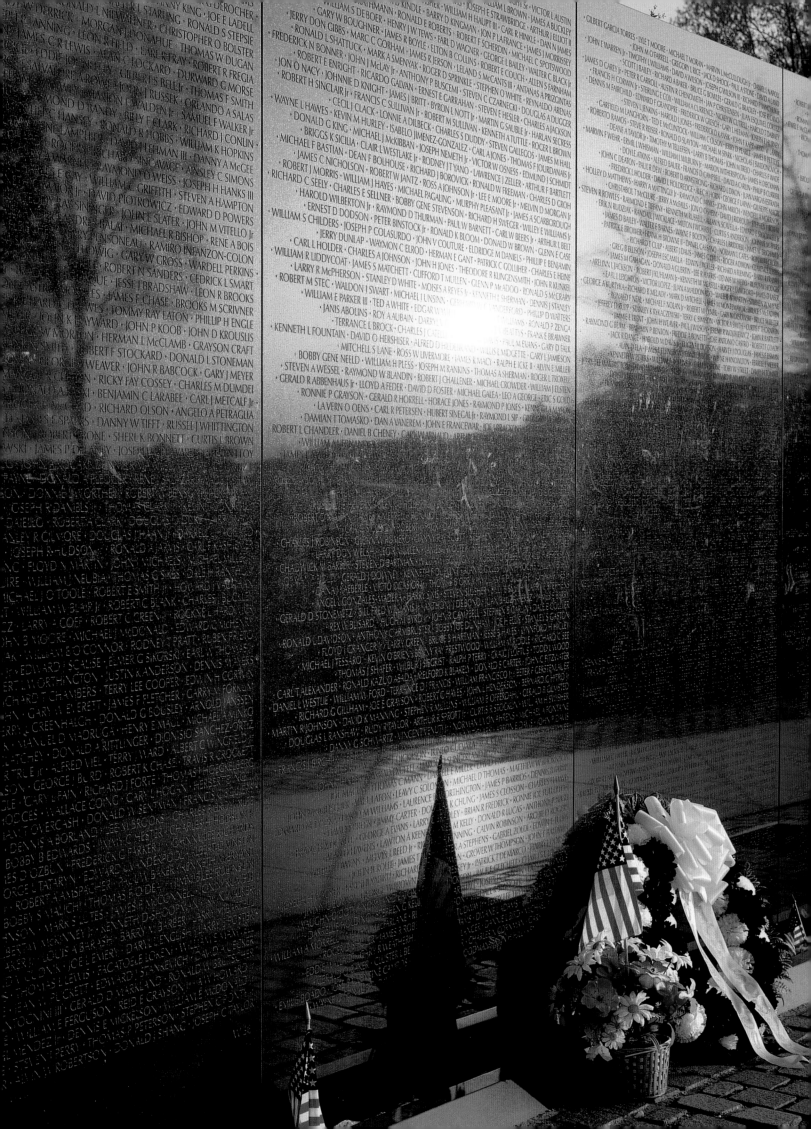

112 Reflecting the trees in Constitution Gardens, the light of sunset catches the black marble that commemorates the sacrifice and names of the 58,000 Americans who died in Vietnam. The Vietnam Veterans Memorial was designed by an architecture student at Yale University, Maya Ying Lin, who was only 21 at the time. The names are engraved to record the chronological order in which the men died, from the first in 1959 to the last in 1975. The Memorial was raised in 1982 thanks to a Vietnam veteran, Jan Scruggs; two years later, a life-size bronze of three young American soldiers was added.

Some locations in the capital represent both dreams and nightmares, life and death. They are symbols, required by the conscience of the entire country, built to hand down to future generations the memory of the worst wounds that humanity can suffer. These memorials are the Vietnam Veterans Memorial, Holocaust Memorial Museum, Arlington Memorial Bridge, Iwo-Jima Memorial and Arlington National Cemetery.

The first of these was designed by Maya Ying Lin, an architectural student of Chinese origin; it is a mournful black marble wall erected in 1975 that records the sacrifice and names of the 58,000 Americans who died in Vietnam. It is impossible to pass it without reading some of the seemingly endless list of names, engraved in the chronological order in which they died. Another chill runs down the spine when you look at the bronze statue added in 1984 or the nearby Vietnam Women's Memorial, inaugurated in 1993 to commemorate the contribution made by the Red Cross nurses in the same war.

The pain of memory continues with the U.S. Holocaust Memorial Museum devoted to the persecution of the Jews in Europe by the Nazis. The United States was involved directly in this horror when American soldiers opened the concentration camps and offered shelter to survivors and families of the persecuted during and after the war.

113 top The Vietnam Veterans Women's Memorial, by Glenna Goodacre was built close by the wall that honors the memory of the male dead. The bronze group was inaugurated in 1993 to commemorate that courageous and difficult job performed by the American nurses during the Vietnam War. The work shows two nurses providing first aid for a wounded soldier while a third anxiously watches the sky as she waits for the arrival of the emergency helicopter.

113 center and bottom The inside of the U.S. Holocaust Memorial Museum is deliberately dark and bare. The museum memorializes the persecution of the Jews in Nazi Germany and the territories occupied by Hitler's troops between 1933 and 1945. The Holocaust was the most horrifying crime of the twentieth century, rivaled only by gulag and the crimes committed in the Soviet Union of the Stalin era.

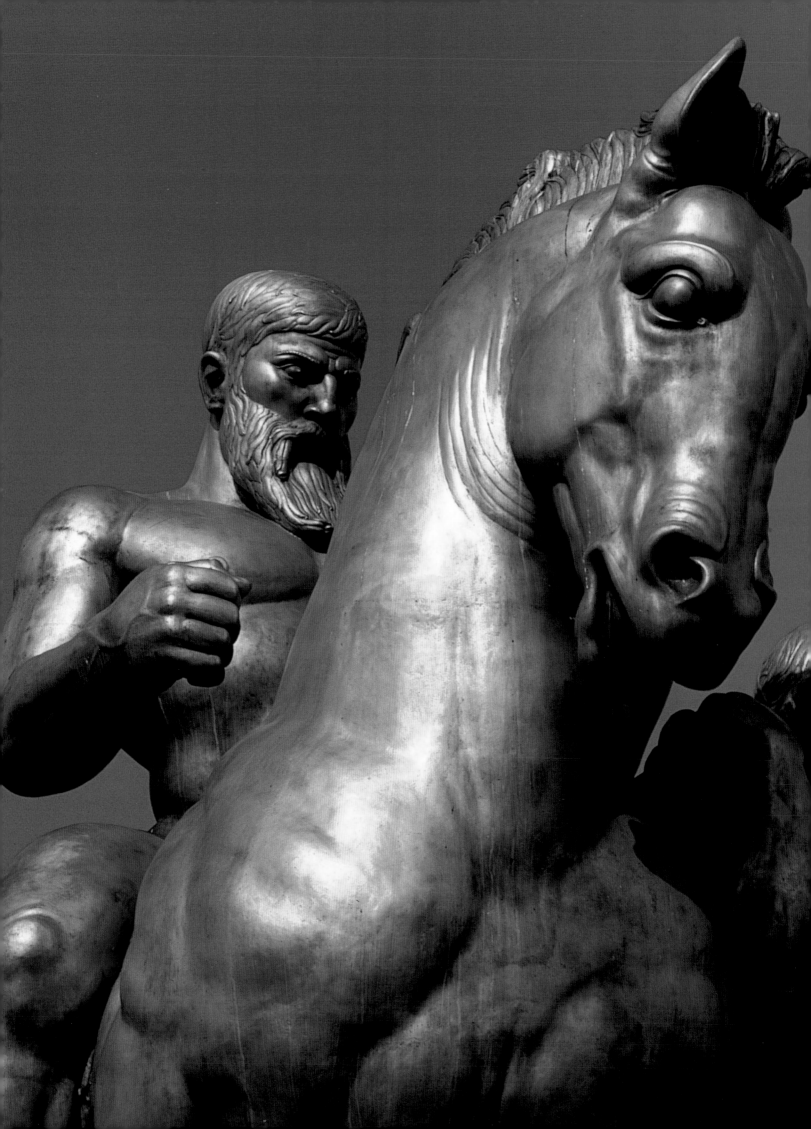

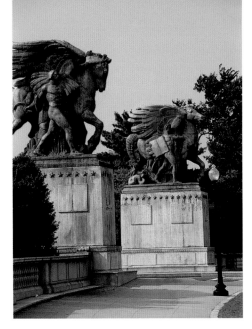
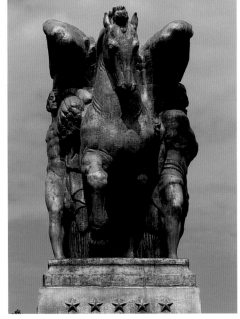

More a means of linking consciences than geographical places, the Arlington Memorial Bridge crosses the Potomac, joining Washington D.C. to Arlington. The bridge was proposed shortly after the end of the Civil War as a symbol of the peace made between the North and South; it was to end at the Lincoln Memorial on the north side, and at Arlington House on the south, the latter the residence of Robert E. Lee, the commander of the Confederate forces. Today the bridge leads into the district of Arlington, a green suburb with many memorials of its own.

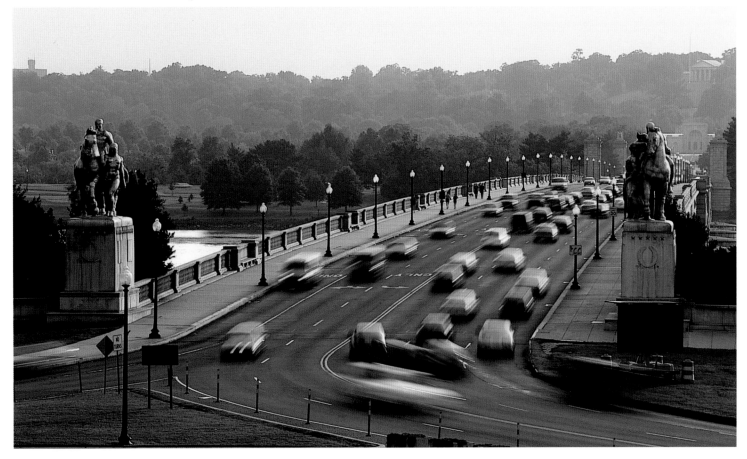

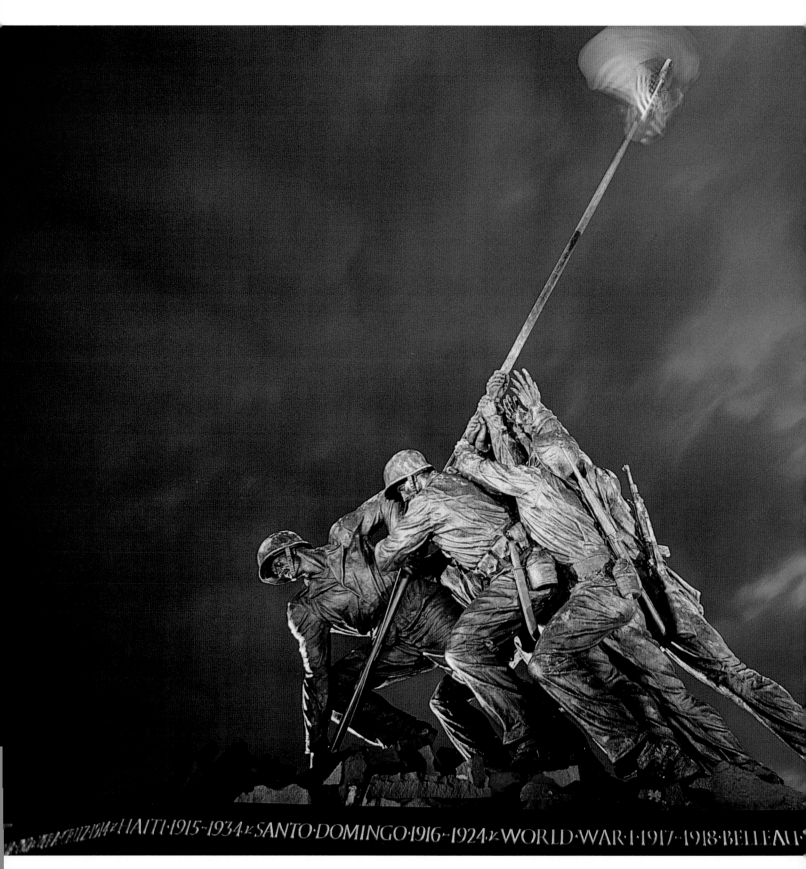

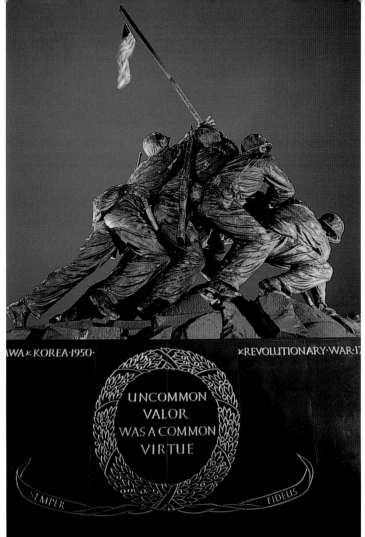

116 and 117 Raising Old Glory at Suribachi hill, Iwo Jima is one of the most famous photographs in war journalism, and winner of the Pulitzer Prize for its dynamism and drama. The image was converted into a bronze statue that stands outside Arlington National Cemetery; it serves as a U.S. Marine Corps War Memorial, also known as the Iwo Jima Memorial. The bronze group honors the dead of the Marine Corps and is inscribed with the phrase "uncommon valor was a common virtue."

On the other side of the Potomac a sculpture depicts the hoisting of the flag that took place at the end of the battle of Iwo Jima, where one of the bloodiest and cruellest episodes of World War II took place between American and Japanese troops. It was a terrible battle. The 21,000 men of the Japanese garrison sacrificed themselves almost to the last man (only 212 prisoners were captured by the Americans) to prevent the Fifth Amphibious Corps from taking the island. Preceded and accompanied by heavy air and naval bombardments, the battle began on 10 December 1944 and ended on 20 March 1945. When five marines planted Old Glory on Suribachi hill in a posed photograph, the battle in the Pacific had only a few months to run. The American bombers, the Flying Superfortresses, were able to strike and destroy the cities of Japan itself but the determination of Emperor Hirohito's men meant they would fight for victory house by house and inch by inch. Thus, President Truman decided to use the nuclear bomb to break the Japanese resistance and the mushroom clouds of the explosions in Hiroshima and Nagasaki rose on the horizon of Iwo Jima. In remembrance of those terrible days and the sacrifice of the disembarking American troops, the U.S. Marine Corps War Memorial (better known as the Iwo Jima Memorial) was raised by the Potomac just over Theodore Roosevelt Bridge. It is a gigantic and extraordinarily detailed bronze sculpture by Felix W. de Weldon, who reproduced the famous photograph that won a Pulitzer Prize. At sunset on each Tuesday evening from June till August, a parade led by a band of the U.S. Marines honors the dead of the most famous and prestigious corps in the American army.

The Iwo Jima Memorial stands at the north end of Arlington National Cemetery where the remains of more than 220,000 heroes of the United States lie.

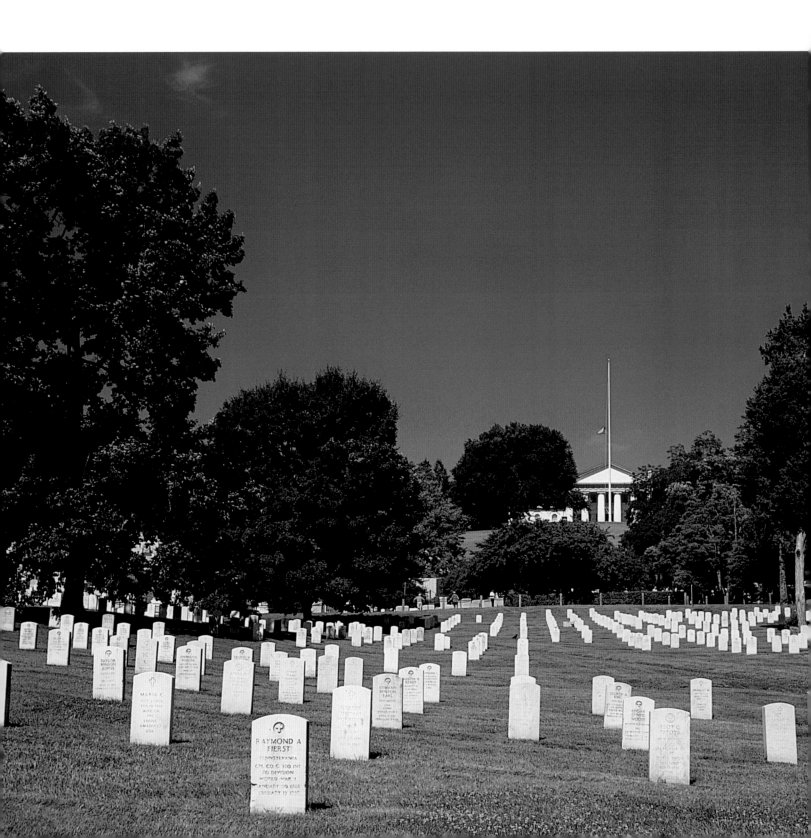

118-119 Arlington National Cemetery honors the American nation's most famous heroes as well as the 200,000 unknown but no less important dead who fell serving their country, nearly always on foreign soil.

119 top left A view of the Memorial Amphitheater in which 5000 seats are set out below the words of Lincoln's Gettysburg Address: "that these dead shall not have died in vain."

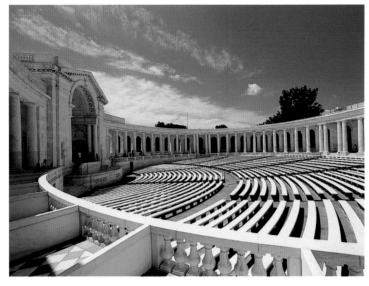

To get there from the Lincoln Memorial, just cross the Arlington Memorial Bridge. It pays tribute to the men who have left a mark, in various ways, on the history of this nation, including the Unknown Soldiers from the first and second World Wars and the Korean and Vietnam wars, and the tombs of two Presidents, Taft and Kennedy, of Pierre L'Enfant, the architect of the city of Washington, of Audie Murphy, the most highly decorated soldier of the Second World War and a rather less famous postwar actor, and finally the extremely controversial monument to the memory of the astronauts who died in the tragic fire aboard the space shuttle Challenger.

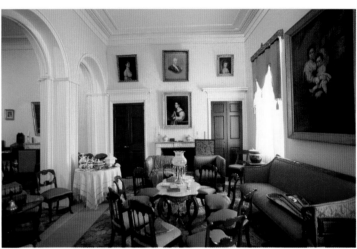

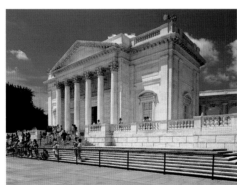

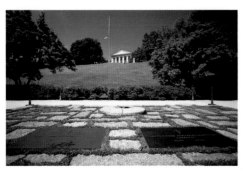

120-121 The Pentagon is the operational center of the U.S. Department of Defense. It has five sides, five floors and 19 miles of corridors. Built during the early years of World War II in this unusual shape, it is the largest office building in the world

and employs 22,000 staff. Like an aircraft carrier solidly rooted to the ground, it is a universe within itself, with a shopping mall, banks, a post office, beauty parlors, laundromats etc. The Pentagon is the heart of the American military where the

General Staffs of the army, navy, air force and others are based. Here the troops and attack systems of the world's strongest forces are armed and launched at the enemy, and here the strategies and outcomes of modern wars are decided.

120 The Conference Room in the Pentagon, where crucial decisions are taken. The Pentagon is also a vital center for communications with the rest of the world and has enough telephone cables to stretch three times around the world.

To the south of the Arlington Cemetery is the Pentagon, the principal military center in the United States and headquarters of the Department of Defense. It is a solid block of reinforced concrete (the largest office building in the world) with five sides, five floors, 19 miles of corridors and 22 thousand members of staff to organize, train, arm and launch the most formidable army in the world. It is the nerve centre where the General Staff of the army, navy, air force and other organizations operate together and where the results of the modern wars are decid-ed. There is a ninety-minute guided tour through the memorabilia of the US army, such as General Macarthur's uniform at the time of his training at West Point, and the Academy of Fame that lists the names of all those who have won the Medal of Honor. But the longest lasting memory of the visit is that of the escort who for the entire tour walks behind the group so as not to allow a single member out of sight. Perhaps to prevent some ill-intentioned person from stealing military or strategic secrets of vital importance in the heart of the U.S. defense system.

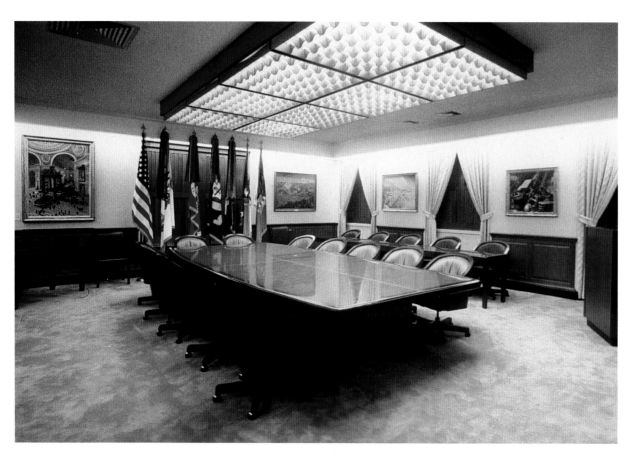

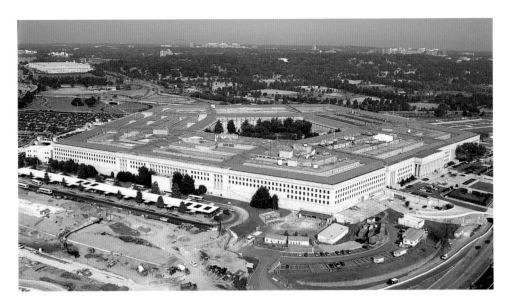

121 The perfect geometrical and stratified form of the Pentagon seems to imitate the invincibility of a medieval castle. Despite its operational capacities, the building was sorely tested by the attack on September 11, 2001, a direct strike at American national security.

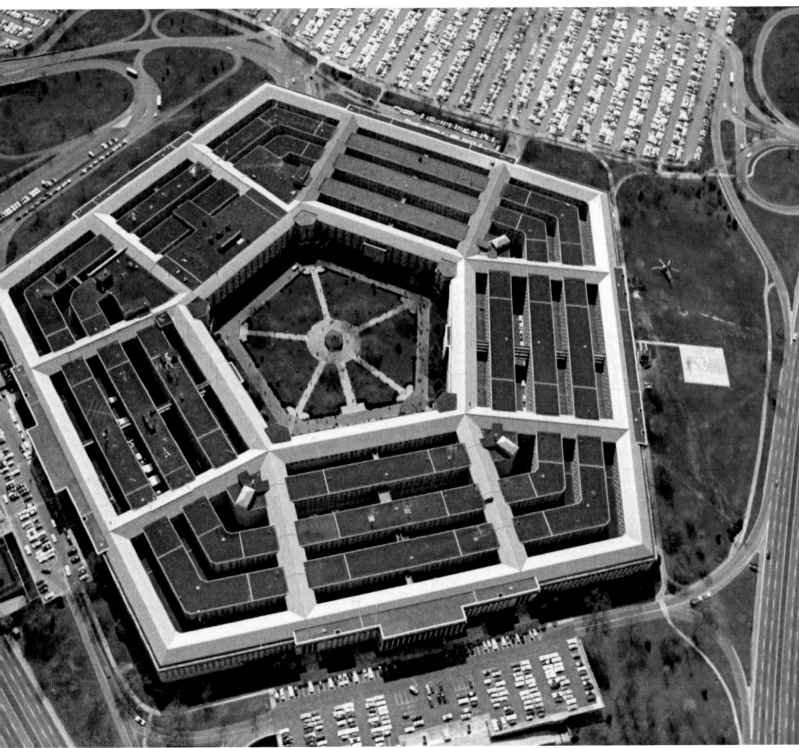

GEORGETOWN

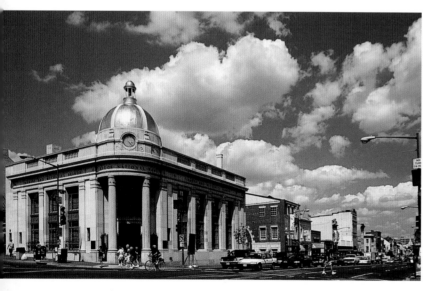

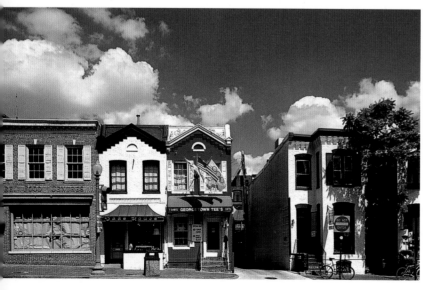

Georgetown settlement was built in 1751 and named after George II, the grandfather of the British king against whom the 13 New England colonies rebelled, but when the first European colony was established, the fur trader Henry Fleet had found a flourishing indigenous center that the American natives called Tohoga. Since 1608, Captain John Smith, the charismatic leader of the Jamestown colony who passed into history for having been saved from death by the Powhatan princess Pocahontas, had praised the climate and position of the territory: "The gentleness of the air, the fertility of the soil and the course of the rivers are utterly propitious. No other place is more suited to pleasure, profit and the support of man." In short, Georgetown became a relatively busy port thanks to its favorable position on the Potomac. A landing area on the river just a stone's throw from Chesapeake Bay was as valuable as gold in the wide terrain that lay between Maryland and Virginia, where means of communication and transportation were still in an embryonic state. The crops grown in the maize and tobacco fields had been transported on the road to Georgetown ever since the first president of the United States had identified the area as the location of the new capital. However, the first effect of that decision was anything but favorable.

The funds that financed agriculture in the area were soon diverted into land investments awaiting the fruits of property speculation that was fully expected to be highly rewarding.

In the meantime, Georgetown was built up with huts to house the workers who were to build the Executive mansion and the Capitol.

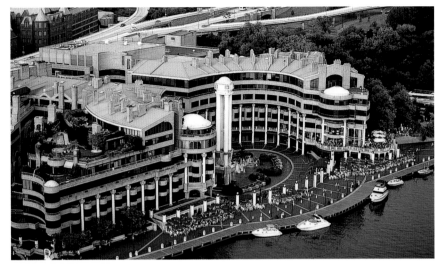

123 top left The bold design of the shopping area in the small port on the Potomac shows how recent the development is.

123 top right Georgetown University, the first Catholic university in the U.S.A., seen from a tourist plane. It was founded in 1789 and built in clear Neo-Gothic style.

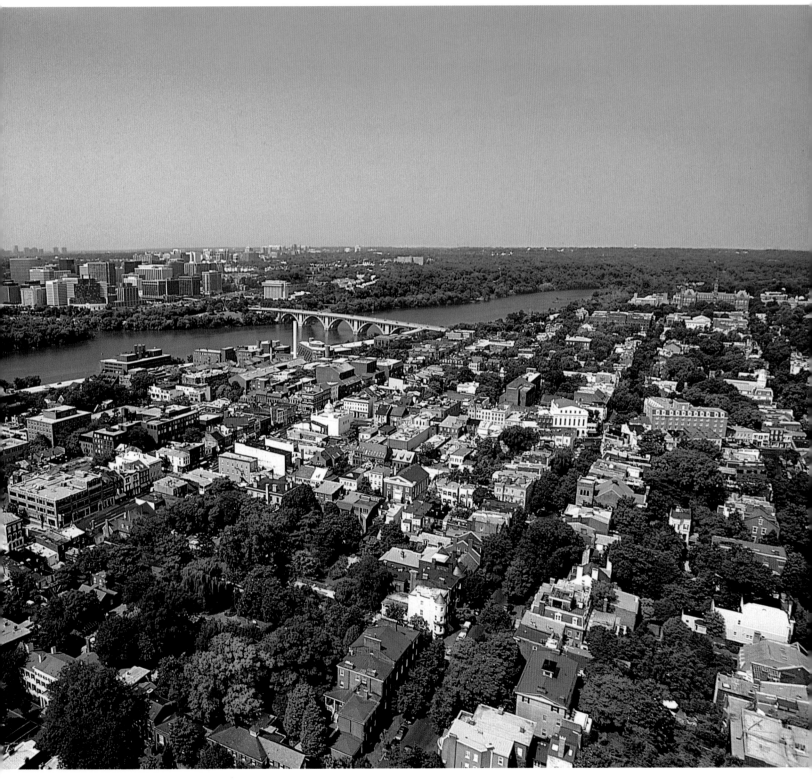

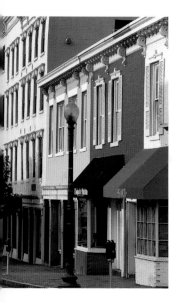

124-125 The decision to build the federal capital close by was the reason for the town's partial eclipse in the nineteenth century. Today the town is famous for its easy-going atmosphere, tree-lined avenues, nightlife, bars, restaurants, pubs and shops. It is a place to relax after the political and social tensions of the capital.

These huts remained a problem until 1877 when a new town planning scheme had all of the decrepit structures pulled down.

Today Georgetown is famous for its relaxed life, tree-lined avenues, busy nightlife, bars, elegant restaurants, pubs and boutiques. The more dynamic section of this district – incorporated into the District of Columbia in 1871 – lies between Wisconsin Avenue and M Street and all the way south to Washington Harbor and the banks of the Potomac. The indiscreet charm of Georgetown in many ways is associated with the students of the university founded in 1789 and organized by the Jesuits which was the first educational institute of this level in the United States. The green, shady college campus with its ordered pebbled paths is reminiscent of a strict, ancient culture but this atmosphere is disrupted by the multi-colored, free and easy student body of the third millennium. An ideal introduction to this cocktail of the sacred and profane, of WASPs and freaks, can be had at the flea market every Sunday from 9 till 5 from March to December. The market is held in a carpark on Wisconsin Avenue between S and T streets. More than a hundred stalls offer wares that are typical of street markets, and it is worth bearing in mind that you won't find the bargain of the century here, but that enjoyment is to be had strolling around, browsing among the poor-taste items of past eras. A visit to the market represents a quick trip to the everyday life of bygone times, to an opaque and rather dusty, but perhaps more genuine, world.

Another feature of Georgetown that is not always emphasized as much as it perhaps should be is Buffalo Bridge in Rock Creek Park. This is an ingenious and daring piece of engineering built in 1914 to connect two unaligned sections of Q Street on either side of the creek. The solution found was extremely unusual in that it is a bridge with a 12 degree curve that pleasantly interrupts the straight line dullness of the uncreative, orthogonal street layout. Almost as though to compensate for the phase displacement in the Roman topography imprinted on the city by the founding fathers of Washington and the USA, Buffalo Bridge was designed in form and to the specifications of a traditional Roman aqueduct, even in its unexpected curvature, with severe and functional spans. This cultural mix is further confused by 28 decorations on each side of the bridge that reproduce the head of Kicking Bear, an Indian chief, complete with ceremonial feathered headdress. The four buffaloes that guard the entrances to the bridge – and give it its name – have in the past had to suffer the disrespect of students who have had the cheek to paint the buffaloes' impressive genitalia a bright red. *O tempora, o mores*

In the most heavily congested area of Georgetown, there is an attractive building that dates from the colonial era. The compact structure of the Old

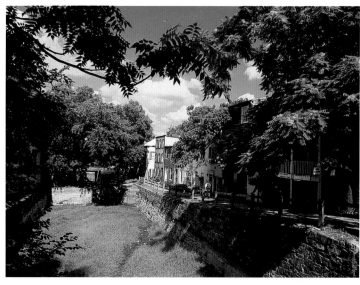

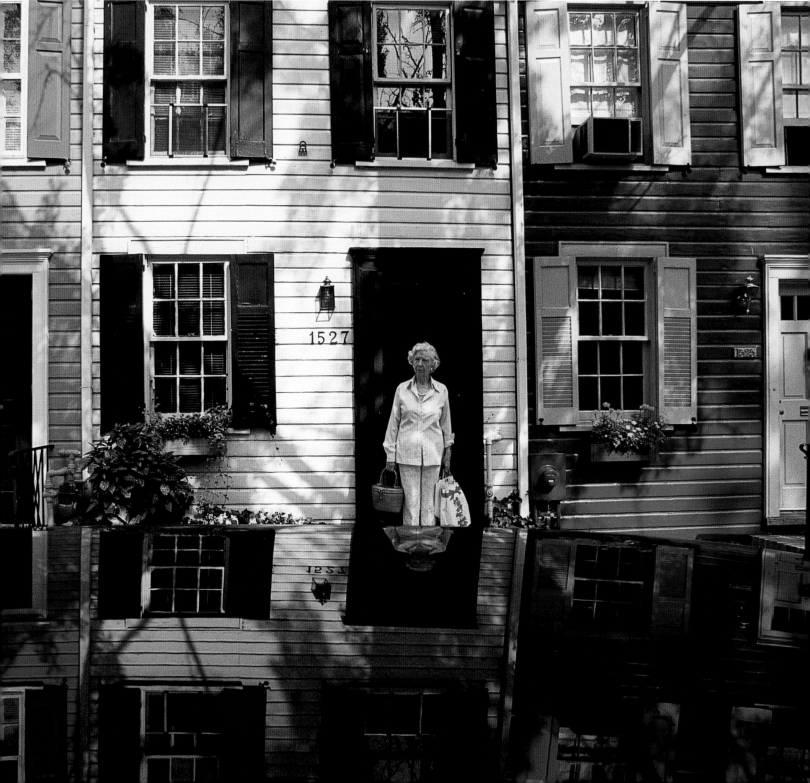

126 top left Old
Stone House was
built in 1765. The
house had a shop on
the ground floor and
belonged to a master-
carpenter called
Christopher Layman.

126 top right This
house at 3051 M
Street (kitchen is
shown) is the only
building from the
Colonial era to give
an idea of those days.

126 center
Dumbarton House at
2715 Q Street NW
should not be confused
with Dumbarton
Oaks, where an
important
international
conference was held in
1944. The house was
built between 1799
and 1805 but in 1915
was moved a few
hundred yards to
allow construction of
Dumbarton Bridge

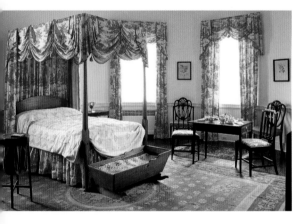

126 bottom
A bedroom in
Dumbarton House.
Since 1928 the house
has been home to the
National Society of
Colonial Dames of
America, which has
furnished the interior
with period
furniture. The house
was built in federal
style, in which the size
and position of the
rooms were the same
on each floor.

127 The Music
Room in Dumbarton
House is soberly
elegant. This is the
house in which Dolley
Madison hid when at
the last moment she
fled from the
presidential home,
shortly before the
British burnt it down
during the sacking of
the city in 1814.

Stone House – built in 1765 – was once the house and shop of Christopher Layman, a master carpenter. A spacious and terraced lawn behind the house, with flowerbeds in bloom from April to November, is a pleasant place to pause and escape the din of the traffic of the center. The Old Stone House stands at 3051 M Street, and is the only building of that period to have been preserved from the wear of time and affronts of progress. In its history it has been a tavern, a hostel, a shop and even a brothel. Today, the four rooms open to the public have been carefully furnished with items from the end of the eighteenth century and offer an interesting slice of life in the pre-revolutionary era.

Georgetown's most important land-marks are associated with some of the men and buildings that have played a role in the major events in the history of Washington D.C. Dumbarton House at 2715 Q Street was completed in 1805, and it was here that Dolley Madison found refuge for a brief moment in her adventurous flight, the portrait of Washington rolled up under her arm, from the presidential residence just before it was burned down by the British in 1814. A cup of tea and then she was on the road once more, heading for a ferry that would take her to Virginia.

The guided visit of the building is a little tedious but it gives an idea of the life and history of the early post-Independence period.

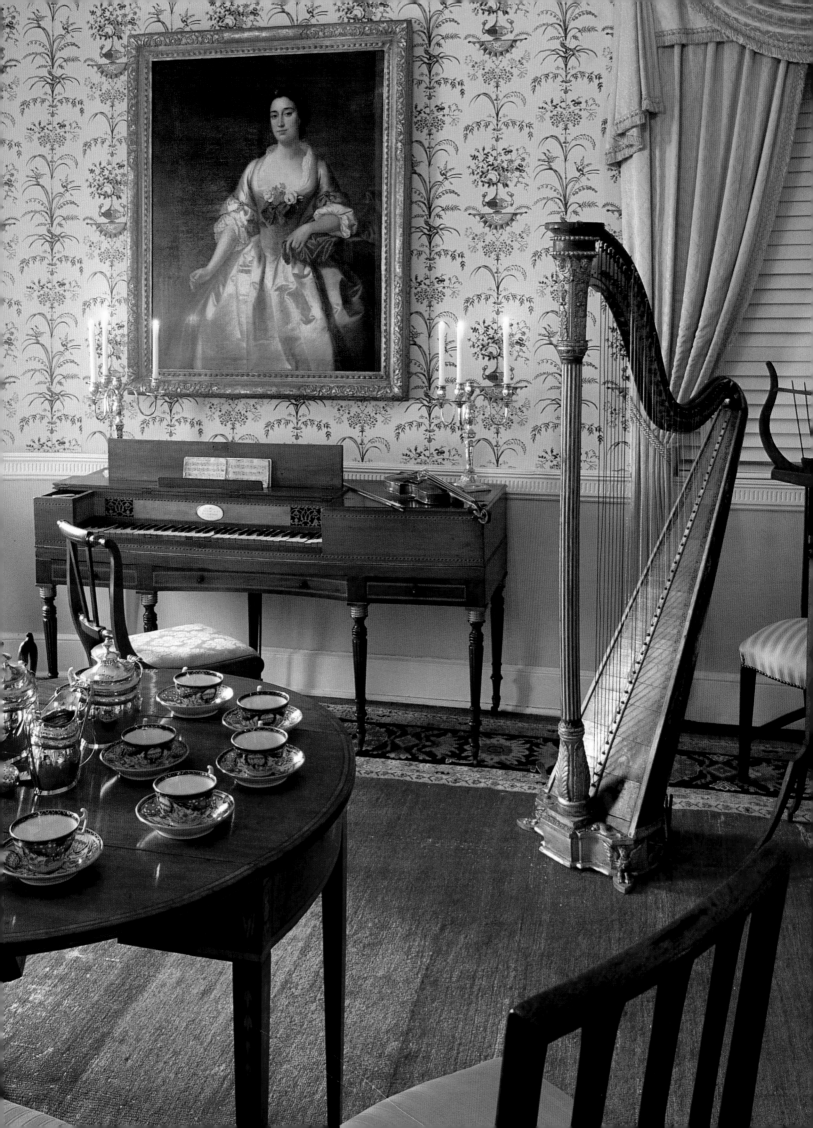

*128 and 128-129
Tudor Place is a fine
Palladian villa
designed by William
Thornton, the first
architect of the
Capitol in
Washington. The
five-acres garden is a
famous tourist sight
in Georgetown and
offers the opportunity
for pleasant walks.*

Another place close by that should be seen is the Tudor House at 1644 on 31st Street. This is a villa in Palladian style designed by William Thornton, the first architect of the Capitol in Washington. The house was purchased by the granddaughter of Martha Washington, wife of the first President, and still has much of the furniture of Mount Vernon, the official residence of the Washington family. The five-acres of grounds are a lovely place for a relaxing stroll.

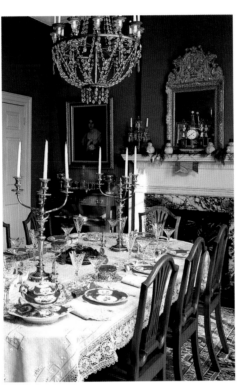

Lastly, for fans of the tormented and often dramatic saga of the Kennedy family, it is possible to take a look – from the outside only – at the residences that were used by the then Representative and, later, Senator Kennedy. The address is 3307 N Street, which was JFK's last address before his leap to the White House. He never moved house again: his appointment with death took place on a bright morning in November 1963, in front of a warehouse in Dallas, Texas.

130 top Built in 1800 and given the name of an old Scottish castle, Dumbarton Oaks is typically Georgian in style. It was used to host an international conference in 1944 that opened the road to a conference in San Francisco a year later, in which the existence of the United Nations was ratified.

130 bottom The garden at Dumbarton Oaks was designed with European styles in mind. The idea of preparing a series of signed commitments by all Allied nations to contribute to the construction of a new world order came to Roosevelt and Churchill during the final days of the Third Reich and Empire of the Rising Sun.

The real highlight in Georgetown is Dumbarton Oaks, the patrician villa with grounds measuring 15 acres where, in 1944, the Dumbarton Oaks Conference was held to prepare the way for the San Francisco Conference, held in June 1945, that ratified the protocol of the foundation of the United Nations Organisation. The Atlantic Charter had been signed in 1941 and, when the Third Reich and Japan were close to collapse, Roosevelt and Churchill decided to set pen to paper and draw up a series of commitments to be subscribed

tion where the representatives of the four Great Powers could take off their jackets: they were Lord Halifax from Great Britain, the hardy Andrei Gromyko of the USSR, Wellington Koo from China and Edward Stettinius for the United States. We do not know if they smoked good cigars with their feet up on the table because the talks were held in complete confidentiality, but we do know that everything took place in the Music Room, led a few months later to the UN. Perhaps it was something to do with the atmosphere

130-131 A view of Dumbarton Oaks and its garden. The owners, Robert Bliss and his wife Mildred, created an extraordinary collection of pre-Columbian and Byzantine objets d'art during their more than thirty years of diplomatic life around the world.

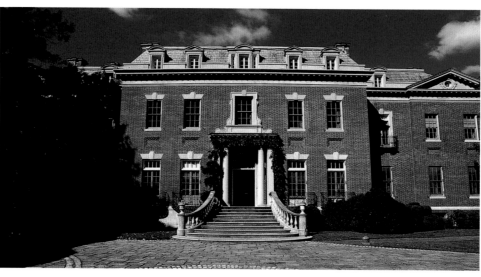

by the Allies regarding the construction of a new world order. The idea was neither original nor easily applied. At the end of the Great War – the war that was supposed to end all wars – Woodrow Wilson had launched a platform of Fourteen Points that were supposed to usher in universal peace through the good offices of the League of Nations. The spectacular failure of that project had not impressed Roosevelt and he gave his personal thoughts on the requirements to resolve the most intricate political questions on the agenda for those years. "If you can get all the parties in a room seated around a round table, and you can get them to take off their jackets and smoke a good cigar, you will always get them to agree." Naturally Roosevelt was very wordly wise and experienced, and far less ingenuous that he let on. Roosevelt chose the residence of Ambassador Robert Wood Bliss in Georgetown as the loca-

of the building, with its immense sixteenth century stone fireplace, its eighteenth century parquet floor, the antique furniture from Spain, France and Italy, and the visual effects of the *Visitation* by El Greco. Today, Dumbarton Oaks not only offers the visitor the fascination of a mansion redolent of international diplomacy, it is also home to an extraordinary collection of Pre-columbian and Byzantine *objets d'art* assembled by Robert and Mildred Bliss during thirty three years of diplomatic life in all corners of the earth. The mystery and religiousness of Mayan ceramics and jade Olmec statuettes mingle with icons, manuscripts and mosaics from the Byzantine empire. In 1940, the Bliss family gave the entire collection to Harvard University, along with the historic building (built in 1800) and its glorious grounds with their lawns, orange grove, cherry orchard and magnolias.

131 top *Dumbarton Oaks is now a museum of Maya ceramics, objects from the Olmec civilization, and icons, manuscripts and mosaics from the Byzantine period. In 1940, the Bliss family donated the collection to Harvard University, together with the house and garden.*

To bring this journey of discovery of Georgetown and the Washington area to an end, the visitor must make a trip down a stretch of Chesapeake Bay and the Ohio River Canal. The canal stretches for 186 miles from Georgetown to Cumberland, Maryland and rises 590 feet above sea level through 74 locks, joining the inland eastern states with Chesapeake Bay and the Atlantic. The original idea was to build a series of canals that would form a chain with rivers so that waterborne communication existed between the Pacific and the Atlantic. However, construction of the first transcontinental railway made the canal project obsolete. Yet the path alongside the Potomac and M Street, where teams of mules used to haul transport barges against the current, is used today to take visitors on unusual excursions. From April to November, tourists are transported using the same system of locomotion, accompanied by a ranger who explains the most important events that took place in the area. A very pleasant hour passes in the old way, while streams of hikers, joggers, skaters, cyclists and horse-riders pass by along the riverside. History, architecture, conferences, obelisks, libraries, museums, fires and assassination. Cherries, presidents, senators, representatives, lobbyists, horoscopes, statues, paintings, long distance pilots and murals. A lot of water has passed under the bridges of Washington since that dry, crispy dawn on which two men on horseback ambled through an unexplored corner of Maryland.

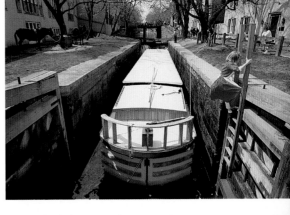

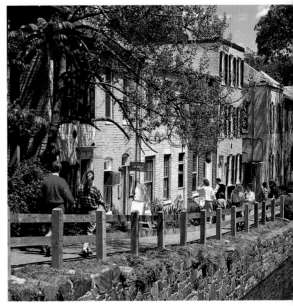

INDEX

PHOTO CREDITS

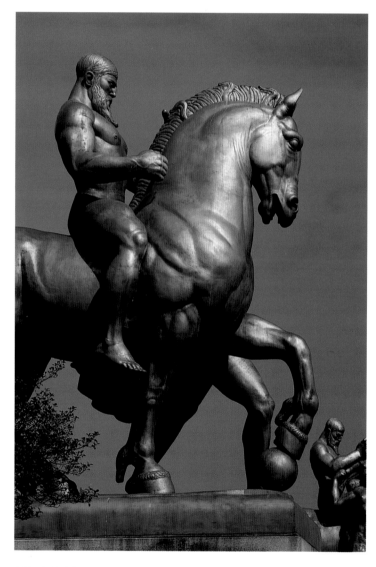

136 As it joins Washington D.C. to Arlington, the Theodore Roosevelt Memorial Bridge passes over the island dedicated to the twenty-sixth President in recognition of his environmental policies. Here one of the bridge's statues.